THE ATLAS OF BEAUTY

women of the world in 500 portraits

MIHAELA NOROC

TEN SPEED PRESS
California | New York

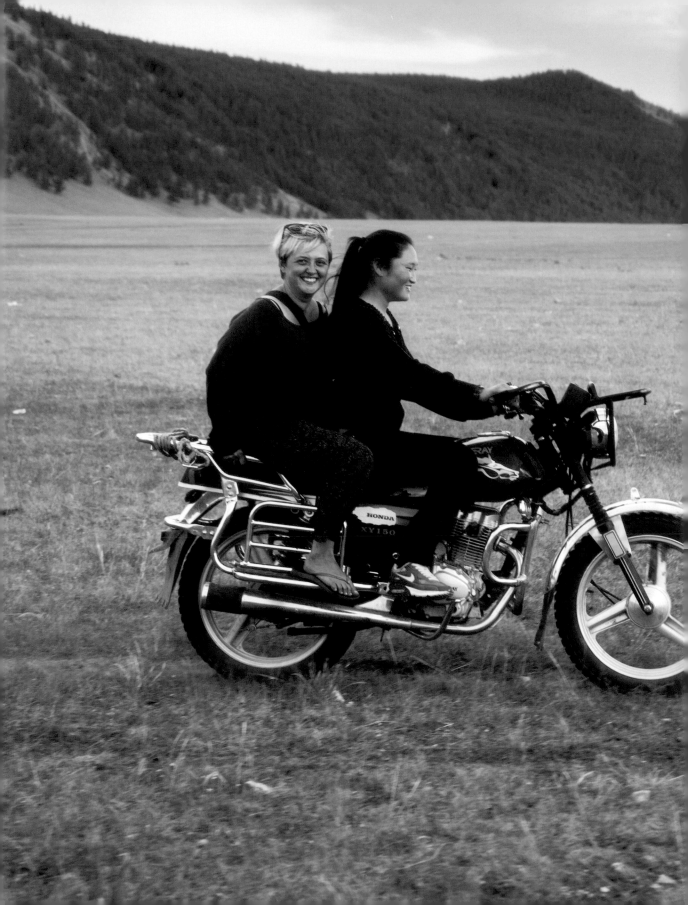

THE ATLAS OF BEAUTY

WELCOME TO THE ATLAS OF BEAUTY

Thank you for embarking on this journey with me. I'm Mihaela Noroc, the one on the back of this motorcycle. This colorful journey will take you to more than 50 countries, through 500 portraits of wonderful women. Together, we will celebrate the diversity of this fascinating world, but first, let's go back to where it all began.

I've spent most of my life in Bucharest, the capital of Romania, a place roughly equidistant from Western Europe, Asia, and Africa. The 1990s, when I was growing up, were difficult years in Eastern Europe, with a lot of unemployment and poverty. As a result, my family moved often. Almost every year I would be sent to a new school, have to get used to a new neighborhood and make new friends. Back then, I struggled each time I had to leave one group of friends for another, move from one flat to another, but years later I realized that this gave me the capacity to adapt in so many new environments.

My father is a painter so I spent my childhood surrounded by his paintings, enjoying the diversity of colors. When I was 16, he gave me an old, second-hand film camera. I was too shy to go on the streets and take photos of strangers, so my first subjects were my mother and my sister. That's how I started to photograph women, in a natural and very low-key way. At night, when my family was sleeping, the bathroom was mine and I would transform it into a darkroom to print my photos.

I went to college to study photography, but received little encouragement from my professors. These were the years of the digital boom, when everybody started buying cameras and I saw myself as just another average photographer surrounded by millions of others. I felt that the world didn't need another mediocre artist, so I quit photography. I took work in other fields for money and a practical future, without really enjoying what I was doing.

For years I felt that I was in the wrong place, but didn't have the power to escape. Then in 2013 a trip to Ethiopia changed my perspective. I brought along my camera, just like any other tourist.

Right away, I was fascinated by the women I saw during that vacation. Some were living in tribes, just as nonchalant about nudity as their ancestors had been generations before. Others were part of conservative communities, covering their heads. And still others, in the big cities, were embracing modern life.

Most of them were struggling and working hard, sometimes facing discrimination as women. But in these harsh environments, they were shining like stars—with dignity, strength, and beauty.

If there's so much beauty and diversity in one country, what about the rest of the world? I wondered. I realized that the wonderful women of our planet need much more attention, and that true beauty is more than what we so often see in the media. In that moment, I started to dream again, and found the strength to break from my comfort zone, quit my job, and go back to photography. I started to travel, take photos and, little by little, I regained my self-confidence.

In the beginning, *The Atlas of Beauty* was just a small, personal project, funded with my savings, known only within my own country. I traveled on a very low budget, as a backpacker, mingling with the locals and trying to understand their cultures.

After a while, the project took off on social media, something I had never imagined would happen. Millions of people were looking at my photos, and my email inbox filled up with messages from around the world. Sometimes people even recognized me on the street. Some thanked me, saying that I changed their way of looking at women. I was particularly happy that not just women, but also men, were interested in my work.

I now had a mandate: I would have to work harder, capture more diversity, and find more inspiring stories in order to send a message that really would be heard. People from all over began to donate to the project, allowing me to continue my work independently.

Traveling to so many fascinating places has given me some of the best times of my life, but also the most challenging. I've been close to war zones and wandered through dangerous slums. I've been freezing, overheated, emotional. I've been out of money, and I've been ill while far from the comforts of home. But meeting so many incredible women kept me moving forward on my path with enthusiasm.

I've been refused by hundreds of women whose portraits I had hoped to take, and I saw how discrimination and societal pressure weigh on the shoulders of so many. Some were simply scared to be photographed, even if they might have loved it. Others were not confident enough. But I'm very grateful to all the women I met, whether they said yes or no to my proposal. Sometimes we spent a few seconds together, other times hours, but from each of them I learned something.

I owe everything I am today to these women. Each encounter taught me to be a better person, to see beauty everywhere, and in everything, not just on the surface. I always use natural light for my photos, trying to create a feeling of coziness, and to capture that magic moment when a woman opens up, so I can dive into her eyes and capture her inner beauty too.

When I say "beauty," I mean more than the beauty that we often see today, which is usually about sexual attractiveness, in the service of selling something. If you put the words "beautiful woman" into Google, you'll see mostly images of seductive women: mouths pouting or lips parted; hands pushing their hair into a bed-head tangle; not many clothes at all. But in this book you will see that beauty means much more.

I think that beauty is about being yourself, natural and authentic, about letting people see what is inside of you. Today it is not always easy to do that, because there's so much pressure on women to look and behave in a certain way. In some environments, it is the pressure to

be modest and cover up as much as possible. In others, by contrast, the pressure is to look attractive. But in the end, each woman should be free to decide how to present herself, and to explore her own beauty without feeling pressure from the outside world.

So many times I approached women who told me that they don't feel beautiful, or that they should be dressed up and wear make-up to be photographed. Fortunately, after I posted their photo and story on my social media, receiving thousands of "likes" and lovely comments, they understood how special they are. They needed a little shot of fame to recognize their own beauty.

Beauty, as I see it, can teach us tolerance, honesty, and kindness, and our world needs these values more than ever.

This book will take you to many diverse environments. I've traveled through Afghanistan, Iraq, Iran, and North Korea as well as the United States, France, and Brazil. And I realized that although we are so different, there's something deeper that connects us all as human beings. In the end we are all part of the same beautiful family. We shouldn't build walls between us, based on gender, ethnicity, color, sexual orientation, or religion, but find paths that connect us to work together—women and men—and make this world a better place.

I hope this book will be one of these paths. Let's start the journey!

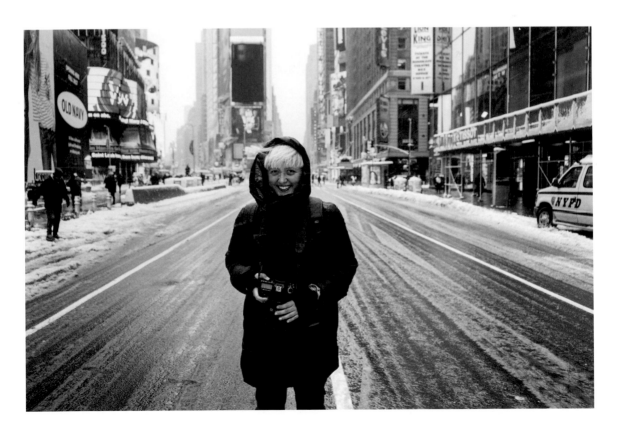

NEW YORK, USA

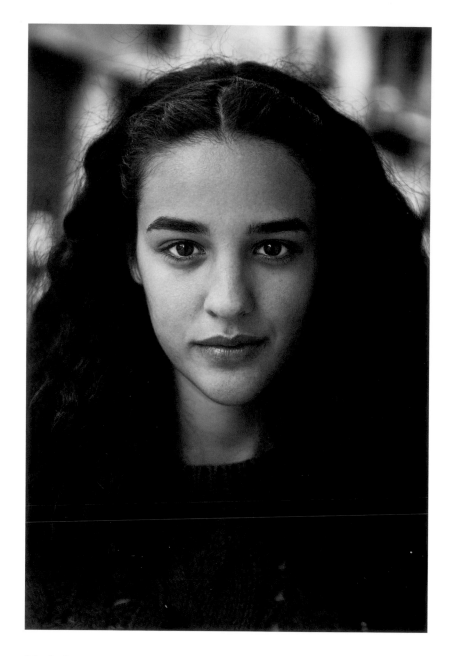

ARACHOVA, GREECE *(Above)*

Cristina is a student in Athens, but was on vacation in this mountain town.

CHICHICASTENANGO, GUATEMALA *(Opposite)*

Maria is a vegetable vendor in the market of her small town. She became shy as soon as she saw the camera.

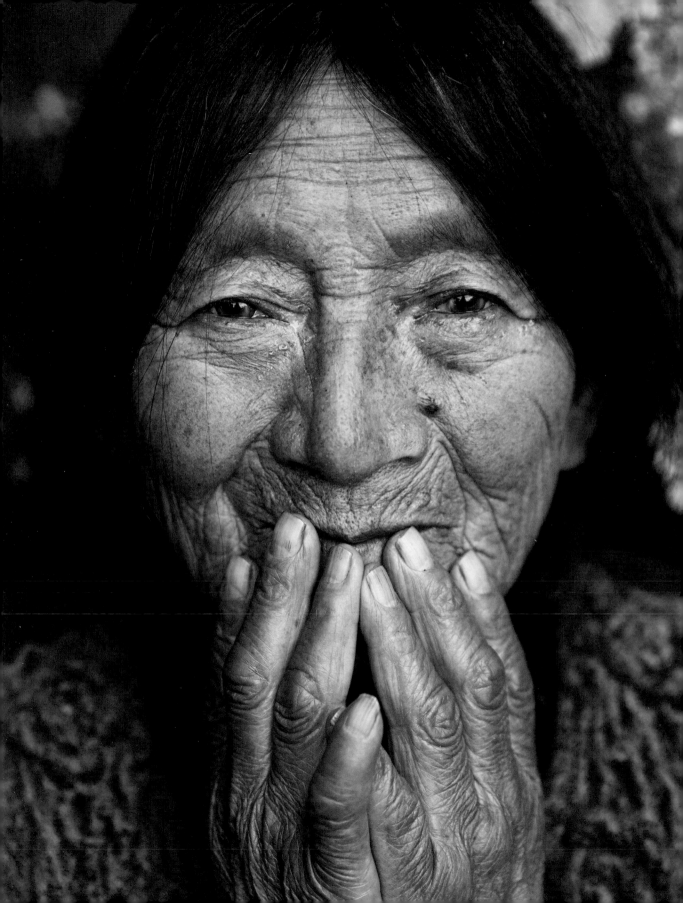

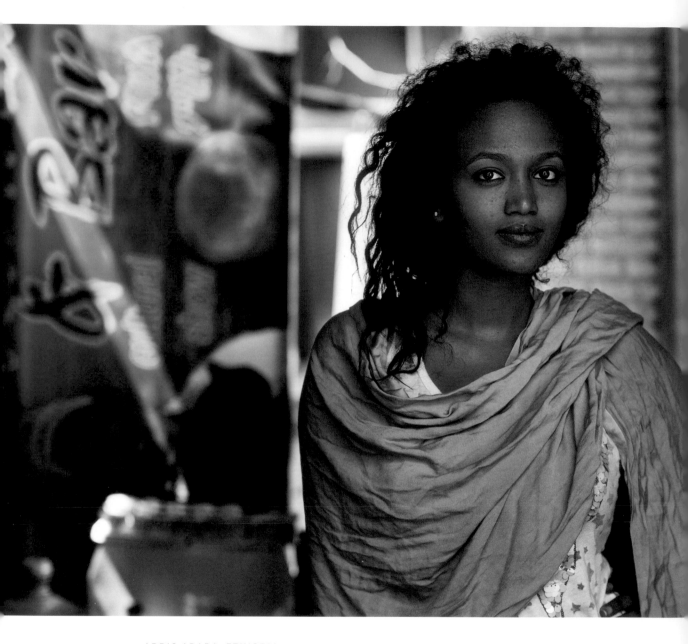

ADDIS ABABA, ETHIOPIA

I met Samira in her best friend's coffee shop. She is Muslim and her friend
is Christian. While visiting this stunning country, I saw many beautiful
friendships that go beyond religion. But there were also terrible conflicts,
rooted in differences of ethnicity. Samira's serene look gives me hope that
kind-hearted people like her will make this world a better place.

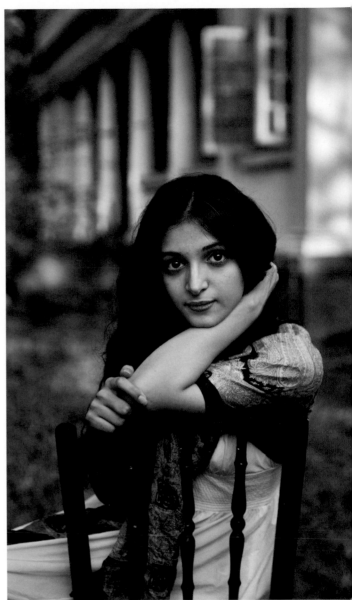

MUMBAI, INDIA

Anaisha is Parsi, descended from Persian Zoroastrians who immigrated to India more than one thousand years ago and formed new communities around Zoroastrian temples. I photographed Anaisha outside her beautiful home, in one of the biggest Parsi areas, in an elegant part of Mumbai, where they follow ancient traditions but also are very active in the modern world.

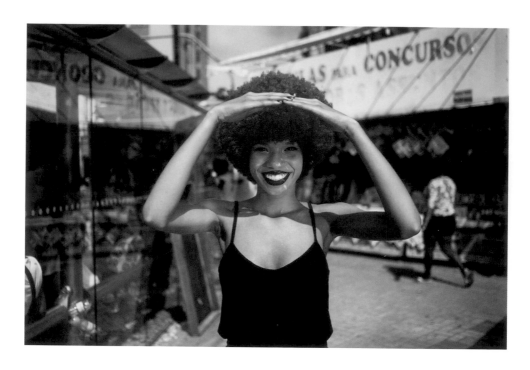

SALVADOR, BRAZIL

NAPLES, ITALY

LAS TABLAS, PANAMA

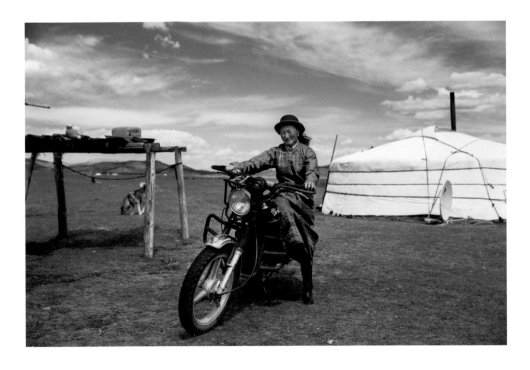

CENTRAL MONGOLIA

BERLIN, GERMANY *(Above)*

Lisa was coming from a trip when I met her. She carried a huge backpack and had many interesting memories. When she was eleven years old, she had been hit by a tram. She survived, miraculously, but was left with many scars. As she told me about that, her cheeks blushed bright red.

For many years, she felt very insecure with her skin. She was in some bands, but was too afraid to sing in front of an audience because of her blushing and the scars from the accident.

In time she realized that beauty is about being yourself, natural and authentic. She understood that the accident gave her a second life, and she now lives it with confidence.

"I had many broken bones, some smashed organs—but also, plenty of angels by my side."

SICHUAN PROVINCE, CHINA *(Opposite)*

Among the most graceful women I encountered, this Tibetan mother of two in a rural village looked like this the moment she opened her door to me; she had been cleaning her house, and yet she was wearing her jewelry. I found that Tibetan women display this kind of style in every moment of their lives.

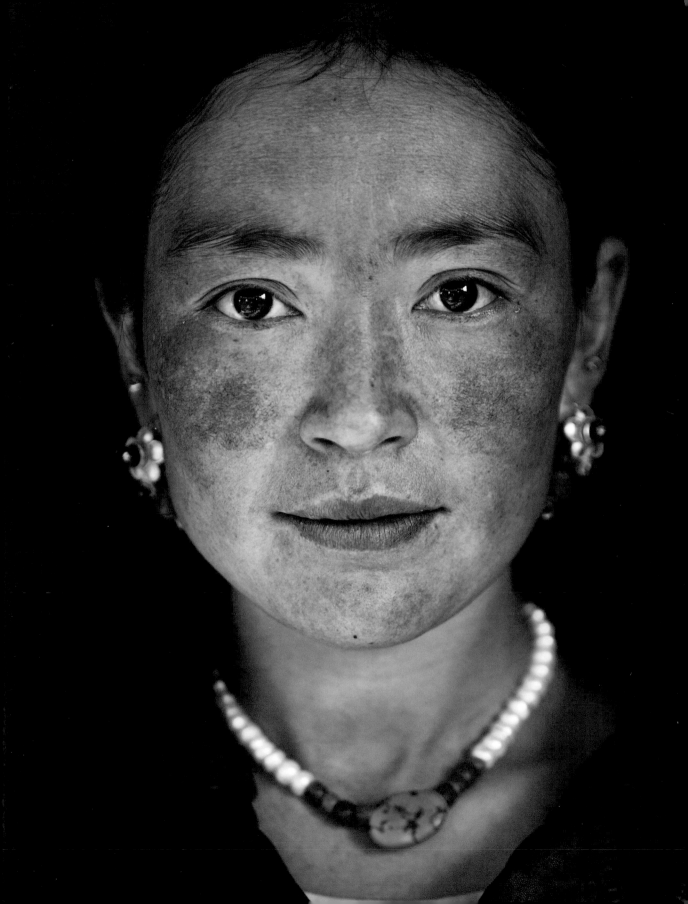

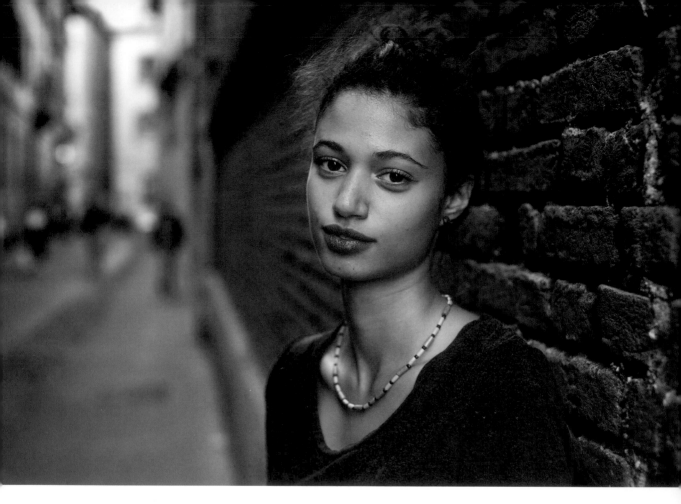

MILAN, ITALY

The daughter of an Italian mother and a Moroccan father, Malika lives in a city famous for fashion. But she prefers the outdoors to couture or the city.

"Many people from the fashion industry have tried to convince me to become a model. But I have other passions. I was never into fashion. I'm actually in love with hiking. When I was eight, I joined a scouting group and I started to explore nature. I often go to the mountains. I hike there alone and I don't see any human beings for days. I always do that when I feel stressed and tired. I live in a rough neighborhood of Milan, and sometimes it's a bit dangerous for a woman there. So I actually feel safer in the mountains than in the city."

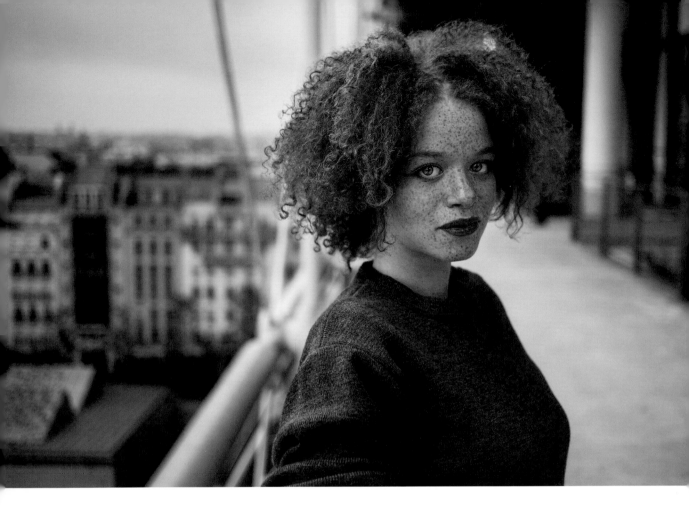

PARIS, FRANCE

I met Imane at an art exhibition at the Pompidou Centre, her favorite place to dream, before she had to leave for a job interview. She is studying art at a university and also works in three restaurants and does some babysitting to support herself. But she wants to someday have an art gallery, one that will bring together artists from different cultures. She has African and European roots and loves the diversity of the world.

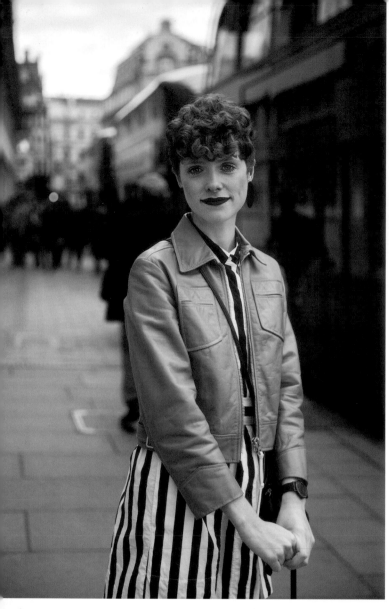

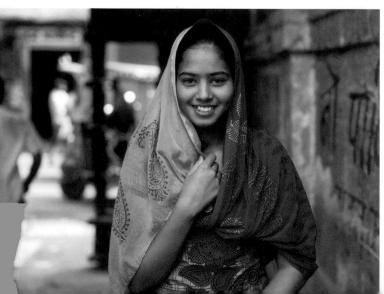

LONDON, ENGLAND *(Left, top)*

She is a floral designer, and besides arranging flowers, she loves to mix clothes in her playful outfits.

JODHPUR, INDIA *(Left, bottom)*

She was really surprised that a stranger asked to photograph her.

ATHENS, GREECE *(Opposite)*

We couldn't talk much because of the language barrier, so I gave her my business card and she gave me a beautiful smile.

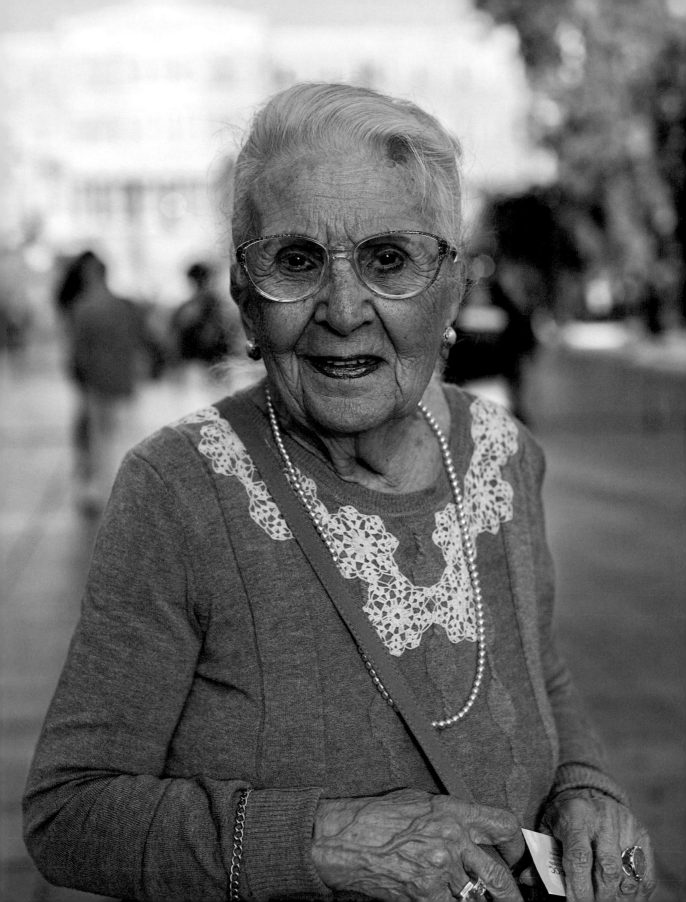

HAVANA, CUBA

An actress? A model? No, she wishes only
to finish her studies and become a nurse.

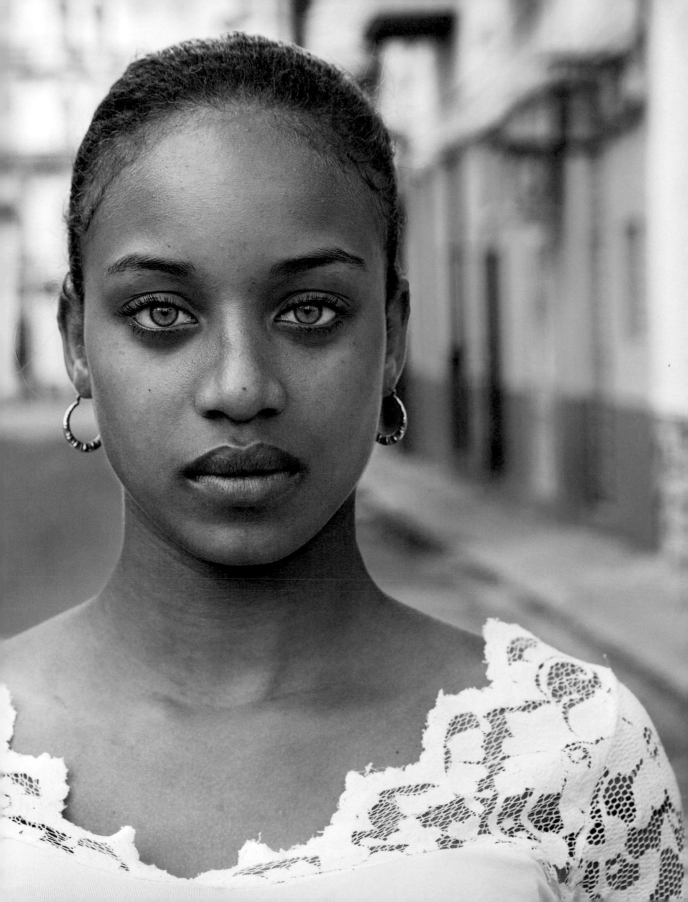

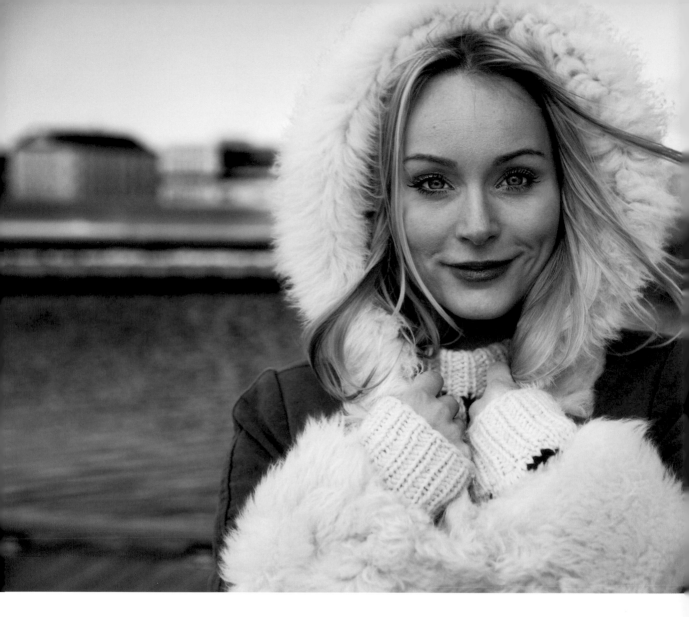

REYKJAVIK, ICELAND

I met Thorunn in her hometown on a freezing day. But her warm personality made me forget the cold. A popular singer in Iceland, she was also a new mom to a baby girl, whom she wants to grow up happy and confident. So Thorunn started an online community called "Good Sister," which drew a third of the women in her country to join in support of one another by sharing their stories and giving encouragement.

"I think women are just so thirsty for beautiful, nonjudgmental communication. Instead of constantly dragging each other down and dragging ourselves down, we can help each other to be our own good sister."

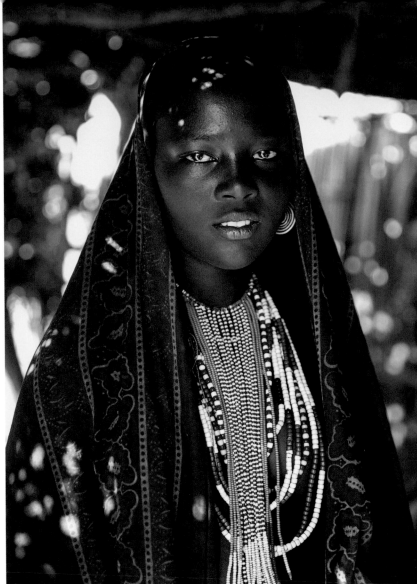

OMO VALLEY, ETHIOPIA

In this remote valley, you can see tribes living as they did thousands of years ago. With the high temperatures here, nudity is not unusual; her veil is only there to protect this young woman from the sun. Her tribe is called Arbore and has lived in isolation for generations. Now the modern world is just a step away. The 4G mobile network has arrived and soon many people here will also be part of a much larger community called the World Wide Web.

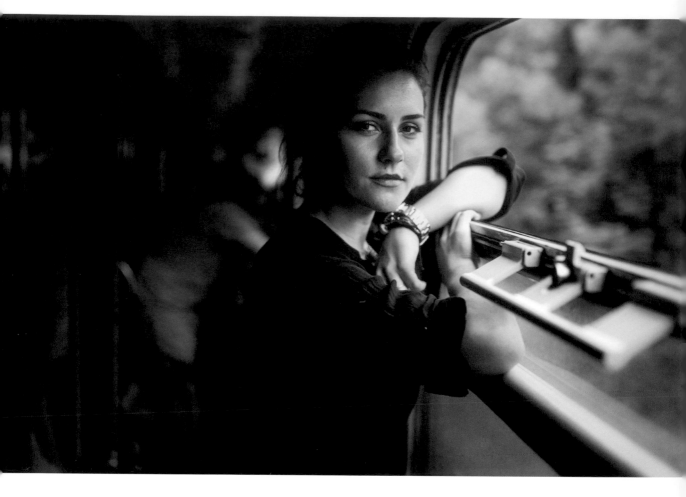

TRANSYLVANIA, ROMANIA

We met during a seven-hour train ride from Cluj-Napoca to Timişoara.

"I'm on my way to visit my boyfriend. It's my turn to take this long trip."

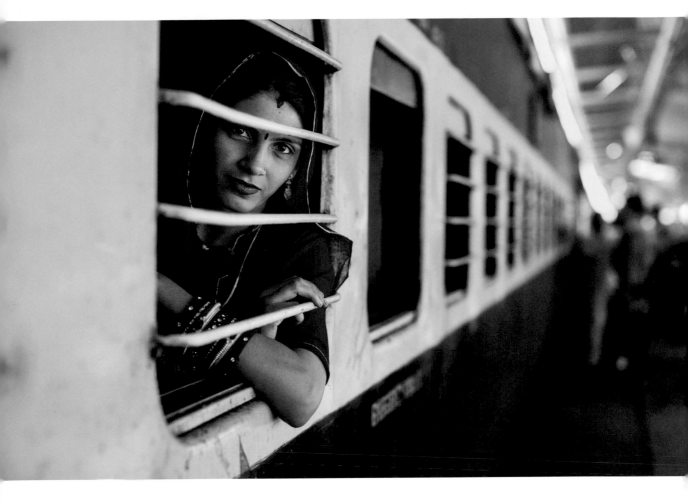

JODHPUR, INDIA

India's trains are the country's vital circulatory system. They transport more than twenty million people every day, in eight different classes of service, reflecting the stratified society. Just imagine twenty million fascinating stories! I wanted to hear hers but the train left after a few seconds.

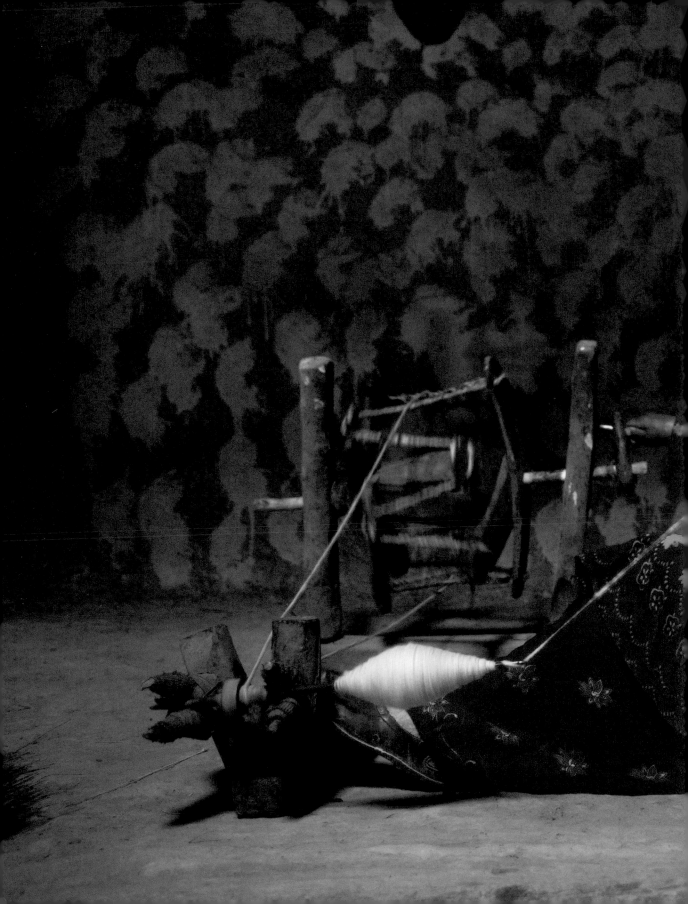

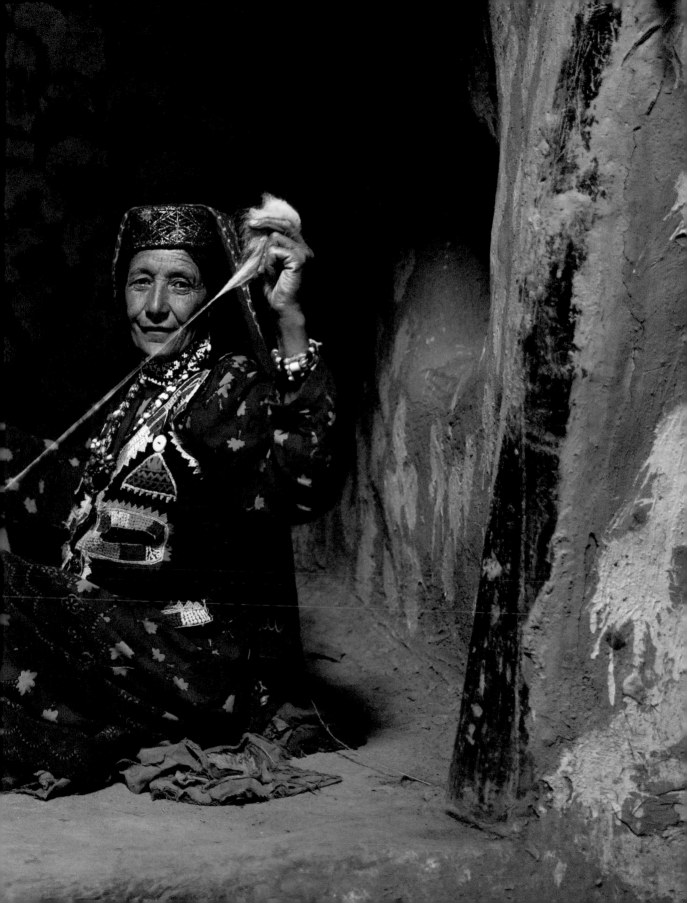

WAKHAN CORRIDOR, AFGHANISTAN *(Previous spread)*

This is a place where people invite you into their small mud homes and open up their lives to you. It's a very harsh existence but it's all they have ever known and they continue to live as their ancestors did; practicing ancient handicrafts.

KATHMANDU, NEPAL *(Opposite)*

Sona is celebrating Holi, the Hindu festival of colors, and among the most spectacular gatherings I witnessed in my travels. A time to forgive and to be forgiven, Holi marks the coming of spring, when good triumphs over evil.

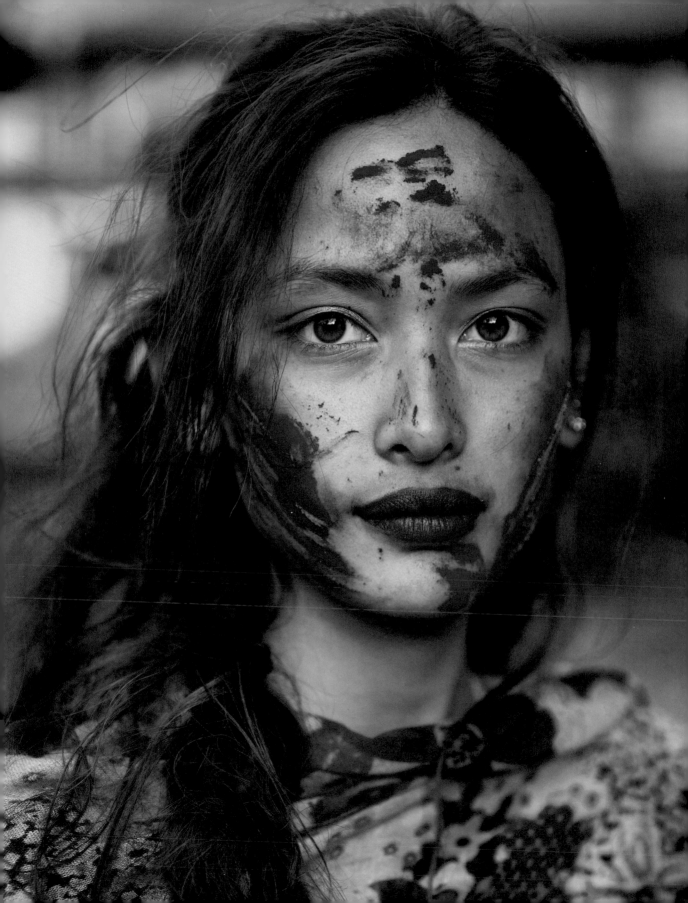

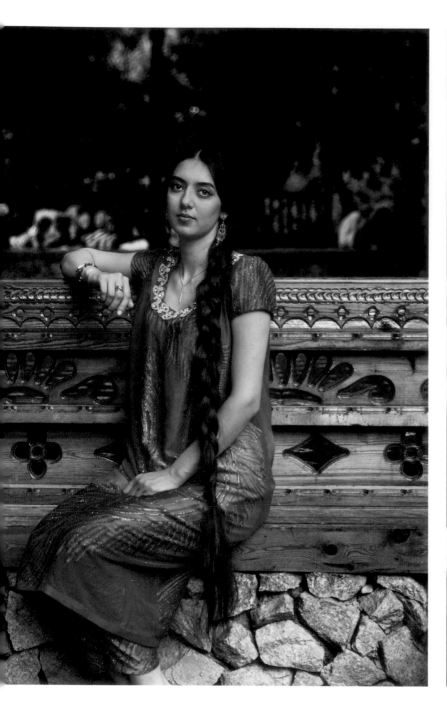

DUSHANBE, TAJIKISTAN

Farzona works in a jewelry shop.

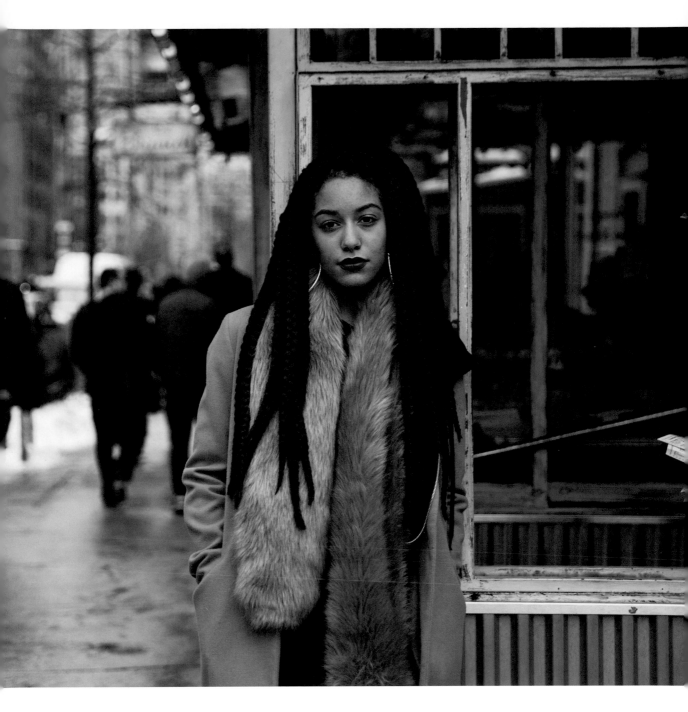

NEW YORK, USA

Leeda is a musician at the beginning of her career.

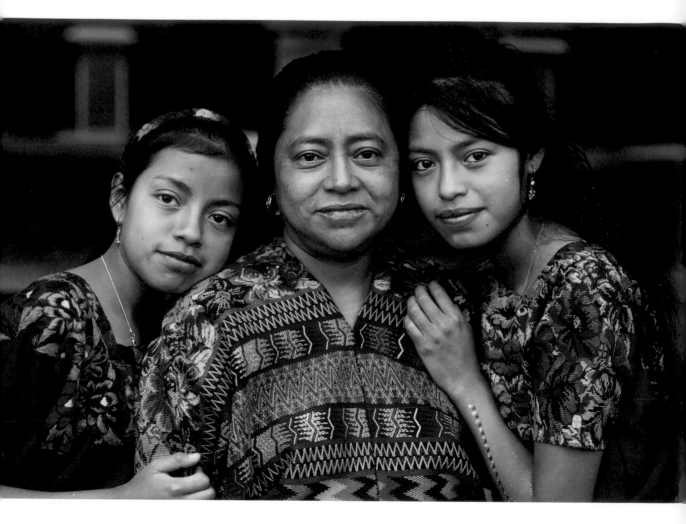

SAN ANTONIO AGUAS CALIENTES, GUATEMALA

Guatemalan daughters and their mother, who made all their splendid outfits.

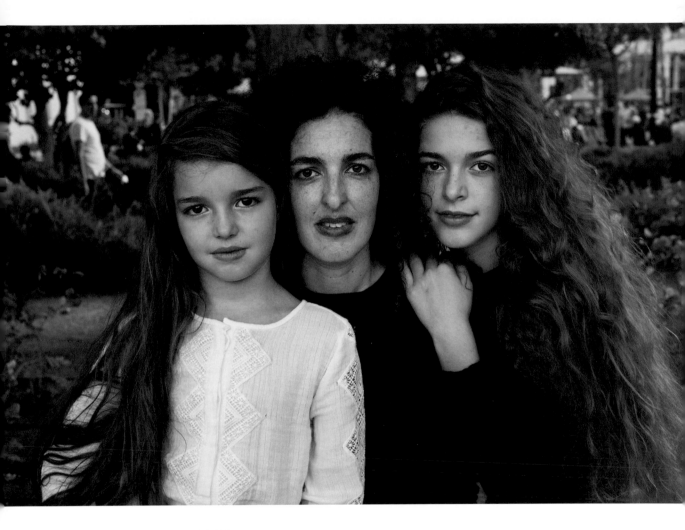

TEL AVIV, ISRAEL

Israeli mother and her daughters, out in the shopping district.

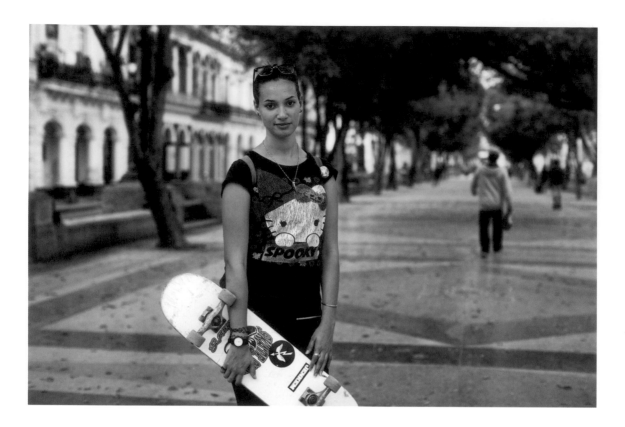

HAVANA, CUBA *(Above)*

In a country affected for many years by embargo and isolation, it's rare to see anyone skateboarding. So I was really surprised to meet Daiana.

"My roller skates broke a few months ago. So I borrowed this and I started to skateboard."

BUCHAREST, ROMANIA *(Opposite)*

Iulia loves to cruise the streets of the city with her longboard because it gives her a great feeling of freedom. I imagine it feels like vacation, even on the way to work. But her real love is surfing; she dreams of riding the waves of Hawaii someday.

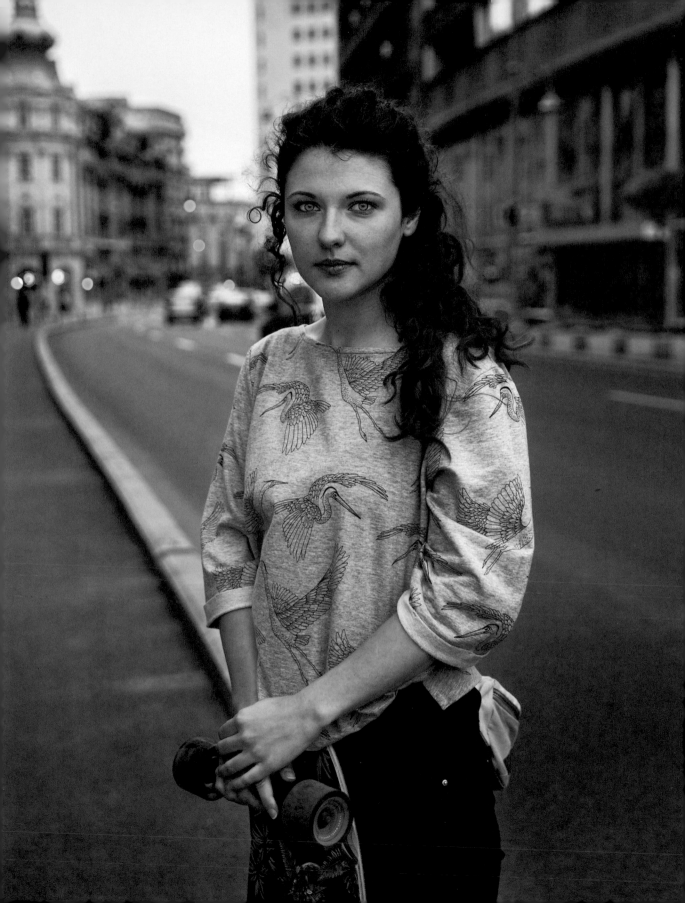

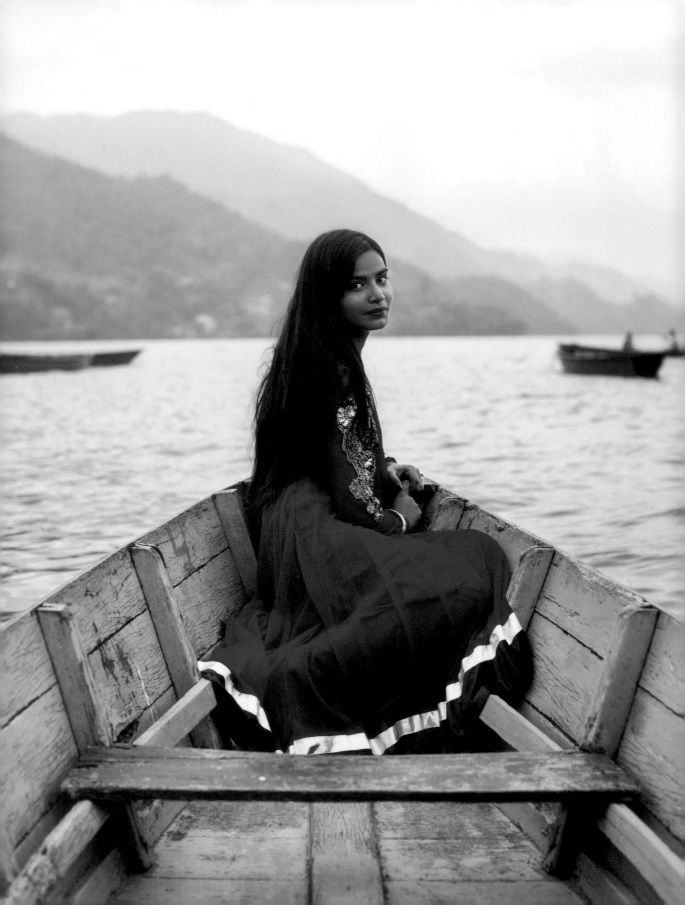

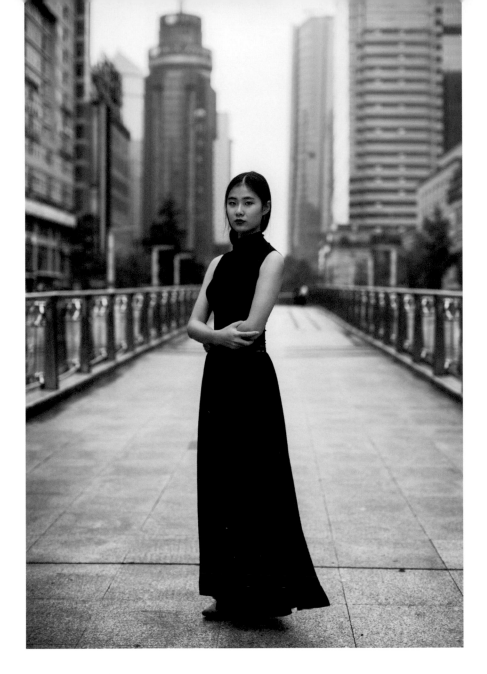

CHENGDU, CHINA *(Above)*

POKHARA, NEPAL *(Opposite)*

Sunday afternoons look the same in many places—city people spending time
in nature. But there was something magical about that Sunday and that place.

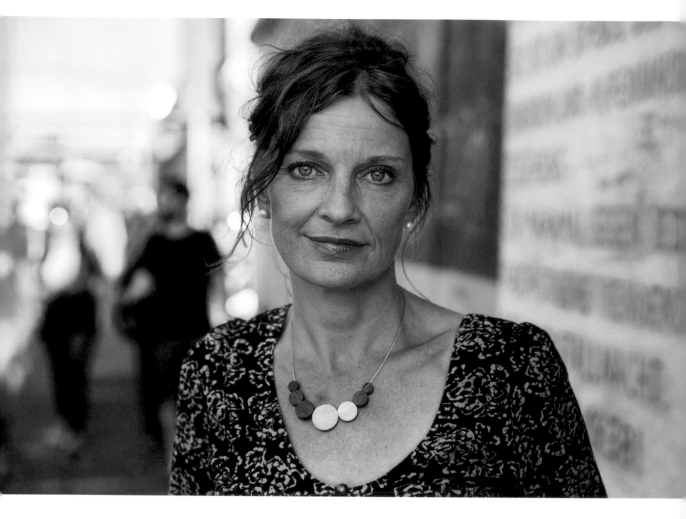

BERLIN, GERMANY

Cornelia is a two-time cancer survivor.

I photographed her next to a remnant of the Berlin Wall. She had moved from the West to the country's new capital in the early 1990s, after the Wall came down, as a young journalist. Berlin was the place to be, and Cornelia witnessed many historical events. Along the way, she gave birth to two beautiful children and always pursued a healthy lifestyle. But eight years ago she was diagnosed with breast cancer. After a great battle and much suffering, Cornelia defeated the cancer. Then, two years ago she was again diagnosed with the same disease. And again, she beat it.

Today Cornelia feels privileged for every second of her life. She enjoys the sun and the rain, the hot days and the cold days, riding her bicycle around Berlin. She encourages her children to make the most of their lives, to travel the world, help people in need, learn foreign languages, and understand the diverse cultures of this beautiful planet.

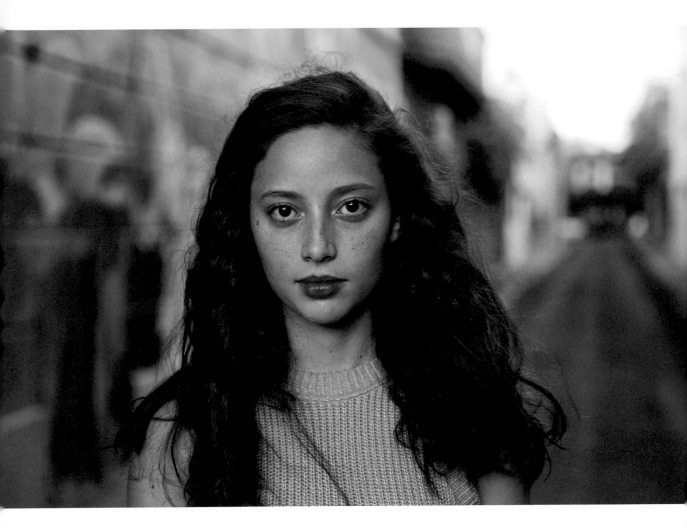

BUENOS, AIRES, ARGENTINA

Ailín is an actress.

"I'm half Argentinian and half Brazilian and that helps me to be cast in many different types of roles."

MEXICO CITY, MEXICO *(Next spread)*

I was so fascinated to meet these brave firefighters. Their dedication to save lives, while risking their own, is impressive.

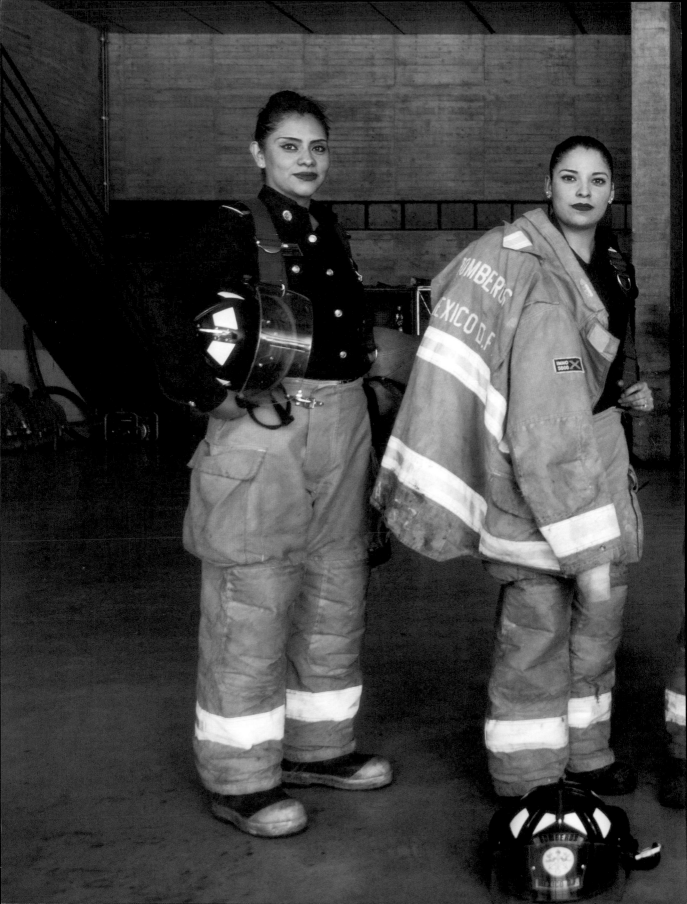

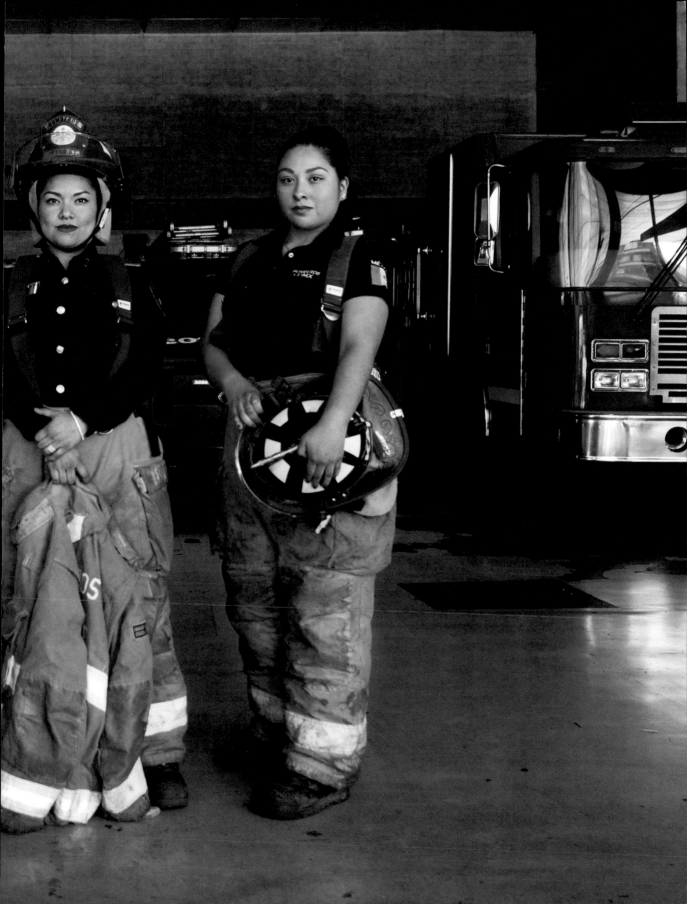

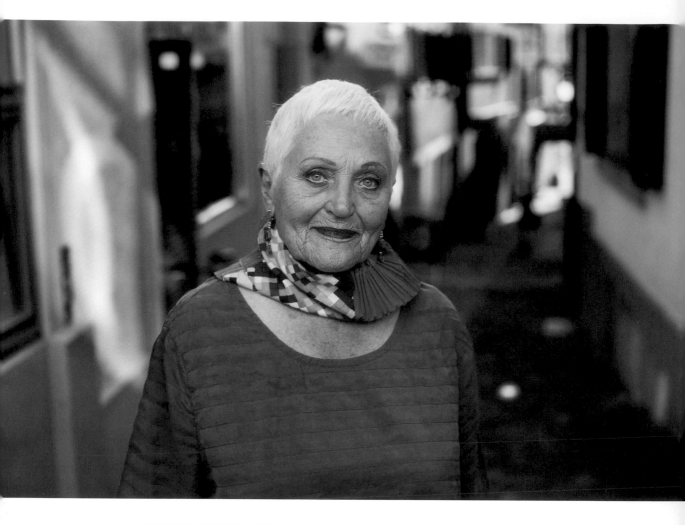

ZURICH, SWITZERLAND *(Above)*

In 1947, when she was a teenager, Elisabeth became a model for a ceramic artist. She fell in love with the art, learned it by watching, and became a ceramicist herself. She stopped working at her art only twice: once when she was thirty-nine and was in a terrible car accident and required nineteen surgeries, then again, nearly thirty-five years later, when her husband was diagnosed with cancer. Elisabeth took care of him until the last moment of his life. Today her work is on display in museums, train stations, and other public spaces in Switzerland. When I met her in Zurich, she was coming from a printing shop where she had picked up some business cards. At age eighty-three, she enjoys life, makes new friends, and still remembers very well how she fell in love with ceramic art almost seventy years ago.

SHIRAZ, IRAN *(Opposite)*

An artist at the beginning of her path. Yalda is a painter.

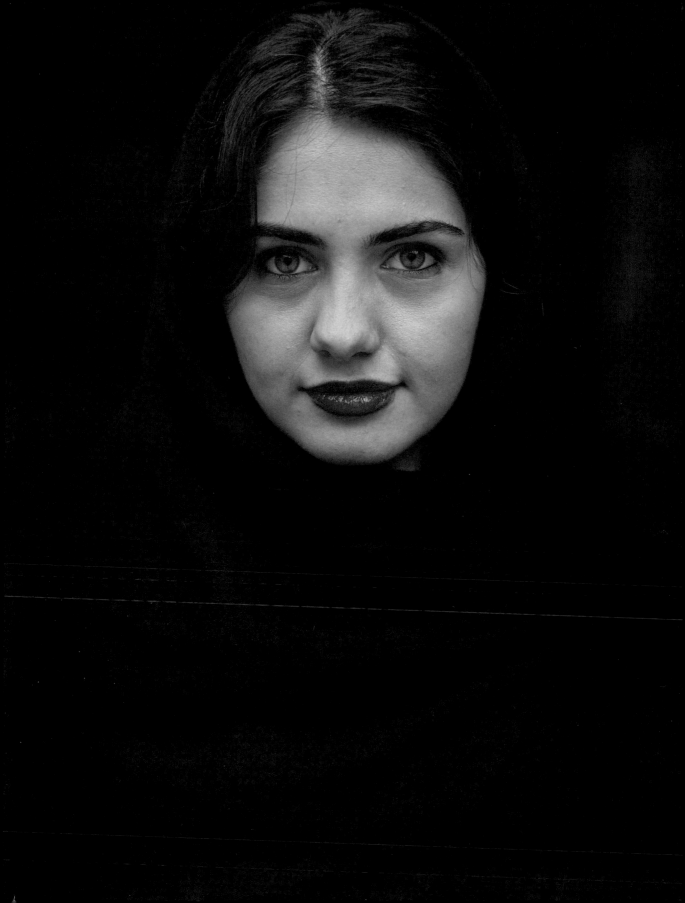

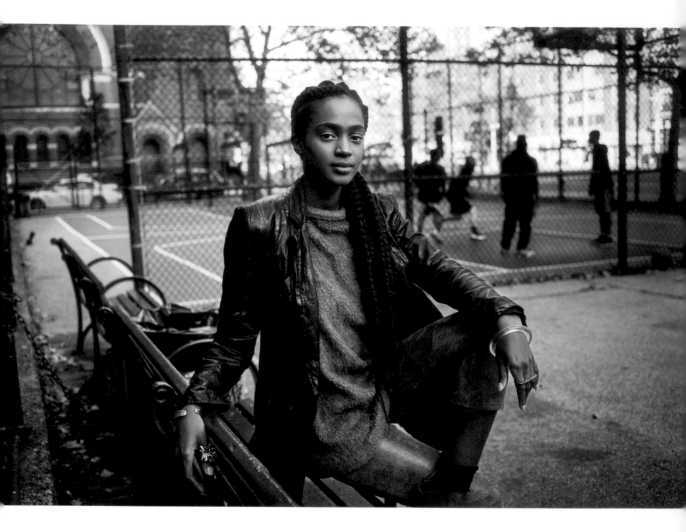

NEW YORK, USA

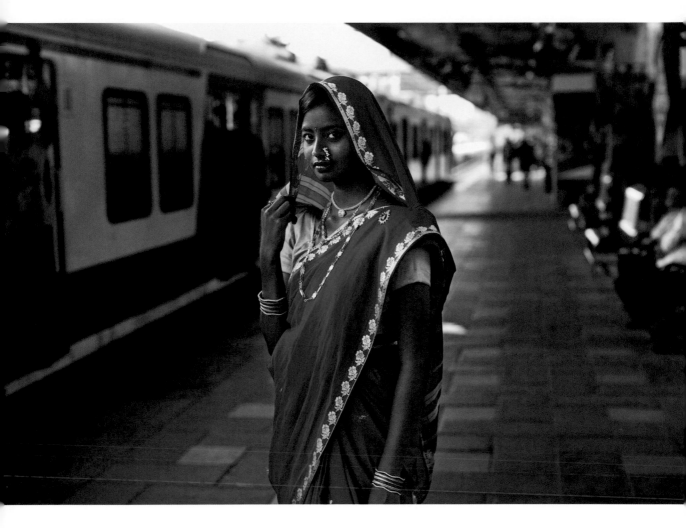

MUMBAI, INDIA

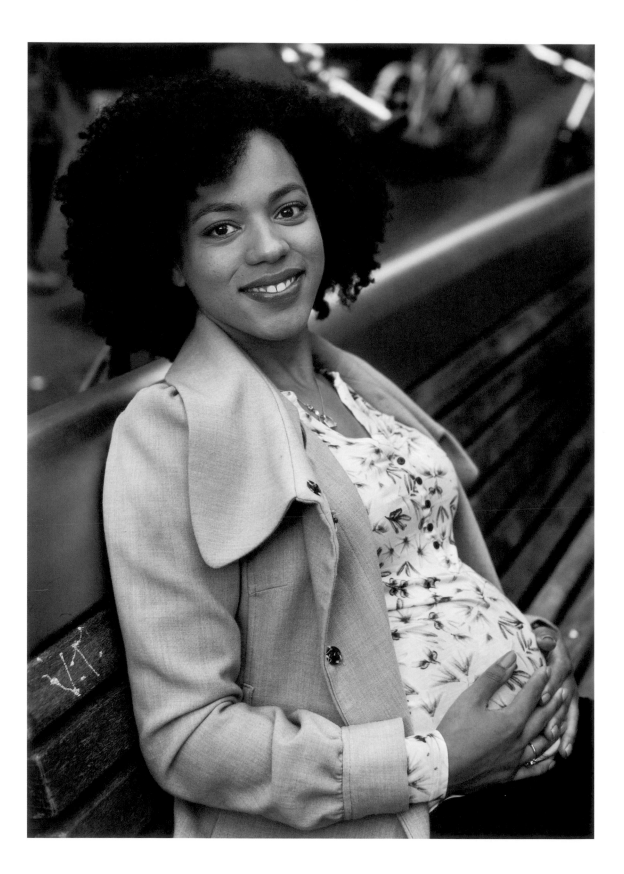

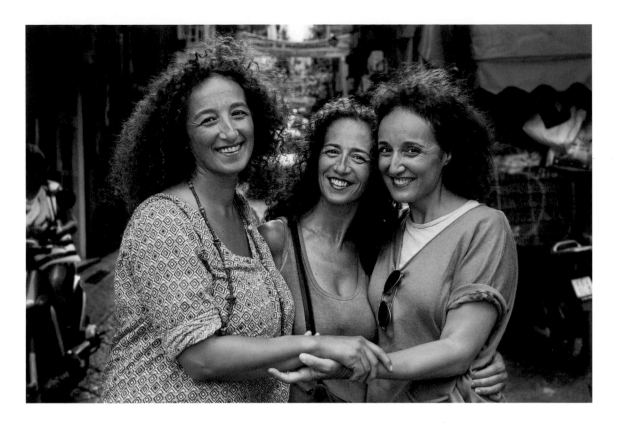

NAPLES, ITALY *(Above)*

I met these sisters, Monica, Francesca, and Rosanna, in their hometown, though now they all live in different parts of Italy, far from one another. They had reunited to visit their mother, and spend some time together.

AMSTERDAM, NETHERLANDS *(Opposite)*

When I met Rachelle, she was glowing with pregnancy and the city's late afternoon light.

"We are resting, after a long day at work."

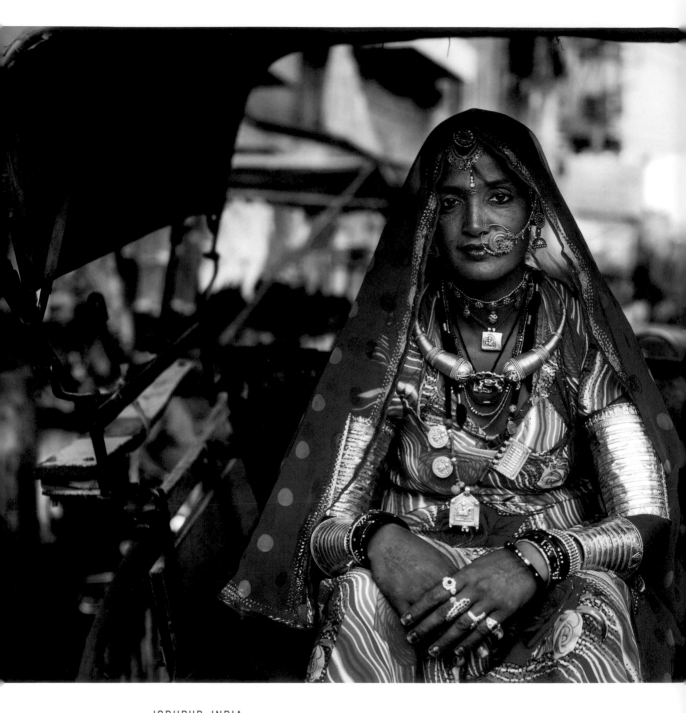

JODHPUR, INDIA

She appears to be dressed for a celebration but, in fact, she was just off
to the market. These kind of spectacular outfits are not uncommon in the
Rajasthan region.

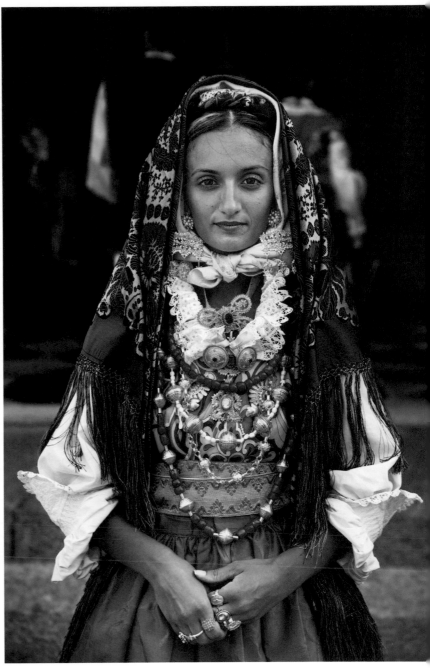

SARDINIA, ITALY

We met during a traditional festival. She has a passion for
Sardinian folk costumes; this one is her own creation.

KOROLYOV, RUSSIA

Nastya takes passport photos in this little shop. But her dream is to take landscape photos around the world. Some time ago she made the first step, starting to study photography. In her day job, her dream might feel far away. But "far" doesn't mean "impossible."

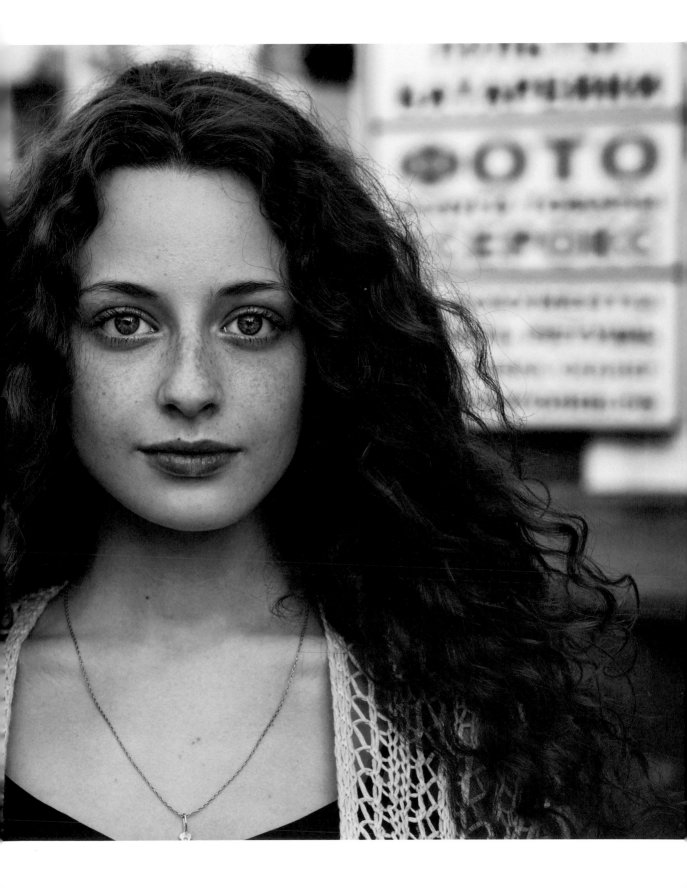

IDOMENI REFUGEE CAMP, GREECE *(Above)*

Most of the refugees that I met talked about experiencing both fear and hope.
They were suffering but also dreaming, like this Kurdish woman from Syria,
who is living in the camp.

HAIFA, ISRAEL *(Opposite)*

I met Zhaleh at the Shrine of the Báb, a holy place of her religion, the Bahá'í
Faith. The story of this American-born Iranian woman is heartbreaking. In
1981, she was forced to watch the execution of her husband in Iran. He was
also Bahá'í and the Iranian authorities asked him to quit his religion or die.
They wanted to make an example to all the Bahá'í community.

*"Before the execution they told him, 'Just say you are no longer Bahá'í and
you will be free,' but he refused, because a Bahá'í should never lie. After that
terrible moment I managed to move to the United States with my children.
My husband is in my heart all the time and I never remarried."*

ISTANBUL, TURKEY

Eda is a poet. Her serenity and strength come through her words.

CLUJ-NAPOCA, ROMANIA

Gabriela is a lawyer. Her strength comes through her knowledge.

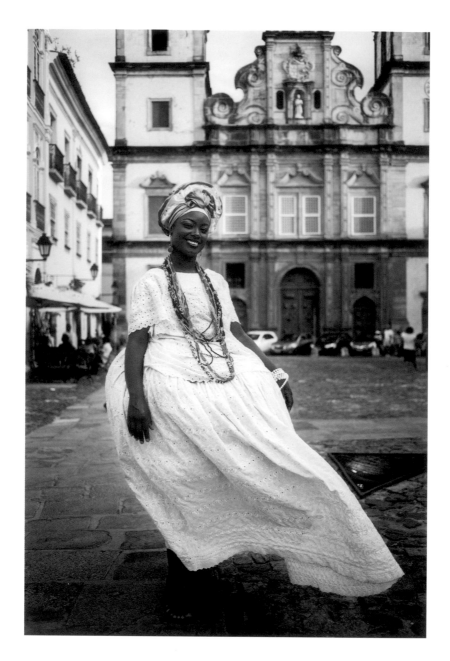

SALVADOR, BRAZIL *(Above)*

The beautiful capital of Bahia state is the soul of African-Brazilian culture, a place that prides itself on having the world's biggest carnival, but also women wearing superb outfits on any given day.

BISHKEK, KYRGYZSTAN *(Opposite)*

This was taken just before her performance in a traditional dance.

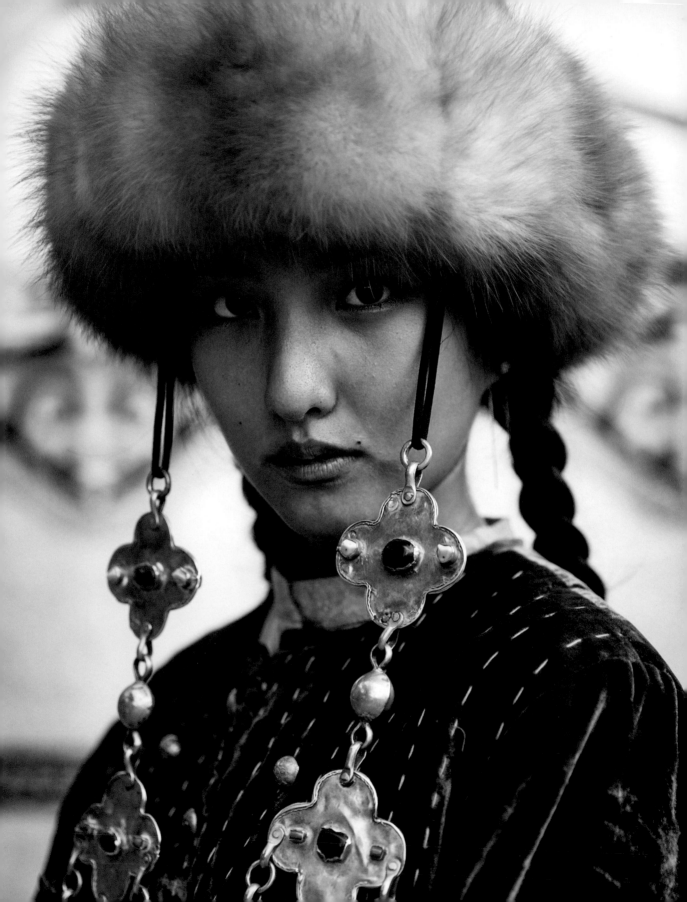

TEL AVIV, ISRAEL

These two friends, Lior and Nor, work in side-by-side clothing shops. They should be competitors for business on this quiet street. But far from being rivals, they enjoy talking every day.

RECIFE, BRAZIL

I noticed them through the wide-open door of their children's clothing shop. They told me that everybody tells them to keep the door closed, because the streets here are some of the most dangerous. But they like to feel the air and sun, and have never had a problem.

Janet, ninety-five, and Aida, eighty-seven, opened their shop twenty-two years ago. They make a great team because Janet loves to talk, and Aida likes to listen.

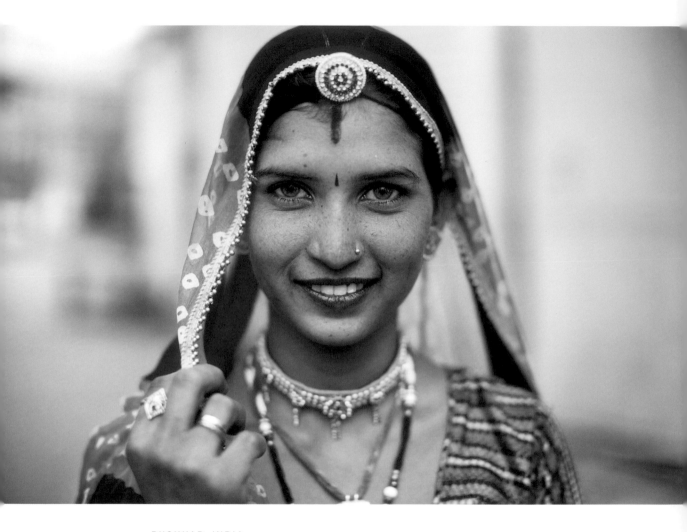

PUSHKAR, INDIA

Two exceptional smiles on two different continents.

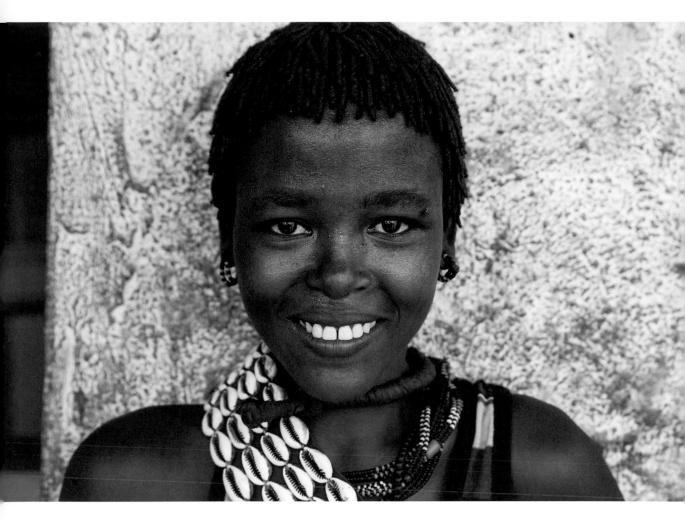

OMO VALLEY, ETHIOPIA

IZMIR, TURKEY *(Previous spread)*

Now living in Germany, Ayça returned to visit relatives. While walking along the sea, she told me a bit about her family's history. Back in the 1960s, her grandfather was considered the first Turkish immigrant worker in West Germany's guest labor program. In 1970, the West German president invited him to the New Year's reception of the chancellor to honor him. Exactly forty years later, Ayça's father was invited by the German president to a New Year's reception and honored as an exemplar of integration and naturalization. Although he came as a worker's son without any German language skills, he studied hard and became a successful ophthalmological surgeon. Ayça feels both German and Turkish—she's a wonderful example of how you can embrace a new society while also celebrating your origins. She now studies health economics, with the goal of working for a global aid organization.

NEW YORK, USA *(Opposite)*

Abby and Angela are sisters with an Ethiopian mother and a Nigerian father. Both parents worked for the United Nations so the sisters grew up in six different countries, on three different continents. This gave them a broad perspective and allowed them to see where need was the greatest. After graduation, they both plan to move to Africa and put their knowledge in the service of that amazing continent. Their enthusiasm is inspiring, and Angela's words express that perfectly.

"Among my peers in my age group, I want to start a movement of coming back to the continent. I want to shine a light on the potential of my people, and I want to lift the entire region out of the health conflict it is in, putting power in the brilliant youth, using local talent, and customizing policies that work in the African setting rather than transposing Western policies."

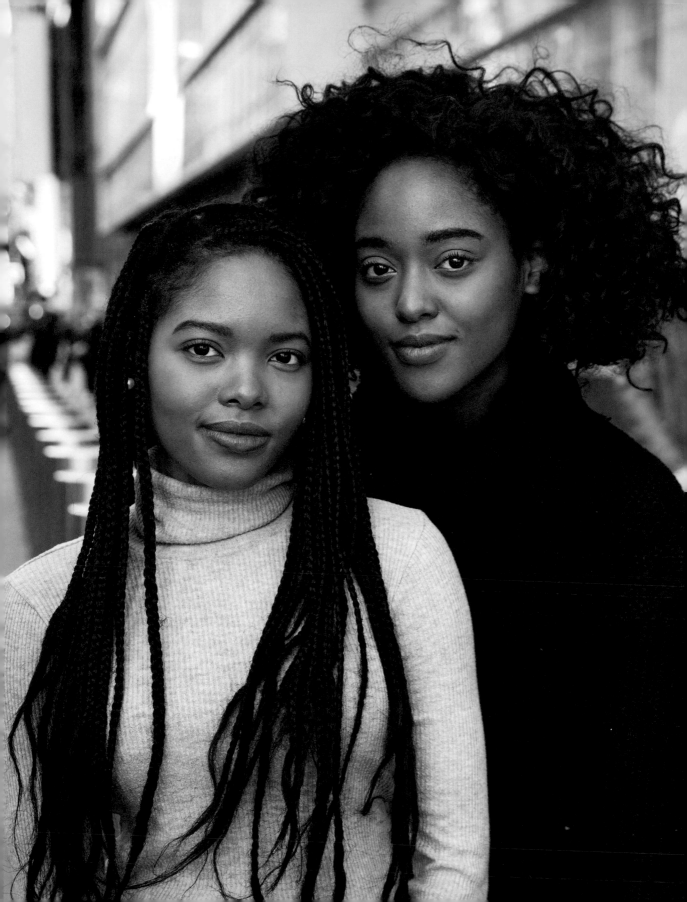

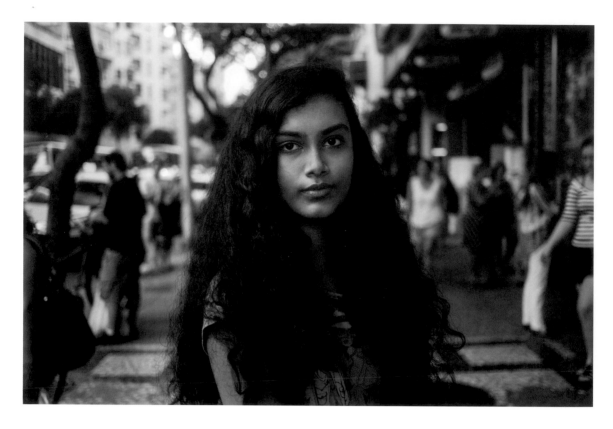

RIO DE JANEIRO, BRAZIL *(Above)*

I met Rachel on a busy street.

"I'm Brazilian, but many people tell me that I look Indian."

PUSHKAR, INDIA *(Opposite)*

This woman is a true example of Indian beauty.

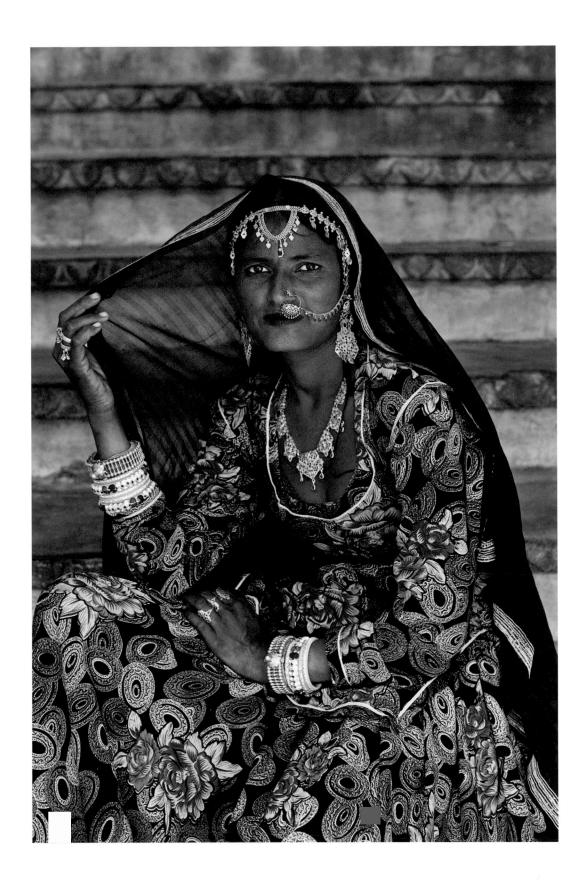

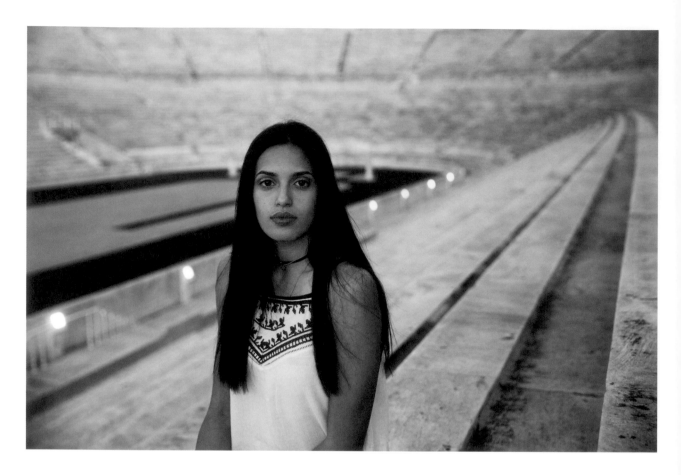

ATHENS, GREECE

Born to an Ethiopian mother and a Greek father, Athina has been in love with running since childhood. We sat in the Panathenaic Stadium, the site of the first modern Olympics in 1896, and she told me her story. After she broke the national record in the 3,000 meter steeplechase, she hoped to participate in the 2016 Olympic Games. But an injury made this impossible; she will have to wait another four years. I've rarely heard someone talk with such enthusiasm about a passion. No suffering will stop Athina, and she will keep running on the way to her dream.

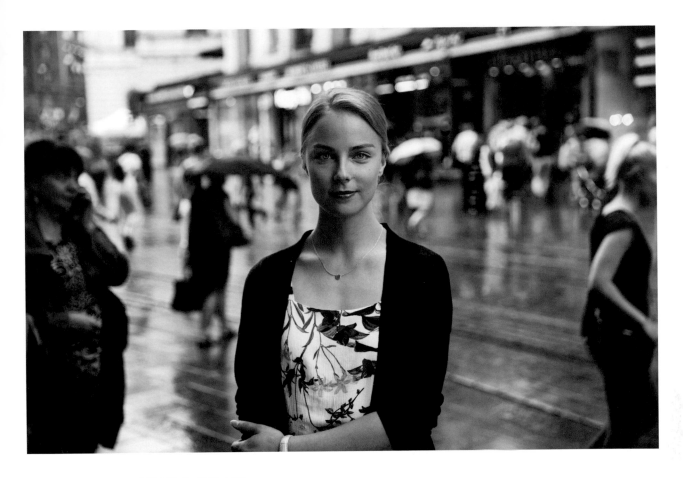

HELSINKI, FINLAND

Kiira is a three-time European Championship medalist in figure skating. She might seem like an ice princess living a fairy tale, but few people understand the sacrifices and struggles that come with such a successful career. She spent thousands of hours training hard while others from her generation were having fun. She suffered horrific and painful injuries, which forced her to retire from competition in 2015. Today, she participates in ice shows around the world and finally has the time to enjoy life.

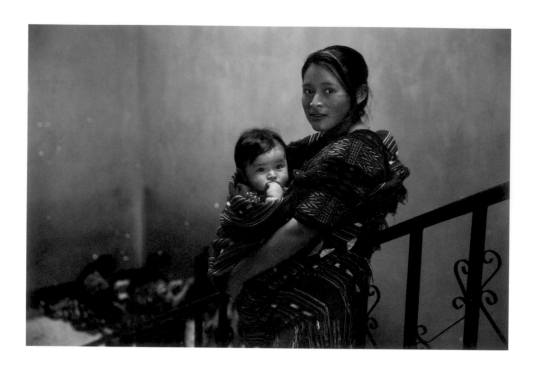

CHICHICASTENANGO, GUATEMALA

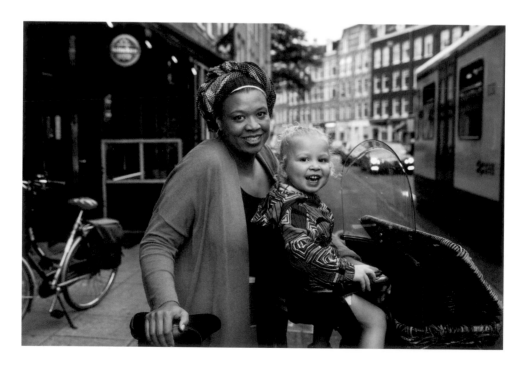

AMSTERDAM, NETHERLANDS

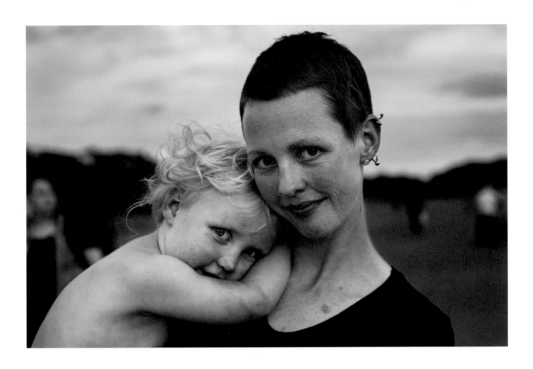

BERLIN, GERMANY

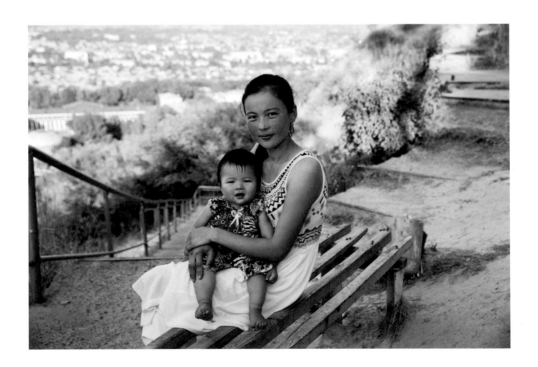

OSH, KYRGYZSTAN

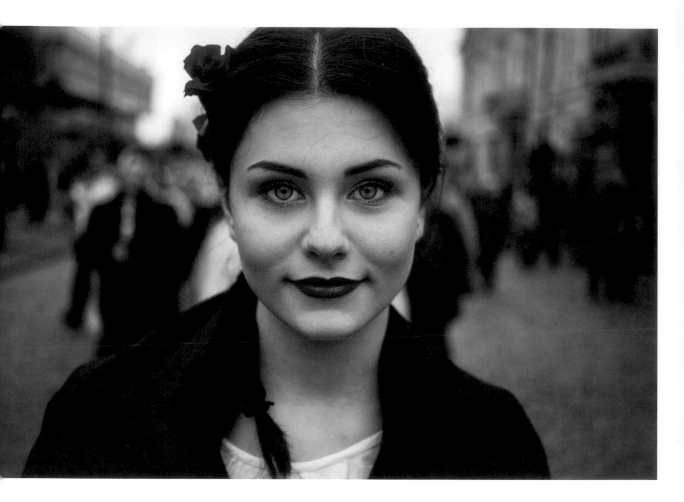

IASI, ROMANIA

Carolina is from Moldova but was visiting Romania to sing with her choir at a festival.

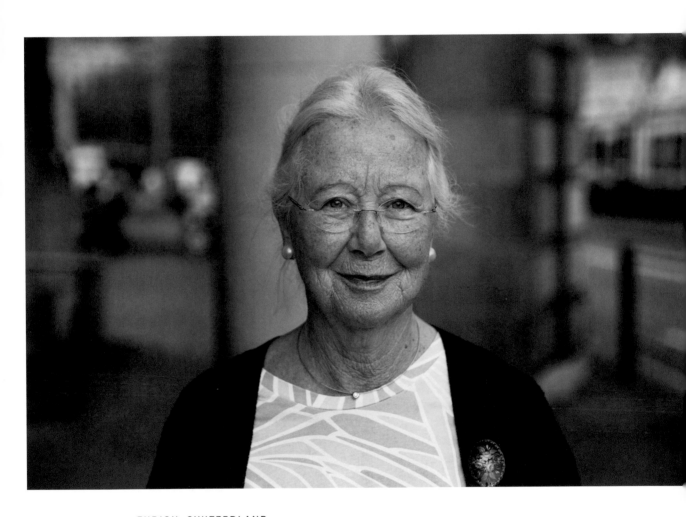

ZURICH, SWITZERLAND

Doris is from Austria and was visiting Switzerland for leisure.

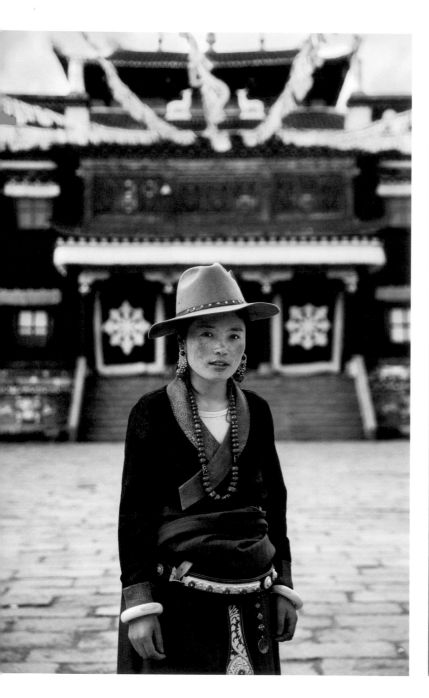

SICHUAN PROVINCE, CHINA

This Tibetan woman stands at a magnificent Buddhist
temple. For most Tibetans, Buddhism is more than a religion;
it is the center of their lives and their communities.

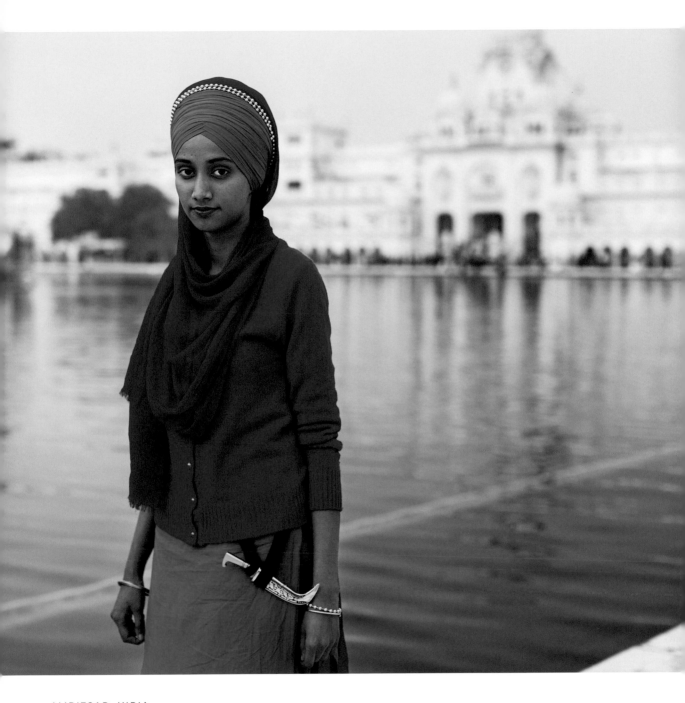

AMRITSAR, INDIA

This Sikh woman is at the Golden Temple, which is visited by millions of pilgrims each year. The knife on her belt is a kirpan, a symbol of a Sikh's duty to come to the defense of those in danger. Many believers, both men and women, never cut their hair, instead they cover it with a turban, as she does.

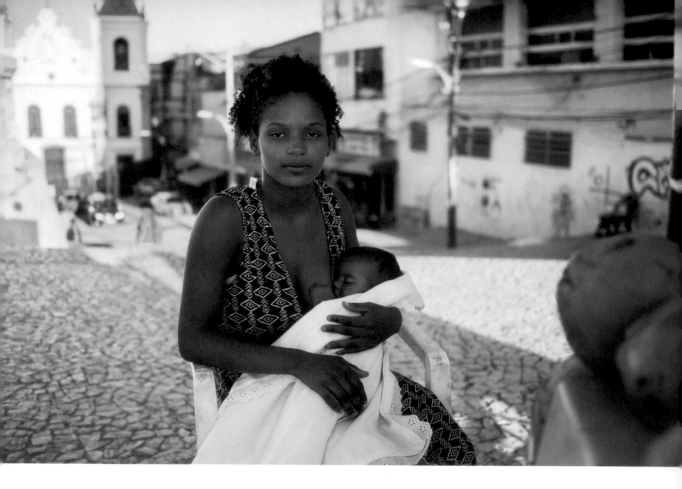

SALVADOR, BRAZIL

When I think about Rachel's story, I feel like crying. At fifteen years old, Rachel is already the mother of a little girl, whose father was brutally murdered weeks before her birth. In Rachel's community, gang violence is common, as are teenage parents. Drugs are also a problem; Rachel's mother was an addict and left the family early. Her father, a street sweeper, raised her and helped her set up this little stall so she could have an income to raise her baby.

Rachel travels two hours by bus to sell coconut juice in the center of Salvador. The second day I visited her, she was crying because she had sold only two juices in a few hours, and she was tired—the baby had kept her up the night before. But talking about her daughter, she smiled, calling her *me biscoito*, which means "my biscuit" in Portuguese. You can't imagine how much love and attention she gives her little girl. Seeing them playing and smiling was incredible and brought tears to my eyes. Every evening, after the long trip home, Rachel boils water to wash her and her clothes by hand. Every day, her biscuit's clothes are immaculate and smell like perfume. Rachel is a true heroine. As young as she is, she is so loving and remarkably strong.

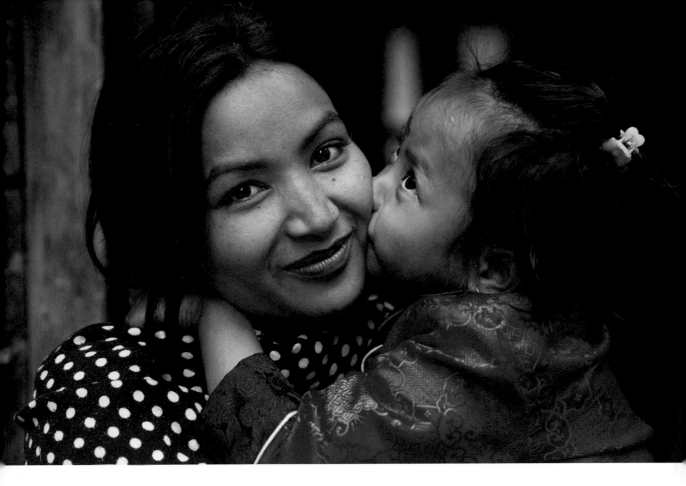

KATHMANDU, NEPAL

Upasha had to quit school at a very early age, because of her family's poverty. Now she works hard in her small tea shop to offer a better life to her daughter, Prayusha.

HAVANA, CUBA *(Next spread)*

Daniela is starting rumba class. Throughout this country's isolation, when its people faced shortages and economical crisis, dancing was a constant, not only in schools, but in every home and on every street, helping to bring joy in tough times.

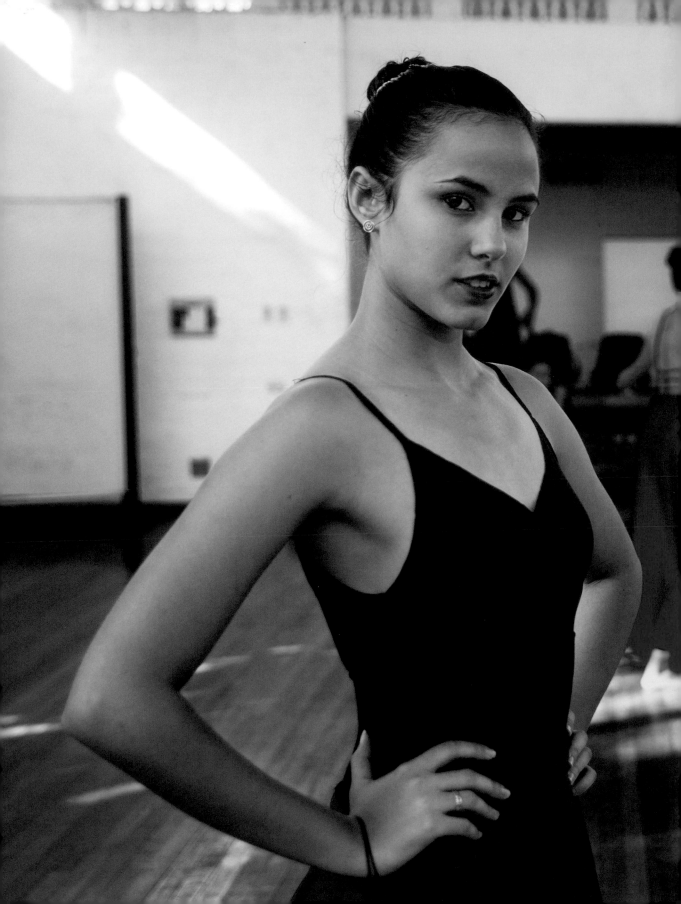

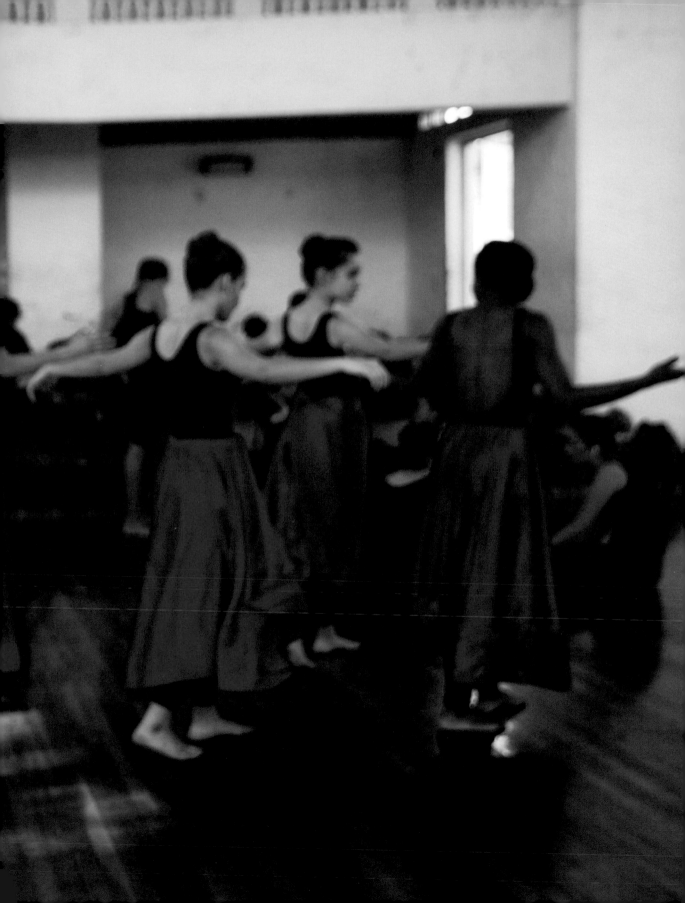

HAIFA, ISRAEL *(Above)*

She's a singer-songwriter and was working on her first album
when I met her.

"It will be a concept album that mixes very different influences."

WAKHAN CORRIDOR, AFGHANISTAN *(Opposite)*

She was working in the field in one of the most remote places of the
world. The people and the natural surroundings are beautiful, but life is
so harsh. The violent conflicts that have plagued Afghanistan for the past
forty years never reached her village but were never far away, and made
it impossible for her to improve her life.

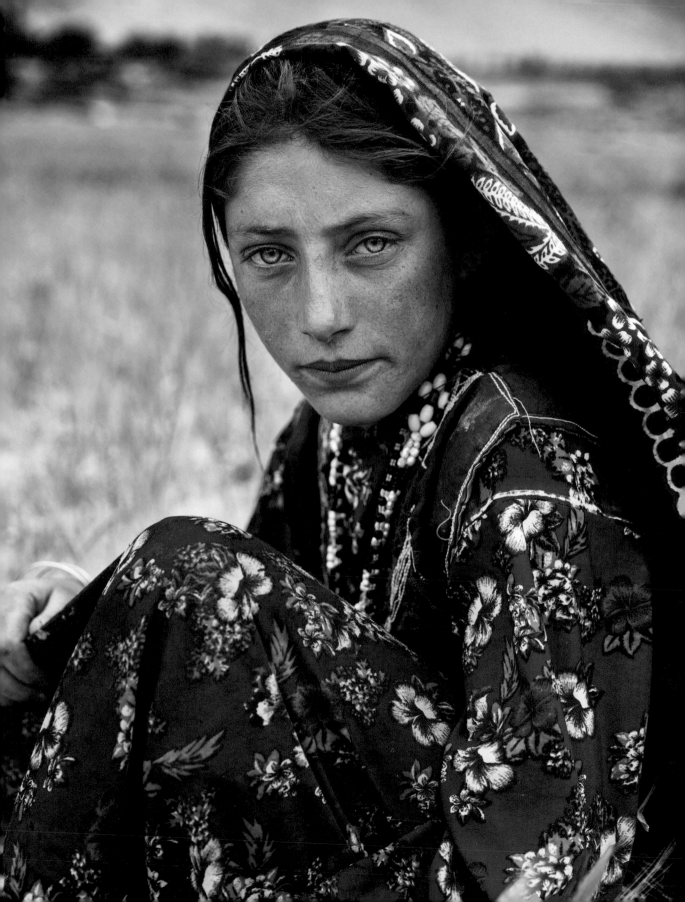

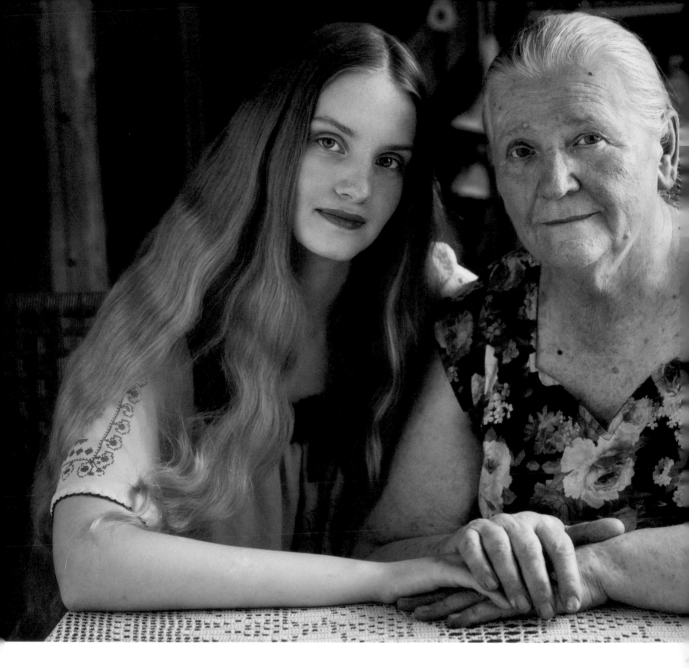

ROSTOV, RUSSIA

These women have dedicated themselves to handmade art. Sonya practices the rare craft of making ball-jointed dolls, which are astonishing to see, while Tamara, her grandmother, weaves traditional textiles.

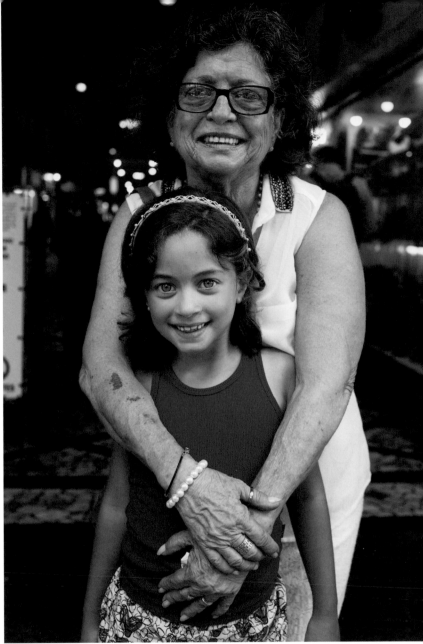

RIO DE JANEIRO, BRAZIL

"She's my beautiful granddaughter."

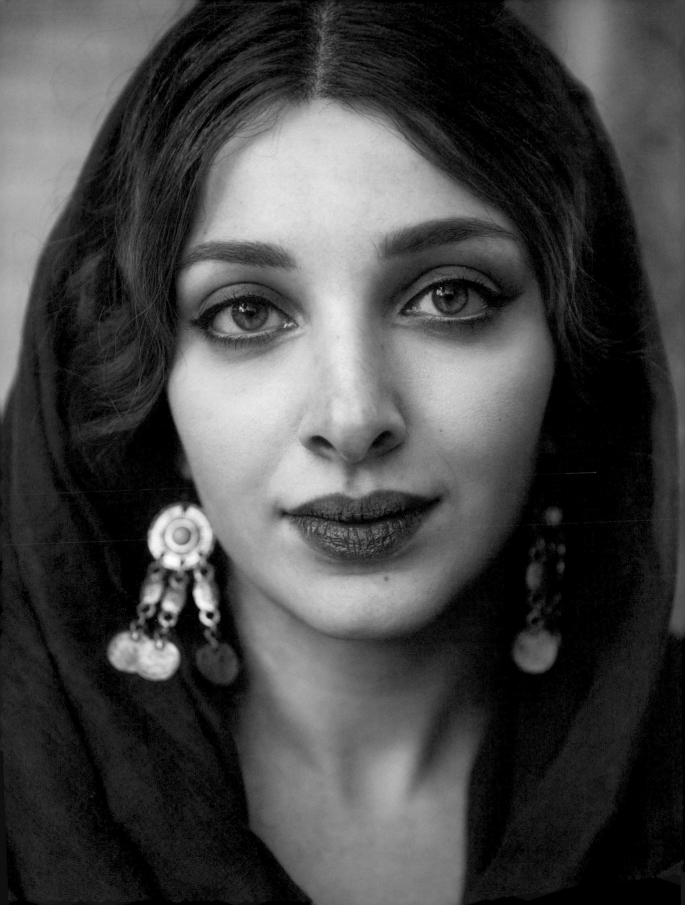

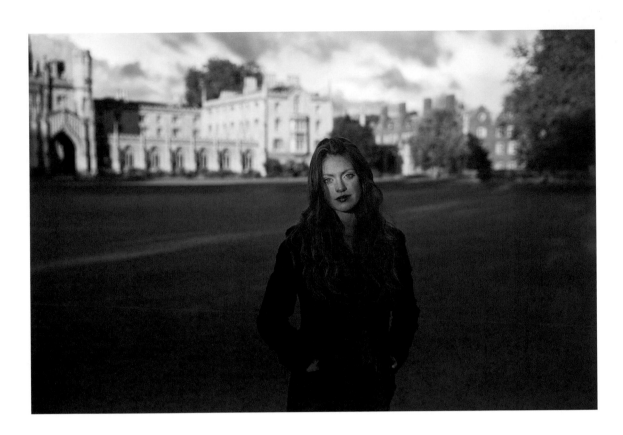

CAMBRIDGE, ENGLAND *(Above)*

Connie is passionate about her education. She studies Comparative Literature at the university here, and plans to get a PhD in Philosophy.

TEHRAN, IRAN *(Opposite)*

Farnoush lives in two different worlds. In one she is an economist, by profession. In the other, she is an artist, because this is her passion.

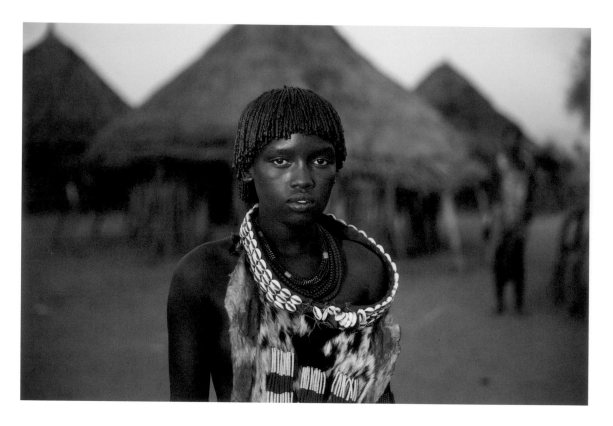

OMO VALLEY, ETHIOPIA

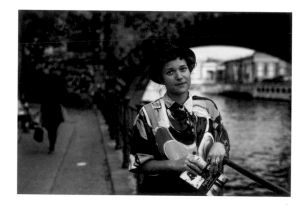

BERLIN, GERMANY

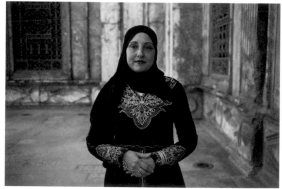

CAIRO, EGYPT

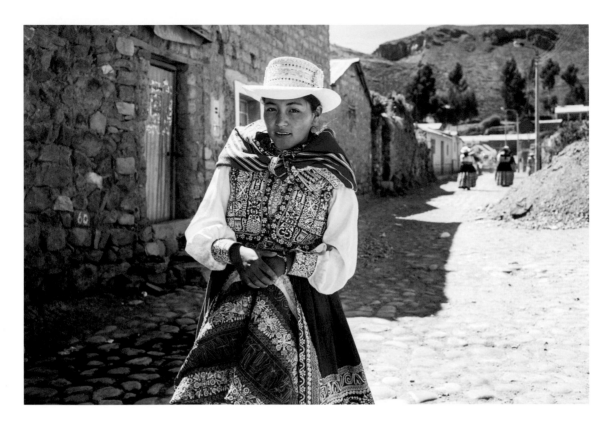

COLCA CANYON, PERU

WAKHAN CORRIDOR, AFGHANISTAN

MUMBAI, INDIA

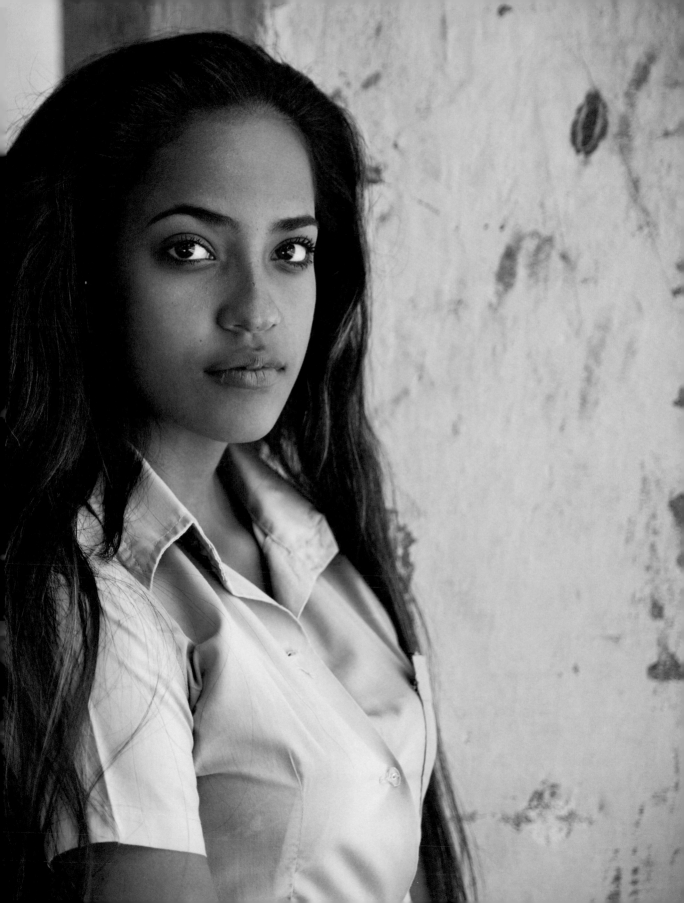

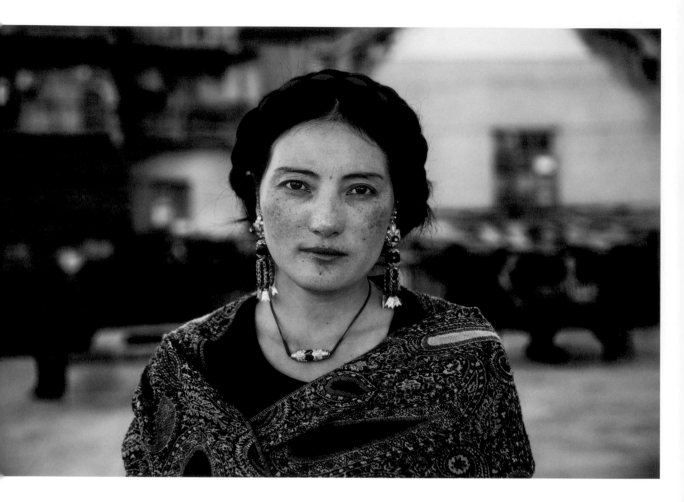

SICHUAN PROVINCE, CHINA

I love to photograph Tibetan women. Although there is almost always a language barrier between us, most of them have an incredible gift to communicate with their eyes, as this woman did.

HAVANA, CUBA *(Previous spread)*

Melissa on the picturesque streets of her city.

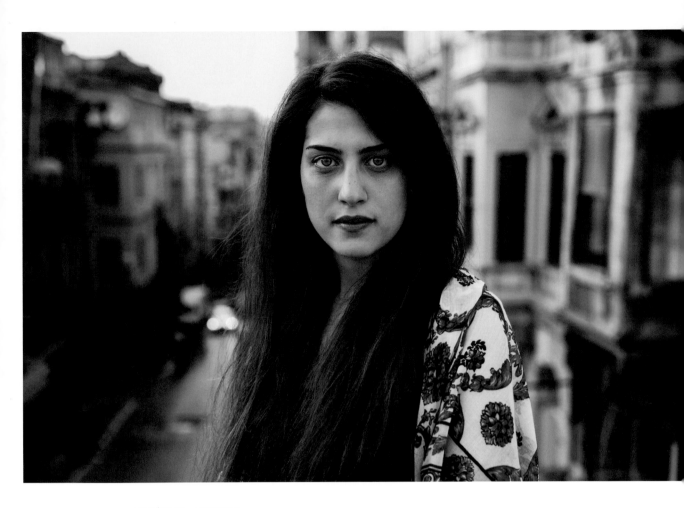

ISTANBUL, TURKEY

Maya, who is Syrian, moved here to study. Her parents are back in Damascus, and it was clear she was worried about them. We kept in touch, and she later let me know that the building where her parents lived had been bombed; miraculously, they survived.

"That was the biggest panic I have ever lived through—seeing my own building's door in the news. An explosion under my own home! How can I explain how I felt hearing that my family was safe?"

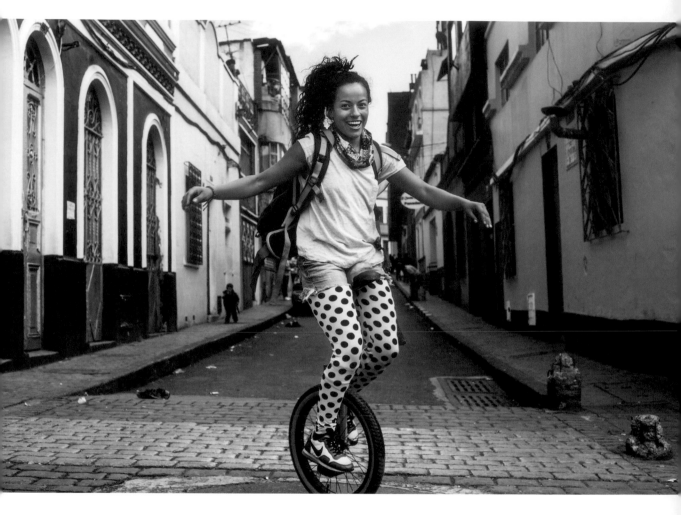

BOGOTÁ, COLOMBIA *(Above)*

During my travels in South America, I met many street artists like her. Some adopted a nomadic way of life, traveling on the little money raised by their performances.

NAMPAN, MYANMAR *(Opposite)*

For many people around the world, this is what shopping looks like. They don't have their own cars, or big homes, or bank accounts. But most of them are great examples of dignity, strength, generosity, and honesty. If more of those who have fortunes and power would learn from these wonderful people, we would live in a much better world.

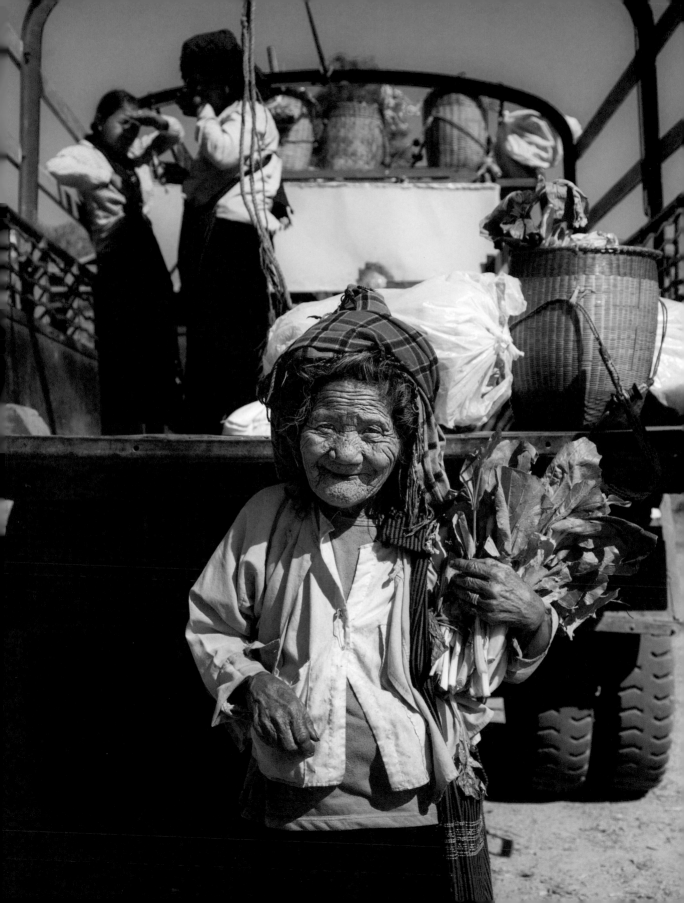

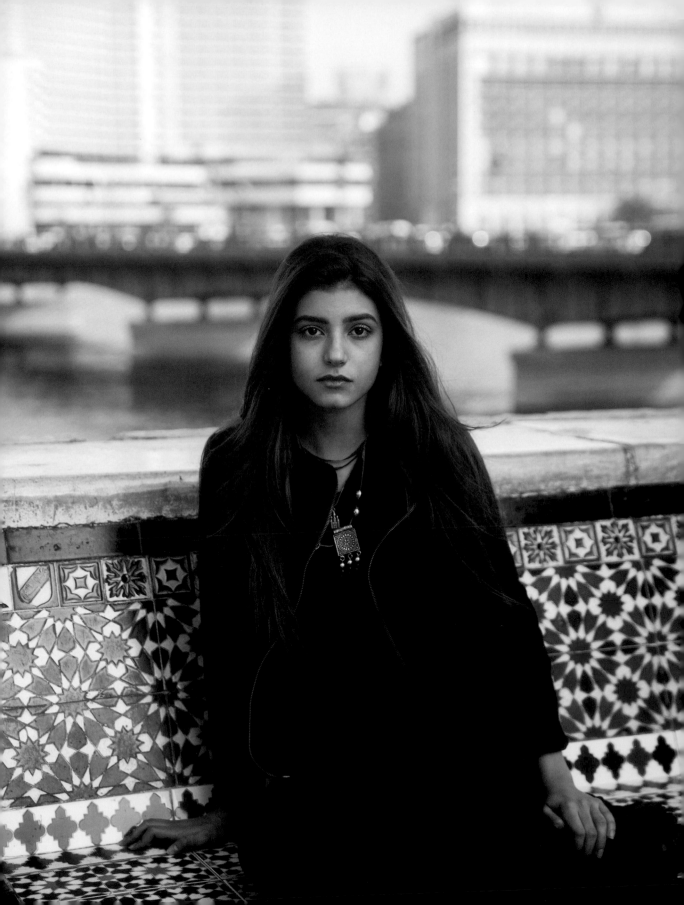

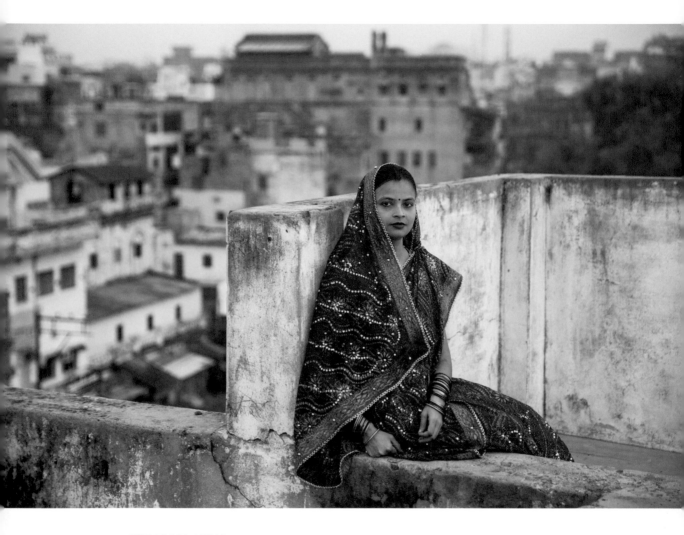

VARANASI, INDIA *(Above)*

Sikha on the roof of her home.

CAIRO, EGYPT *(Opposite)*

Reham with her city in the distance.

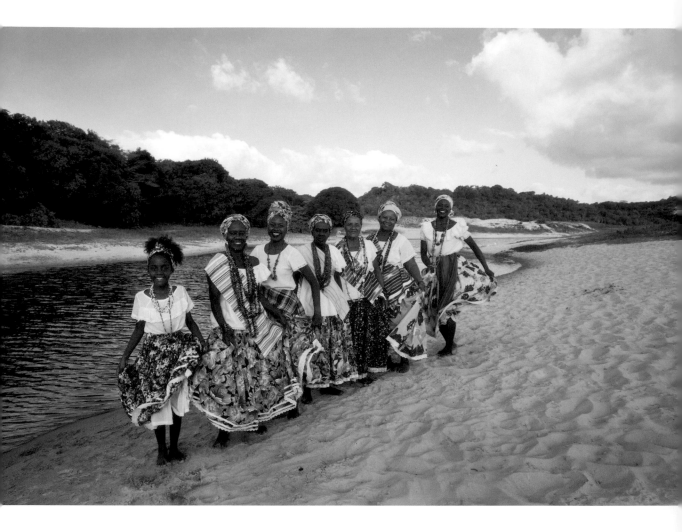

SALVADOR DE BAHIA, BRAZIL

I met these wonderful ladies in their small neighborhood called Itapuã. In 2004, some of them started this music group, Ganhadeiras de Itapuã, to celebrate the traditions of their small community.

It's so rare to see such a range of ages in the same group, and I was fascinated by the chemistry between them. Their joy and enthusiasm is amazing, so no wonder they were invited to perform during the 2016 Olympic Games Closing Ceremony. They brought the world's attention to their community, and became the pride of Itapuã.

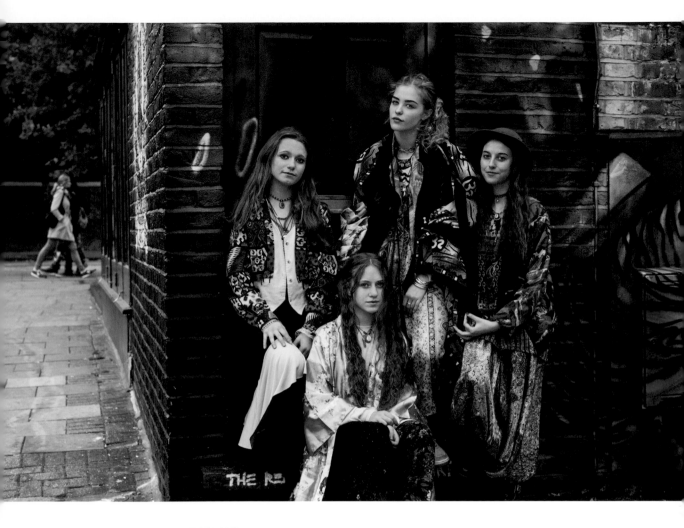

LONDON, ENGLAND

Two of these girls started playing music together when they were just six years old. Now they have a band called "Fire in Her Eyes." When I met them in the colorful streets of Camden Town, they were looking for a place to film their new video. They were very relaxed about it, working with an old camera and no director—the opposite of what you see in the mainstream music industry. They said they wanted their music to inspire peace and freedom.

"Last summer we traveled around Europe, on a very small budget. We did some small shows on the street and we had a lot of fun. We love music, we love freedom. We love to be as we are."

GUANGZHOU, CHINA

What a special day! She was on the way to the hospital to give birth.

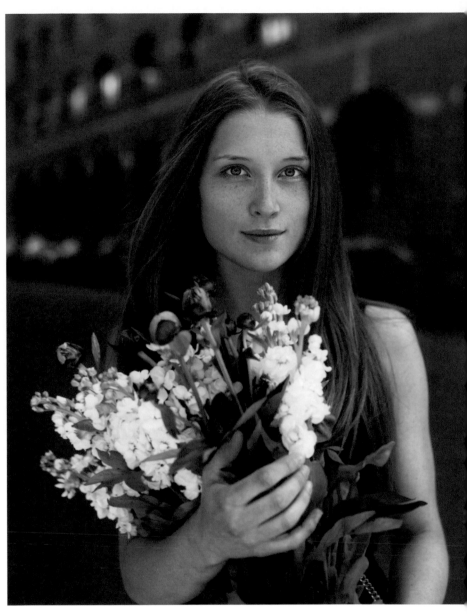

STOCKHOLM, SWEDEN

It was Mother's Day in Sweden and this woman
was on her way to meet her mom to celebrate.

THE CHECHEN REPUBLIC, RUSSIA

Linda is from Grozny, the capital of this southern Russian republic, where ancient traditions mix with modernity and many women wear colorful scarves. Here you can see a new city, totally rebuilt, but also evidence that memories of the war are still fresh. In 2003, the United Nations called Grozny "the most destroyed city on Earth" after years of battle. In one of these battles, Linda lost her father, who was accidentally shot on his way to work. At the time, Linda's mother was pregnant with her second child. Linda and her sister were raised by a single mother, in a time of war, but received a wonderful education. Today, Linda studies medicine, preparing to be a pediatrician. This strong Chechen woman had a tough childhood, and now she wants to dedicate her life to helping other children in need.

CAIRO, EGYPT

Nada had seen "The Atlas of Beauty" online. It was the first time someone wanted to be photographed because she was already familiar with my work.

"Wow, I can't believe it! I know your project. Since I first discovered it, I have dreamed to be part of it."

OMO VALLEY, ETHIOPIA *(Next spread, left)*

MOSCOW, RUSSIA *(Next spread, right)*

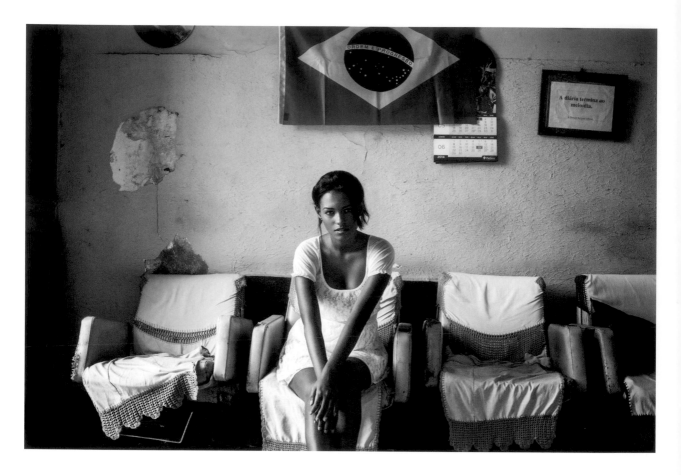

RIO DE JANEIRO, BRAZIL

While traveling in Brazil, I noticed in the newspaper kiosks that almost all the women on the covers of the beauty magazines were white. So I was happy that after I photographed Isabel for my project, she got a lot of media attention in her country.

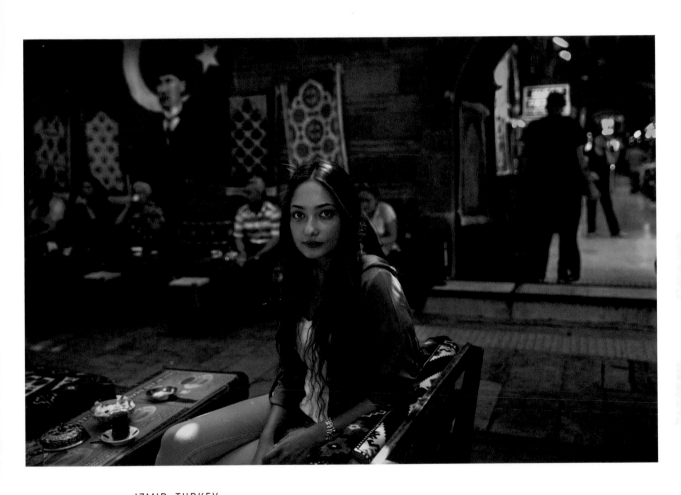

IZMIR, TURKEY

I met Ipek, a future elementary school teacher, in the bazaar.

STOCKHOLM, SWEDEN *(Above)*

After her parents divorced, Nicole suffered through much of her childhood and adolescence. Her brother was always her greatest support, so she honors their relationship with the tattoo on her hand: 2-2-2. It's the age difference between them: 2 years, 2 months, and 2 days.

SARDINIA, ITALY *(Opposite)*

At this festival, locals dress up, or come as spectators. Federica had never participated until now, when she was at last able to borrow a widow costume.

"I have to pose as a widow because this is my role today."

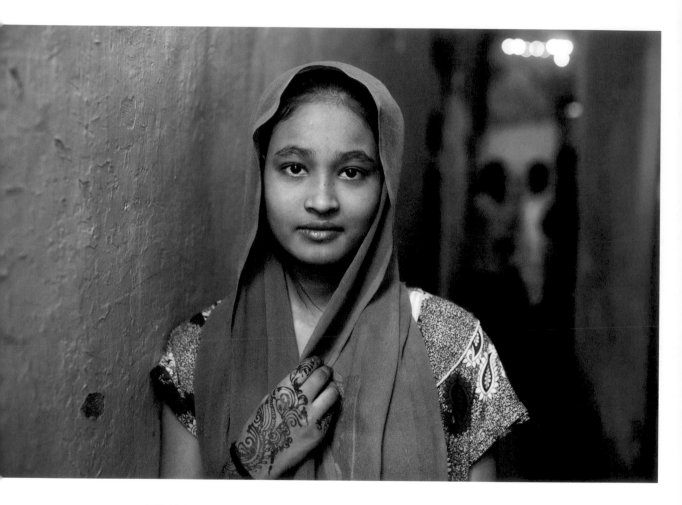

MUMBAI, INDIA

The huge Dharavi slum might seem dangerous and unwelcoming from outside. But while exploring its dark alleys, I met many friendly people and heard wonderful stories. She was preparing to attend a wedding the next day, so following the Indian tradition, she has decorated her hands with henna.

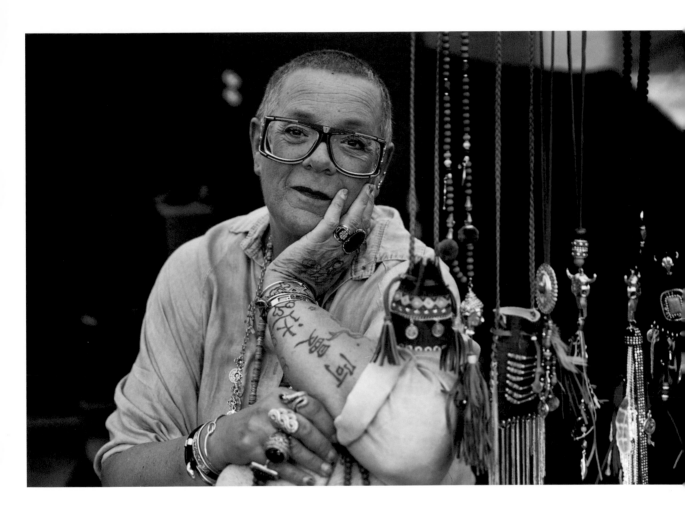

AMSTERDAM, NETHERLANDS

Amanda is a tattoo enthusiast. She has a stall where she has sold accessories six days a week for thirty-six years. When I met her, she was full of energy, even after a long day of standing. She told me that for all those years she never had a chair to sit while working, which was her decision.

SHIRAZ, IRAN

I met Ghazal at the beginning of my project, a time when I didn't have experience as a photographer, but I was trying hard, all the time. I was so fascinated by the traditional Persian costumes that I took dozens of photos of her. I was struggling to capture the magic.

Years have passed and I gained more experience as a photographer, learning that sometimes magic takes just a few seconds to be captured.

Ghazal moved to Poland where she started a new life. We still keep in touch and although we both changed a lot, we are still both in love with the Persian traditional costumes.

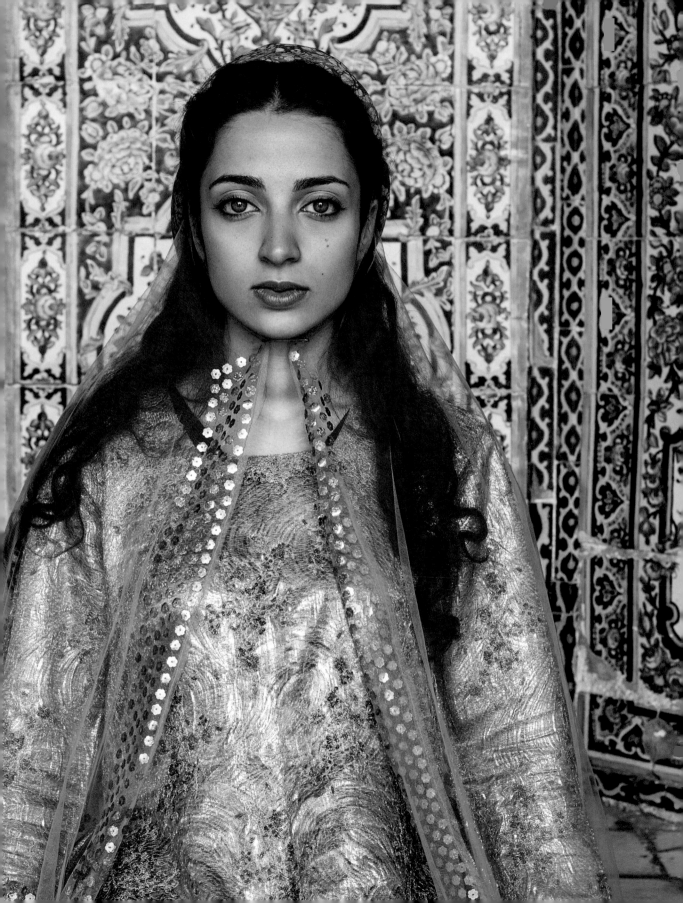

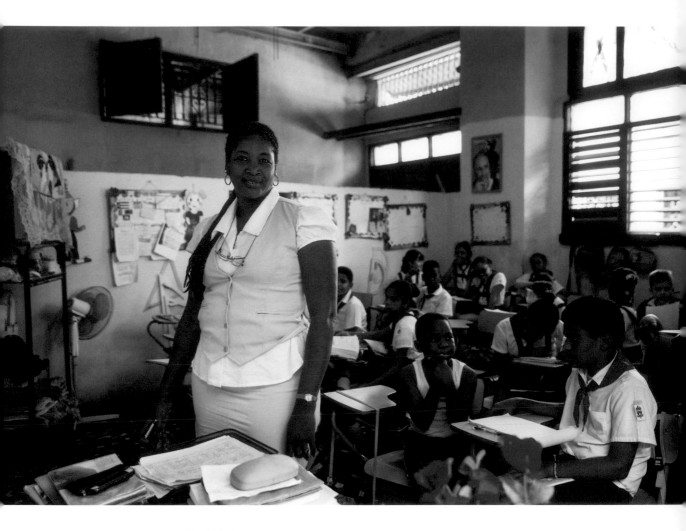

HAVANA, CUBA

The doors to this classroom were wide open on a small street. I was curious, and looked inside. It reminded me of my childhood, because in Eastern Europe, kids also used to wear red ties during the communist years. Yamila, that warm-hearted type of teacher who's like a parent to the kids, was happy to invite me inside.

GUANGZHOU, CHINA

Liz is American but lives in China, where she's the principal of an elementary school. She doesn't speak Chinese, so I was surprised to see that she knows the name of every student. The kids were absolutely in love with her. In the end, education is about vocation, not location.

MONTEVIDEO, URUGUAY *(Above)*

Iriana had to leave her country, Venezuela, a place ruined by terrible economic crisis where many people are starving. There are millions of people around the world who, like this young Venezuelan, had no choice but to emigrate far from home. Let's treat these people the way we would like to be treated if we were in their place.

"I had to leave Venezuela. I was tired of being afraid all the time. As a family, we used to be together during Christmas, but this time I'm in Uruguay, one of my brothers is in Panama, the other is in the United States, and my father is in Venezuela."

AMMAN, JORDAN *(Opposite)*

Tamara is originally from Iraq, but she and her mother fled to Jordan to escape the war. Their lives as refugees have been difficult, but just before we spoke, Tamara received some great news: her application to immigrate to Canada was accepted. Unfortunately, however, her mother would not be able to join her. It seemed Tamara would split in two. On the one hand, joy, thinking about the possibility of better days ahead, and on the other, an incredible sadness at the thought of being apart from her mother. By the time we parted, it was still unclear what she would do; she was tortured by indecision.

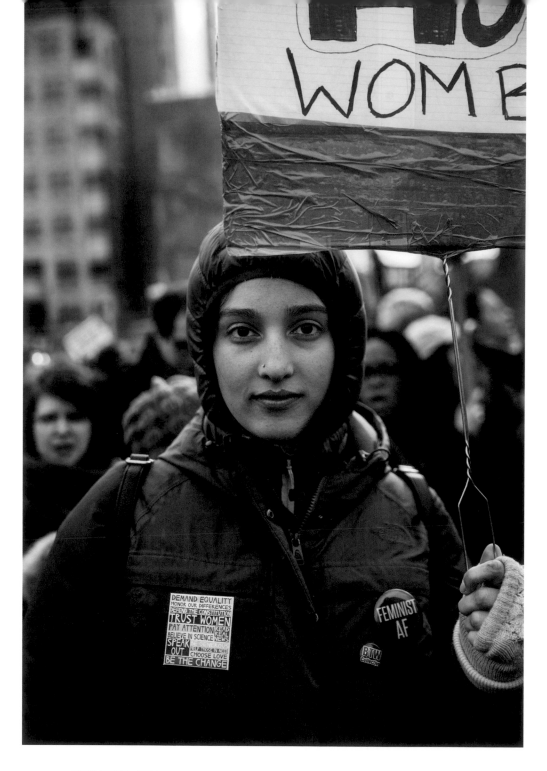

NEW YORK, USA

Amanda is an activist for women's rights and doesn't miss a demonstration related to her cause.

"I'm a serious protester."

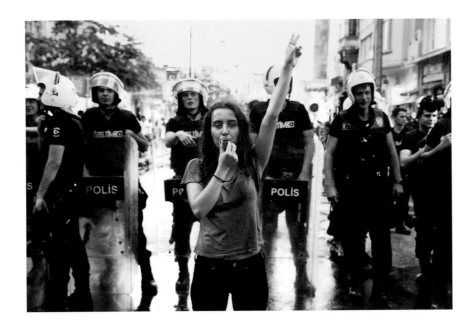

ISTANBUL, TURKEY

This woman was in an LGBT Pride parade. Istanbul is fascinating: There are many conservative and religious people, but also many progressives.

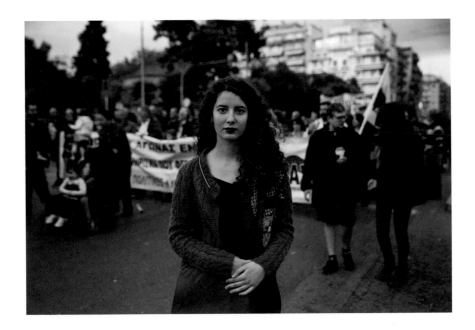

THESSALONIKI, GREECE

She was attending a protest organized by a socialist party.

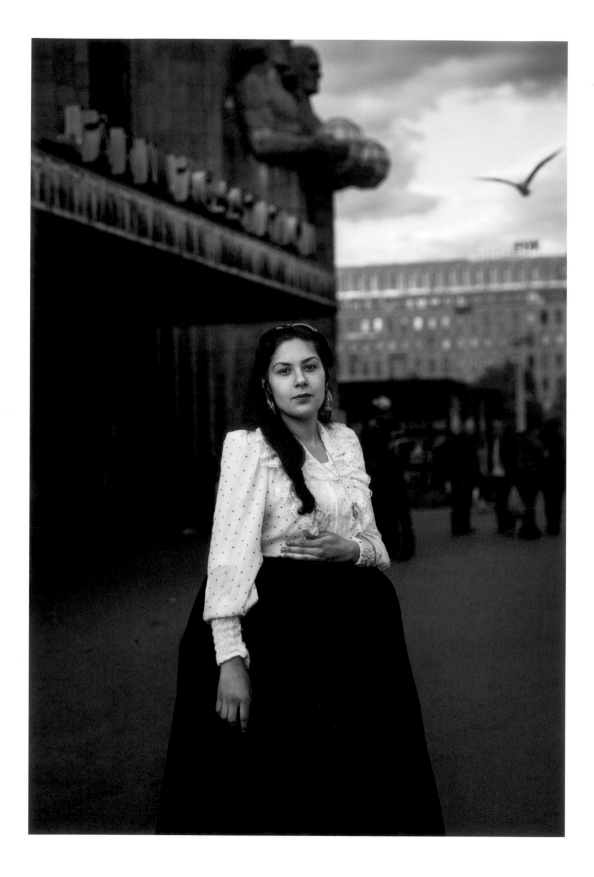

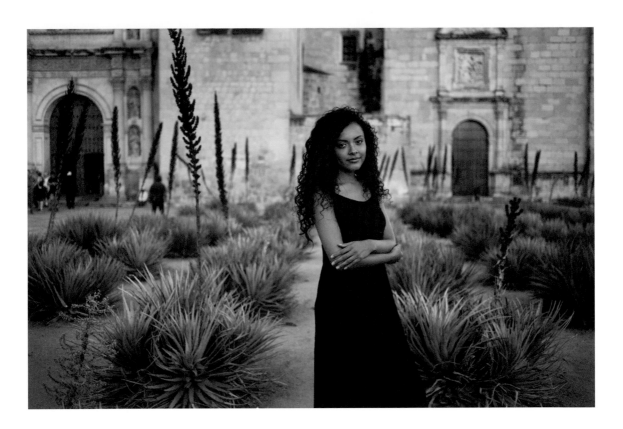

OAXACA, MEXICO *(Above)*

Living proof of the diversity of the Americas, Nadia has
African, Indigenous, and European roots.

HELSINKI, FINLAND *(Opposite)*

I was amazed to notice this woman walking proudly in such an interesting
outfit on an ordinary day. *What is her story?* I wondered. Sofia is part of the
Finnish Romani community and, like most of the other members, dresses
like this every day. The Romani are a nomadic group originally from northern
India who today live mostly in Europe and the Americas.

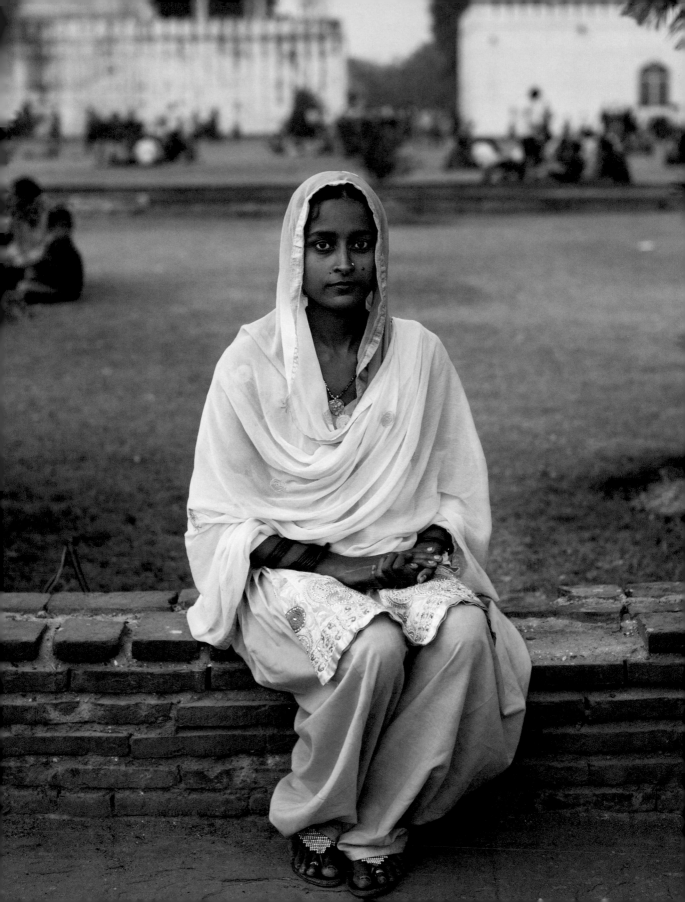

PARIS, FRANCE

Gilberte reconditions furniture and doors. She seemed comfortable at this stage in her life, recognizing that age brings a beautiful patina to the wood, just as it improves wine.

WEST JERUSALEM, ISRAEL *(Previous spread, left)*

When I saw her walking on the street, I briefly thought that we had gone back in time. Rikki loves to wear vintage clothes and is very creative. She was born in Russia to a Jewish family and decided to move to Jerusalem.

DELHI, INDIA *(Previous spread, right)*

The clothes here aren't vintage—just traditional. Dressing the way women here have for generations makes Indian women appear to come from another time.

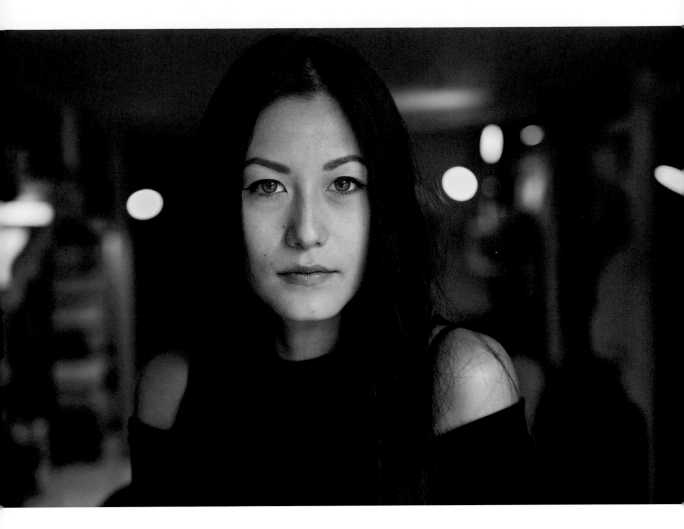

SOFIA, BULGARIA

Iveta's mother is Bulgarian, her father Vietnamese. We met in the tattoo shop where she works.

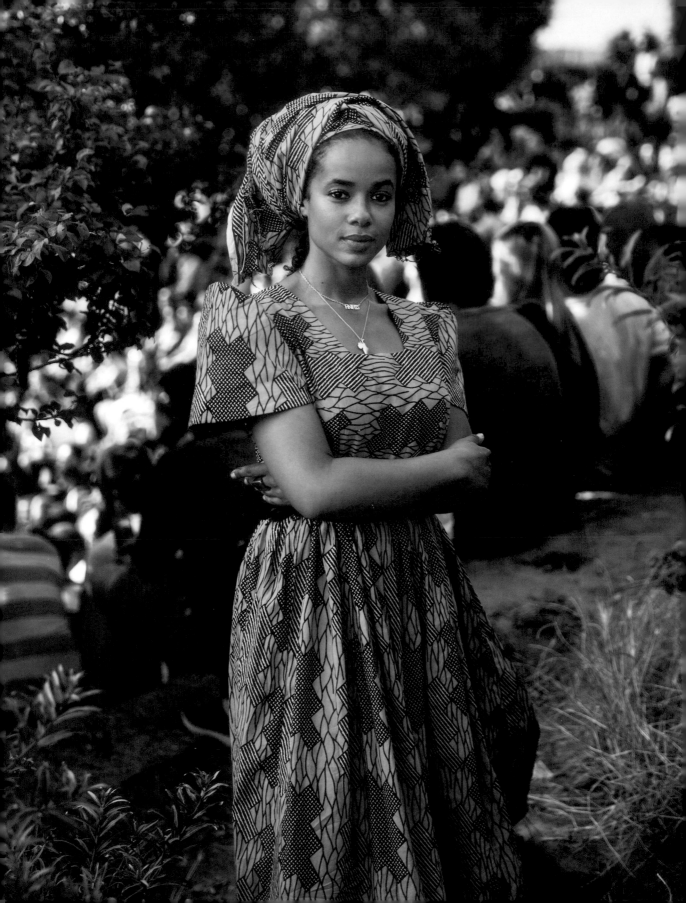

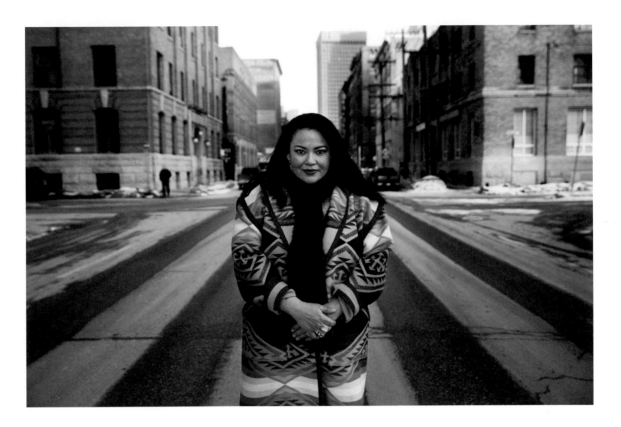

WINNIPEG, CANADA *(Above)*

Like some twenty thousand indigenous children in Canada between the 1960s and 1980s, Jackie was taken from her home as a girl and sent to a boarding school, while her two siblings were put up for adoption far away. Without hope or support, she got into trouble and ended up in prison. There, she started to paint. Her paintings and birthday cards became very popular, bought by the other inmates. When she was released, she studied art at the University of Manitoba. But she didn't forget about her community; the First Nations women who disappeared are the main theme of her painting and her activism. Today she has three daughters and a granddaughter.

"I didn't have anybody to stick up for me when I was young. But my daughters and my granddaughter have me to stick up for them."

BERLIN, GERMANY *(Opposite)*

Anais has a Malian mother and a French father. When she travels to Mali, people consider her to be white. When she's in Europe, she's seen as black. But Anais says she feels both African and European, even if on any given day her clothing expresses a particular part of her heritage.

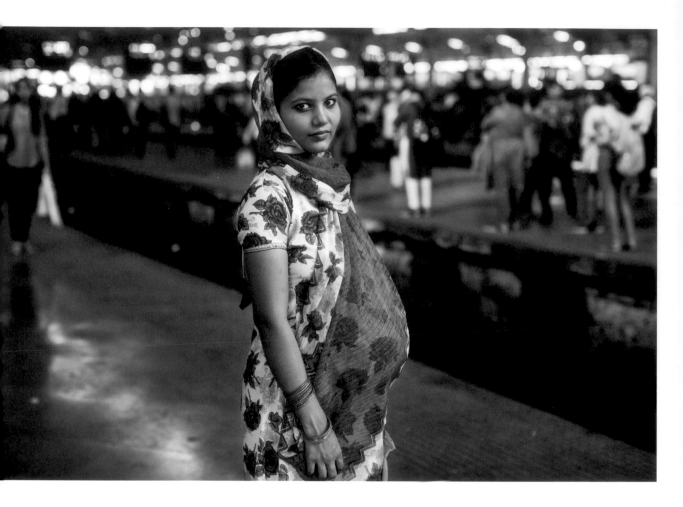

MUMBAI, INDIA

She was waiting for a train to go home.

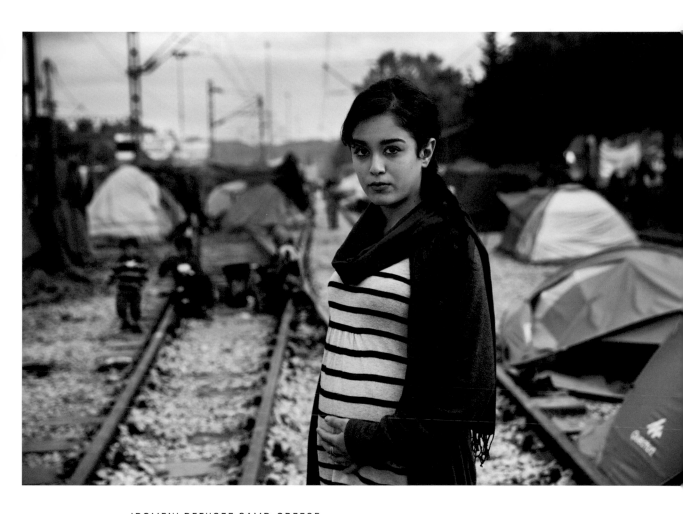

IDOMENI REFUGEE CAMP, GREECE

She left her home in Syria, hoping that her baby would be born far from the
war's violence.

PARIS, FRANCE

You can't imagine what a joyful woman Ania is. She has one of the most impressive stories I've ever heard. She was born without a right leg, in Poland, and her mother abandoned her in a hospital, begging the doctor to take care of her. At nineteen months old, she was adopted by a Belgian family, where she had a bright childhood.

She told me that her parents were amazing. They adopted more children with disabilities and they all grew up happily in the countryside of Belgium, surrounded by farm animals and enjoying nature.

Ania always loved sports. As a kid, she was running on the rocks and in the forests, always feeling free and independent. She broke her prosthetic several times. Back then it was impossible to have a proper one for sport because she doesn't have a femur. Every night before falling asleep, she imagined herself running like an athlete. Her only dream was to have a proper prosthetic for sport. Ania thought if she became a well-known athlete, her biological mother would see her in the media and she would have the chance to find her in Poland.

Years later, determined to be an athlete, she convinced doctors to take her into a medical trial, and today she has an unique prosthetic and can finally run like she used to imagine when she was a kid.

"I dream to compete in the Paralympic Games. I really hope this will help me to find my mother, to let her know that I am doing well and to tell her that I never condemned her for what happened. I imagine she was a poor woman in a difficult situation. In the end, her decision gave me the chance to have this wonderful life and opportunities. She's my mother and I'm sure that this was her intention."

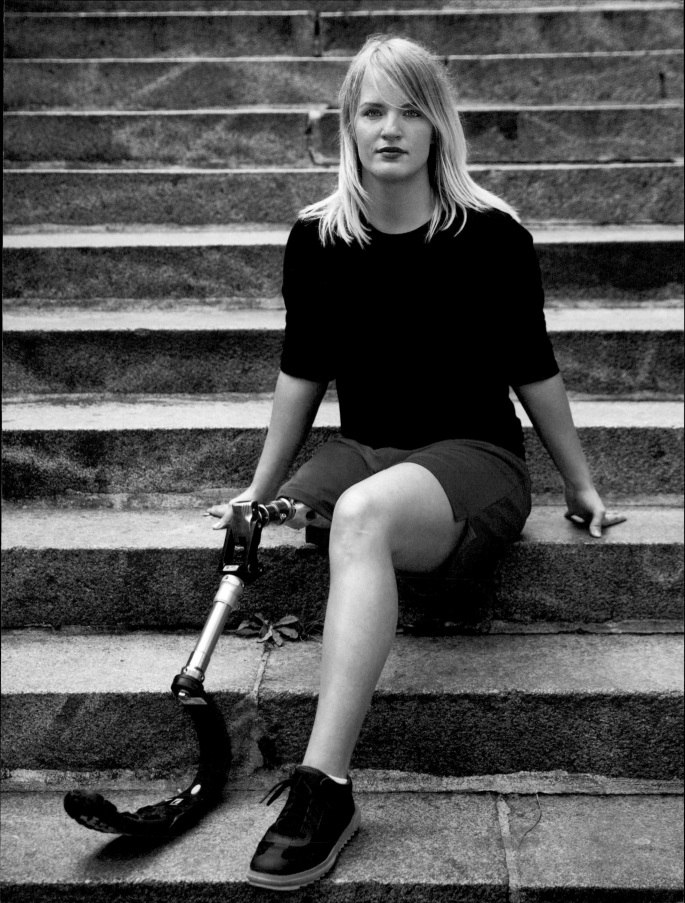

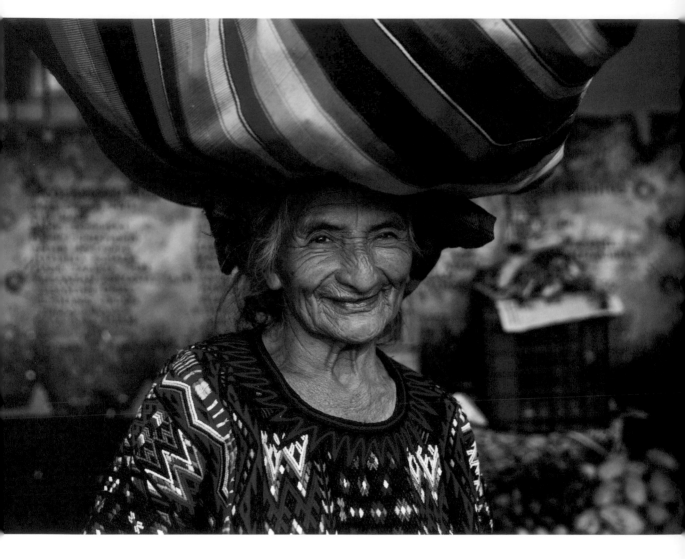

CHICHICASTENANGO, GUATEMALA

Many women of the world carry great burdens every day, either literally or figuratively. And they do it with so much tenderness and positivity.

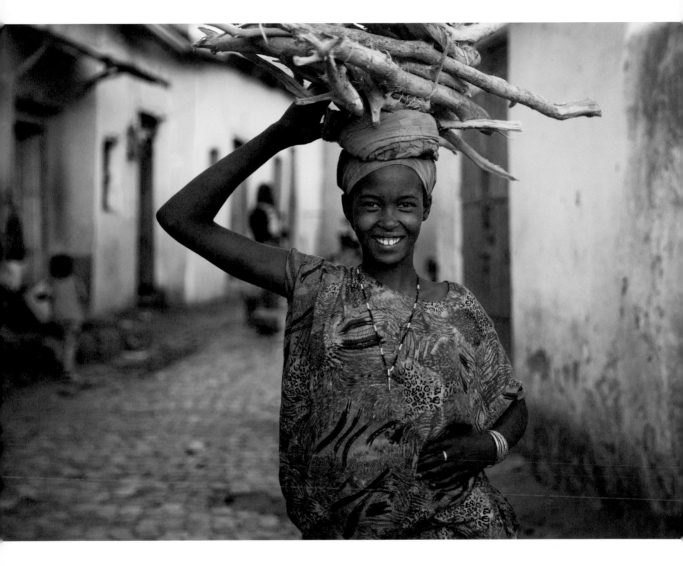

HARAR, ETHIOPIA

In a different part of the world, and at a different time of life, but the same intense smile and beautiful style in the face of daily challenges.

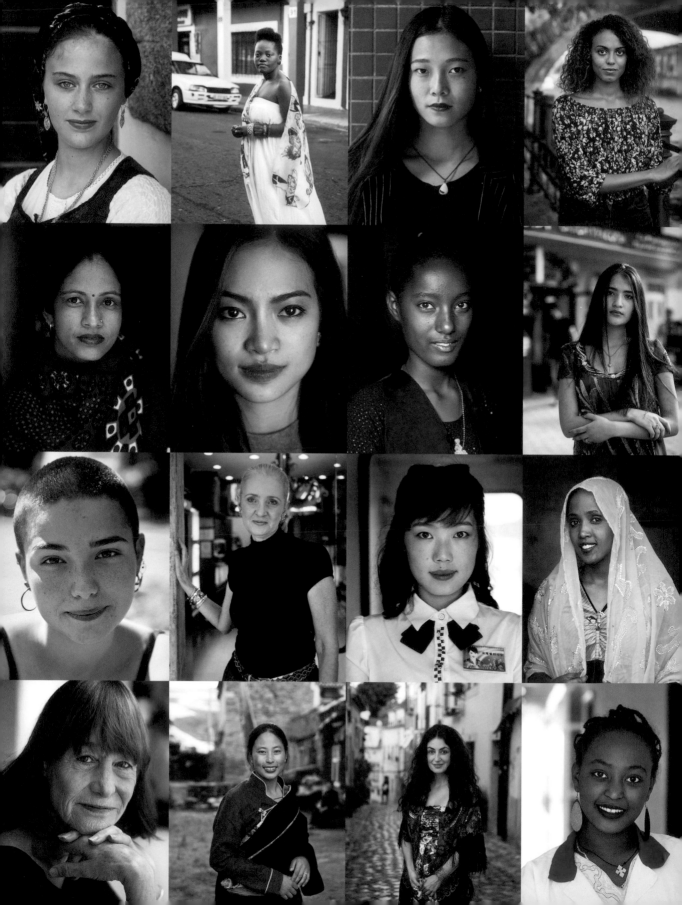

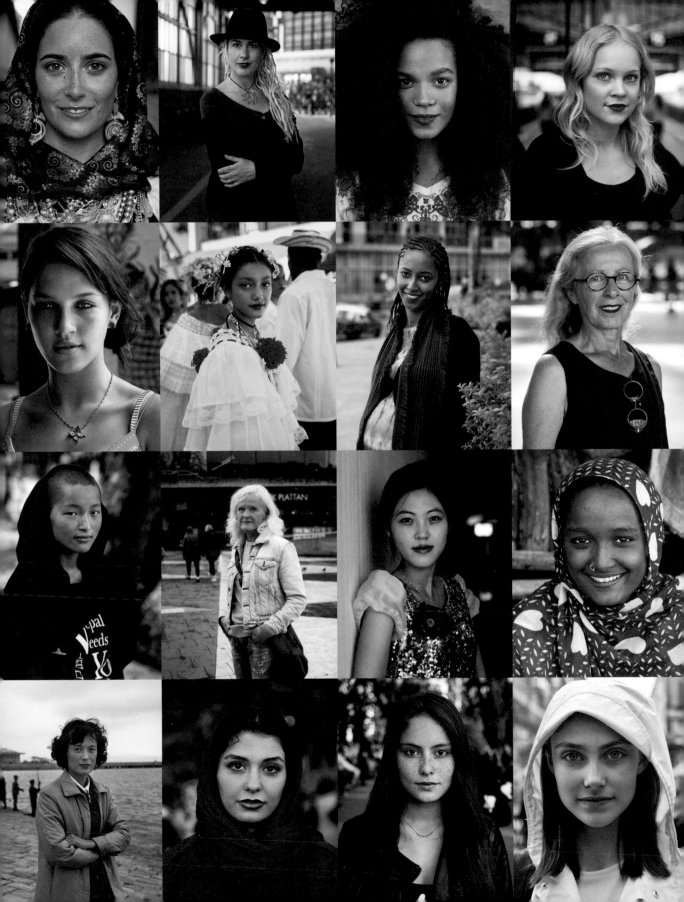

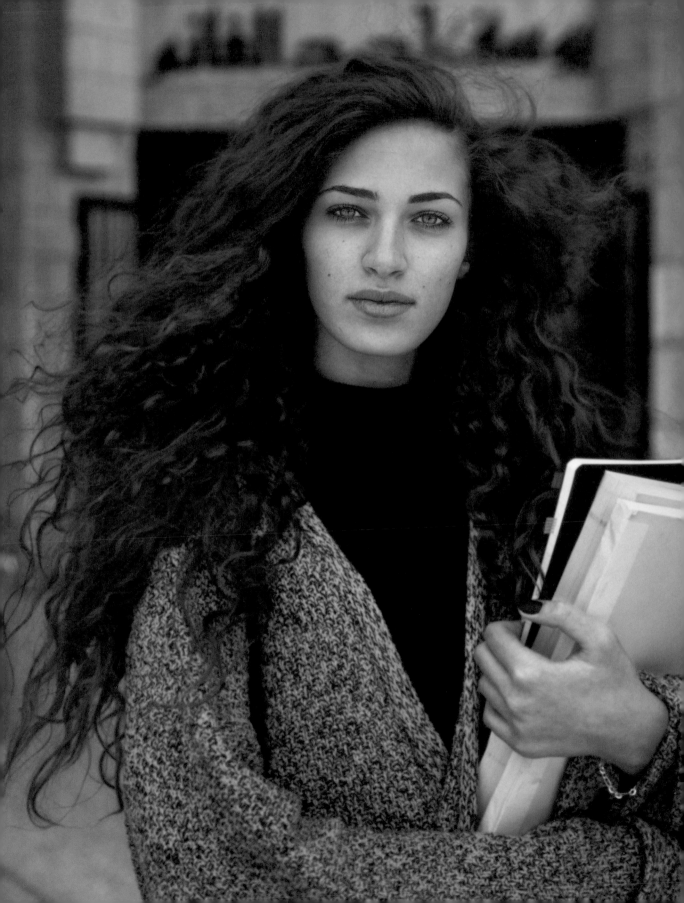

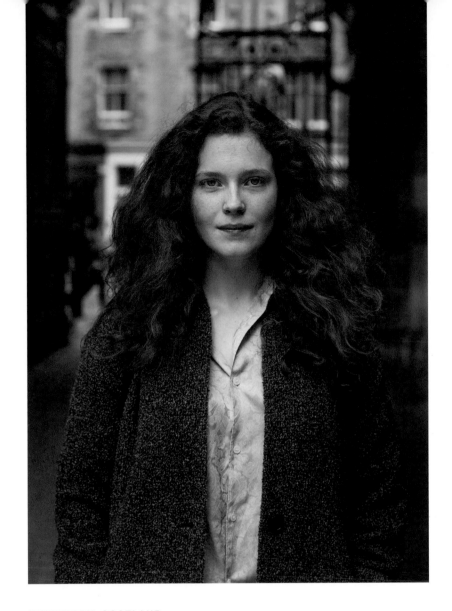

EDINBURGH, SCOTLAND *(Above)*

Ella is passionate about her history studies, and spends hours every day in the library.

RAMALLAH, PALESTINIAN TERRITORIES *(Opposite)*

Amal—her name means "hope" in Arabic—is Palestinian, but had lived in Saudi Arabia from age five, when her family moved there.

"One year ago, I came back to Palestine for my studies. I really feel at home here. I feel I can become the woman I want to be."

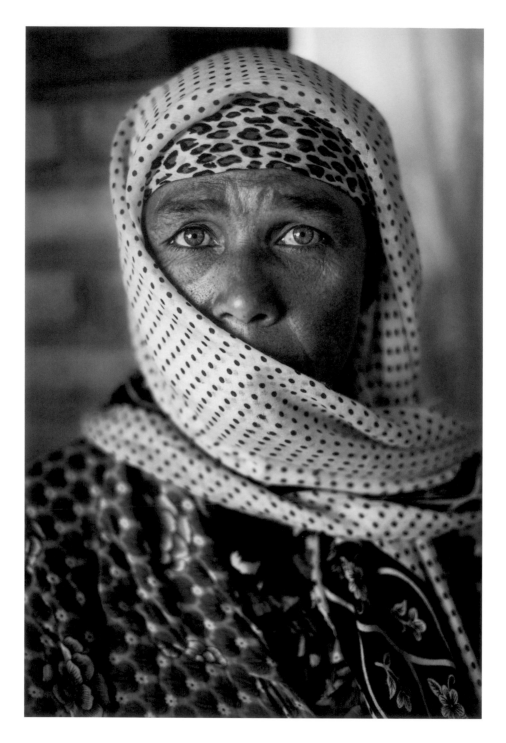

BUKHARA, UZBEKISTAN

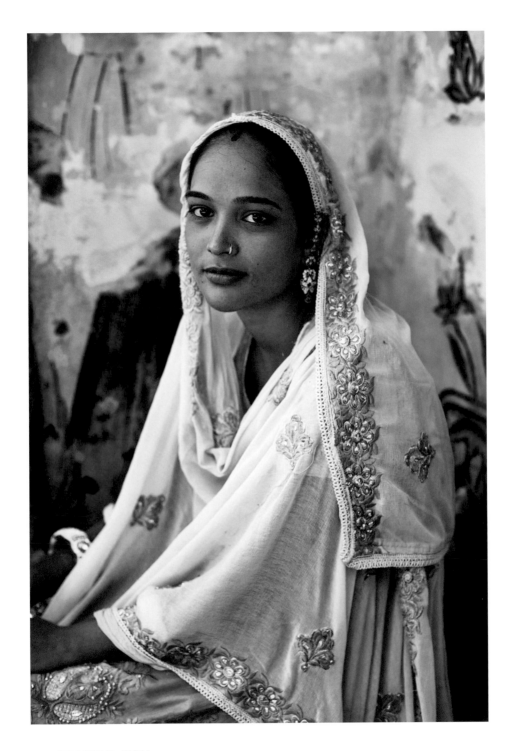

PUSHKAR, INDIA

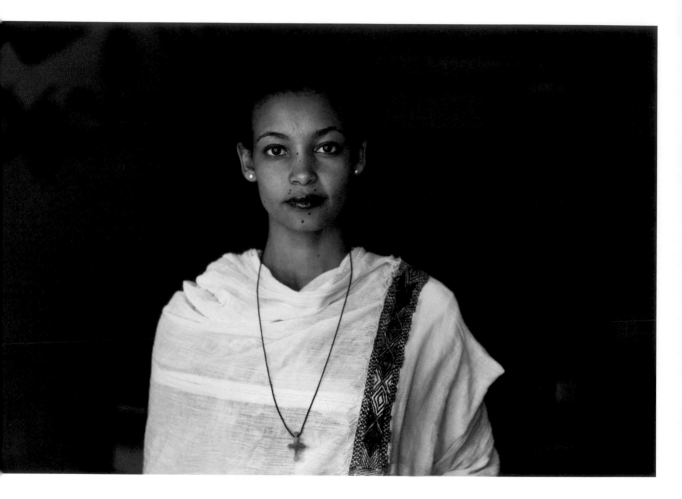

ADDIS ABABA, ETHIOPIA

I met Fana, a young entrepreneur, in her coffee shop. In Ethiopia, where it was first grown, coffee is prepared and served in rituals, as with Japanese tea ceremonies.

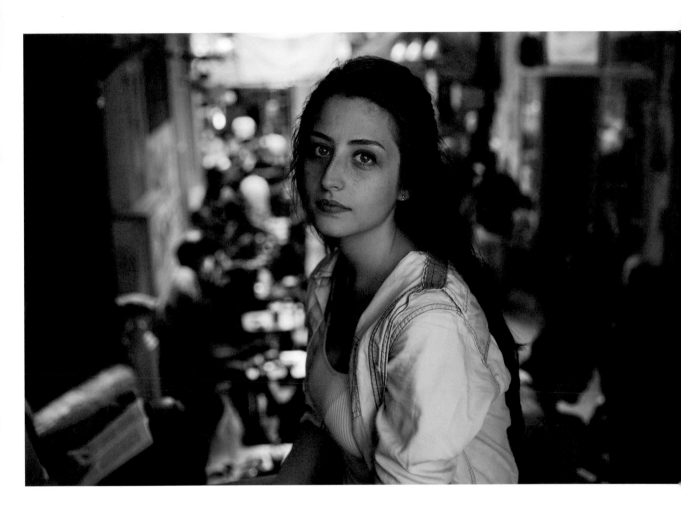

ISTANBUL, TURKEY

This lovely woman was enjoying tea with her friends when I noticed her.
In Turkey, drinking tea is a very common social activity; it's much more than
a tradition.

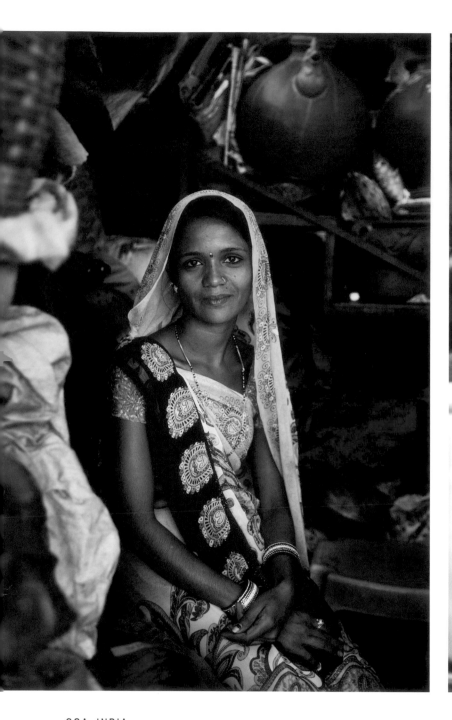

GOA, INDIA

Always dressed in their colorful saris, Rajasthani women
move all across India to sell their wares.

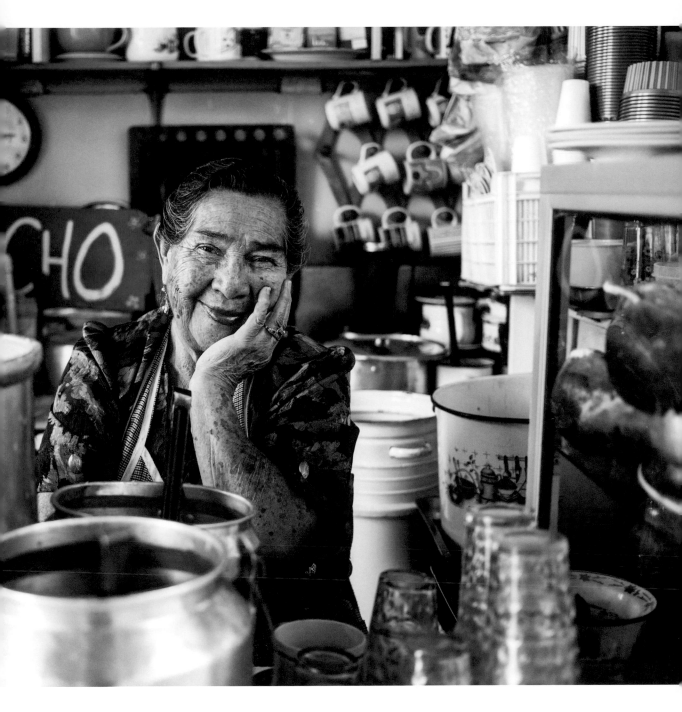

CUENCA, ECUADOR

A moment of tenderness at the market.

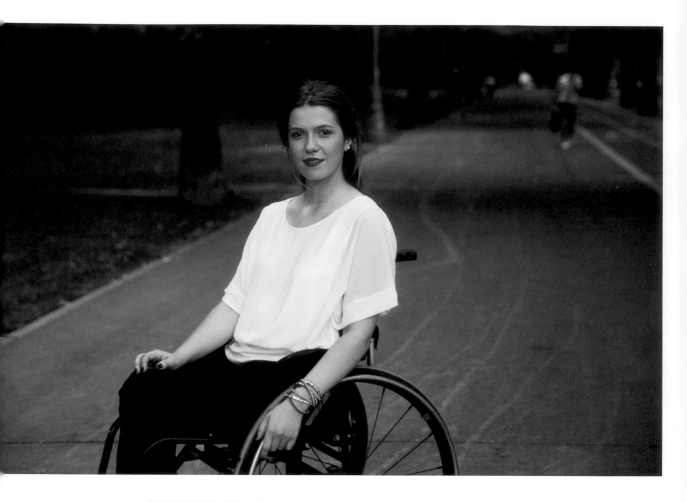

BUCHAREST, ROMANIA

In 2005, Magda was a passenger in a terrible car accident. Something I noticed traveling the world is how, in so many places, people in wheelchairs are often hidden away from the public, condemned to a life of isolation. Sometimes it is because getting outside is too difficult, due to a lack of accessible housing.

Magda wants to change the way people in wheelchairs are treated, at least in her country, through some amazing initiatives. She regularly organizes fashion shows in which the models are ordinary women who use wheelchairs. These events show that a disability does not mean a woman is not talented, capable, and beautiful. She has given confidence to many women who, since working with her, have started families and became mothers. Magda herself is the mother of a six-year-old daughter. I feel privileged when I meet people like her. Through their passion, strength, and generosity, they bring so much joy and support to others.

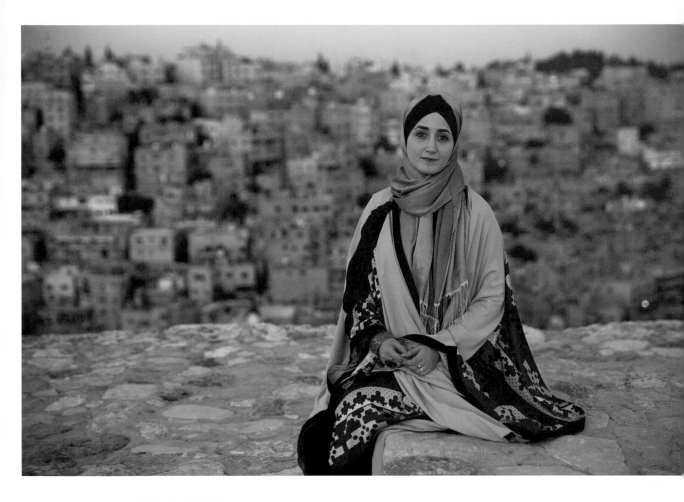

AMMAN, JORDAN

Ala is a promising filmmaker. In college, she fell in love with photography, and worked part-time to make money to buy a decent camera. But her father wouldn't allow her to attend a photography class, as he believed it was not an appropriate environment for a young woman. So she came up with a brilliant idea: She convinced her father to take the class with her. They both registered and after two sessions his eyes were opened—he let her pursue her dream.

CAPE TOWN, SOUTH AFRICA *(Next spread)*

I met this insurance sales team in a bus terminal, on their way to another city. Given their positive energy so early in the morning, I bet they had a successful day.

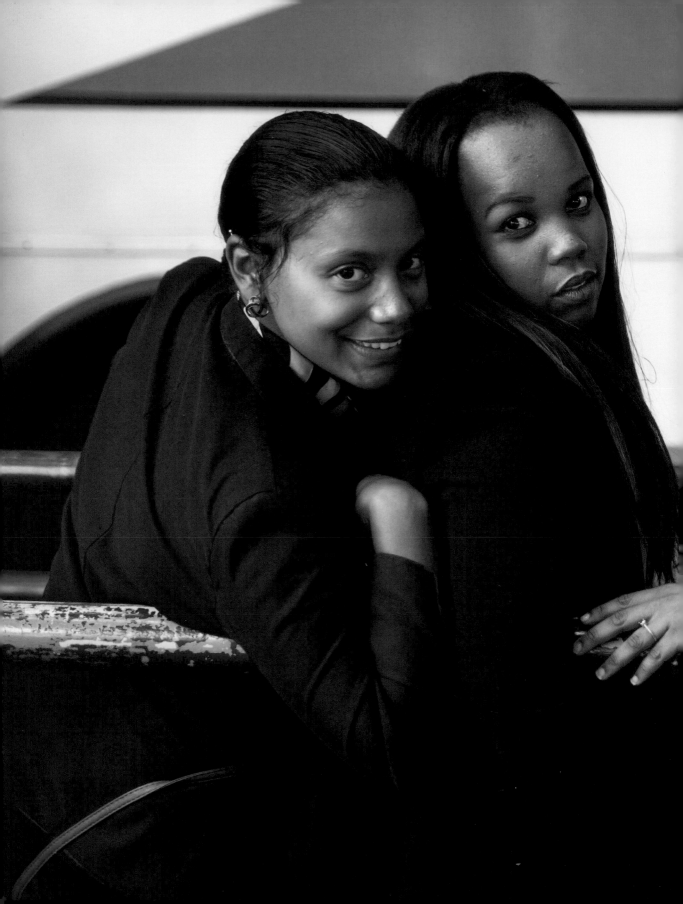

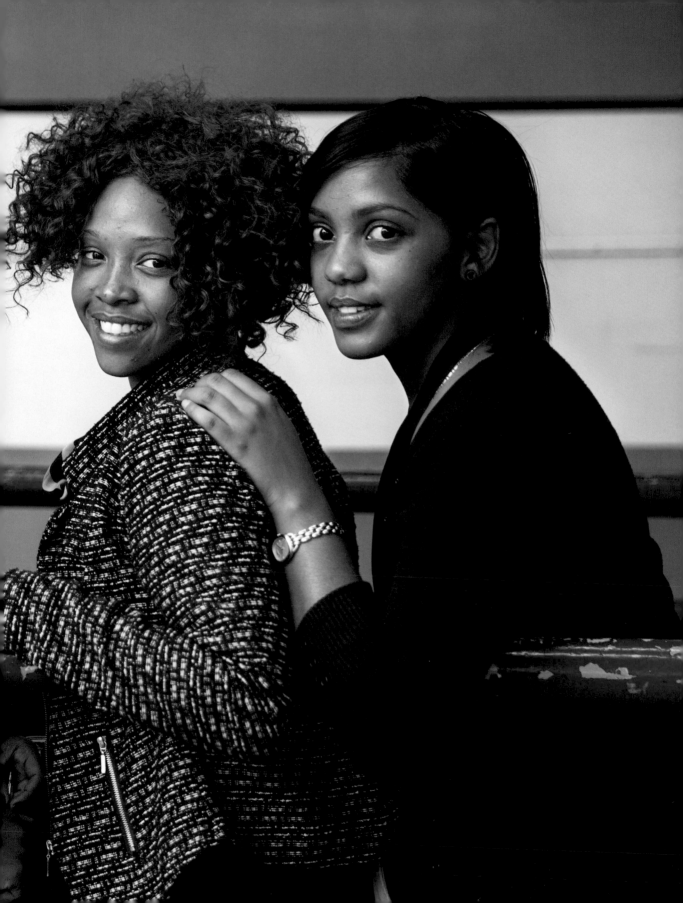

PARIS, FRANCE

It's no wonder the French people gave us the word "chic"—they exemplify it.

CAIRO, EGYPT

She appeared to be deep in thought when I noticed her. And even when she posed for her picture I wondered: *What were the thoughts behind her eyes*?

BISHKEK, KYRGYZSTAN

This woman was waiting for clients in the restaurant where she is a waitress.

RIO DE JANEIRO, BRAZIL

She was relaxing on a bench after a long day at work when I asked to take her photo.

KURDISTAN REGION, IRAQ

Sabiha is the mother of Blesa, Kelpa, and Deria. They all wear traditional Kurdish costumes on special occasions; the love for their homeland and its culture runs through the story of their lives.

The sisters grew up in the mountains with their mother, hiding in caves from bombardments. Their father, a Peshmerga leader, was fighting alongside other Kurds against Saddam Hussein's regime. In 1988, after a terrible chemical attack that killed thousands of Kurdish people, mother and daughters moved to Iran and then to Germany, as refugees. The father remained to continue the fight.

For sixteen years these women lived far away from their homeland, but in 2004 they moved back to be close to their husband and father, who was very ill. After he passed away, they decided to stay and use their knowledge to rebuild their homeland after so many years of war.

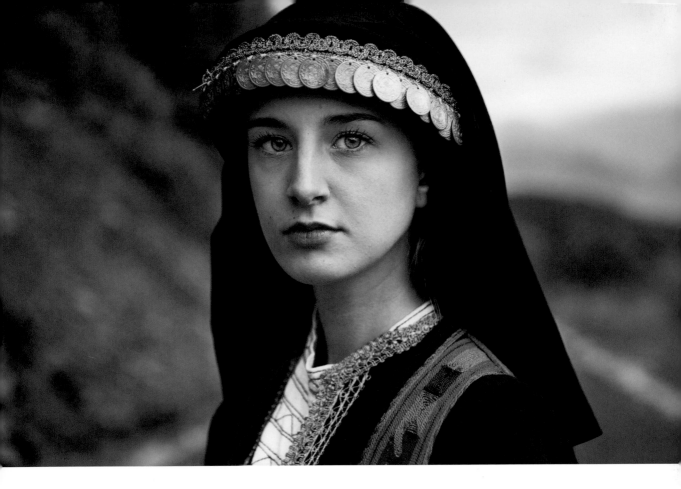

DELPHI, GREECE

On a normal day, Eleni works in her family's restaurant. But once a year, she dresses like this for Easter. It's fascinating to see that, despite the fact that Greece is a modern country, it preserves many of its ancient traditions.

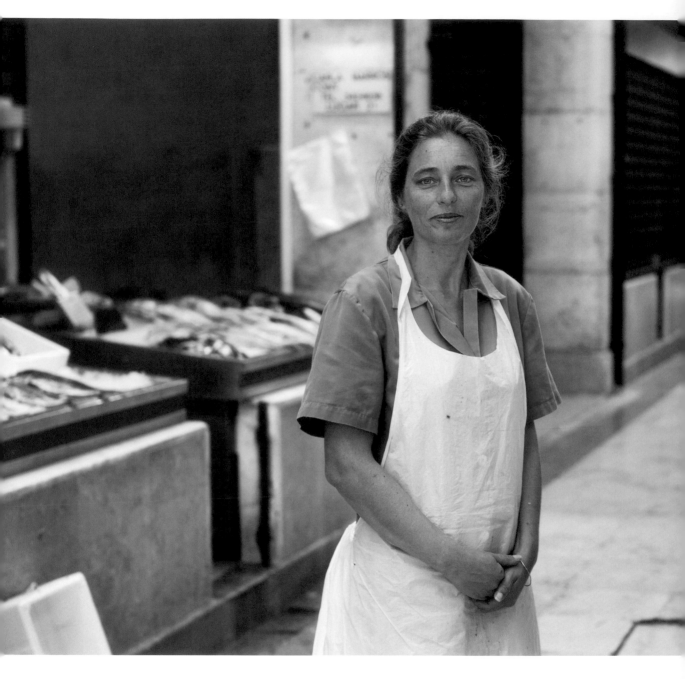

LISBON, PORTUGAL

Carla has a fish stall in one of the markets. Each day she wakes up at five in the morning for work. In the afternoon she takes care of her brother who has special needs. When she spoke about her love for him, her eyes filled, and she couldn't continue. There are millions of hardworking women around the world. They are not famous; their stories and dreams are untold. But each of them is a star in her own family or community.

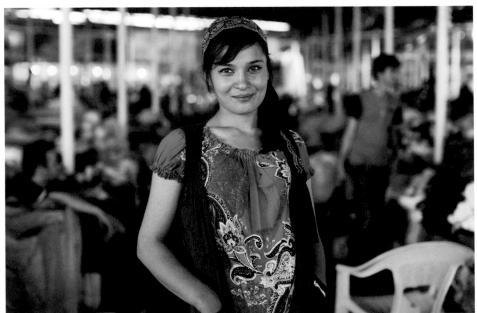

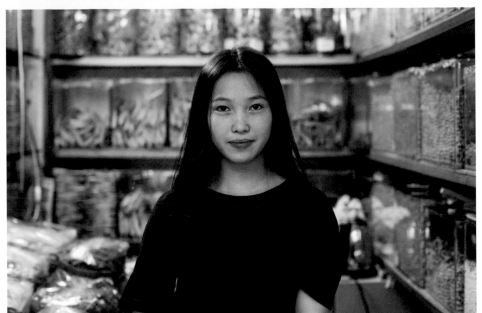

DUSHANBE, TAJIKISTAN *(Top)*

GUANGZHOU, CHINA *(Bottom)*

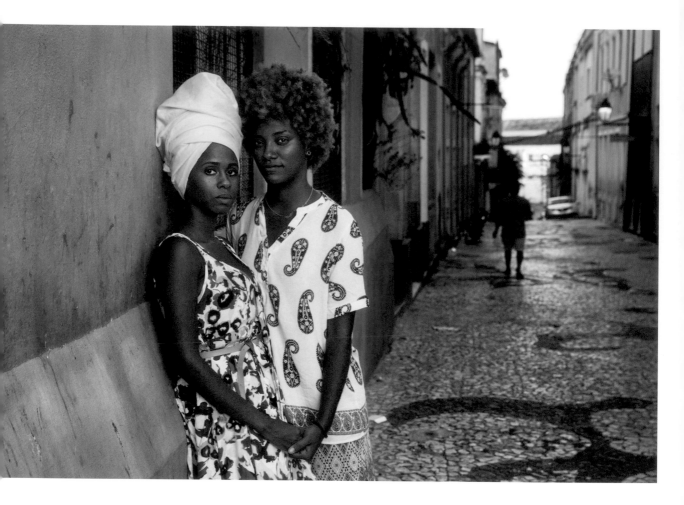

SALVADOR DE BAHIA, BRAZIL

Rafaela and Obax told me about how difficult it is sometimes to be both black and lesbian. But their relationship seemed stronger than the prejudice they face.

PARIS, FRANCE

I met Lucille and Amélie during an LGBT protest. They both felt that the intolerance against sexual minorities is growing year by year in their city.

CENTRAL MONGOLIA (*Next spread*)

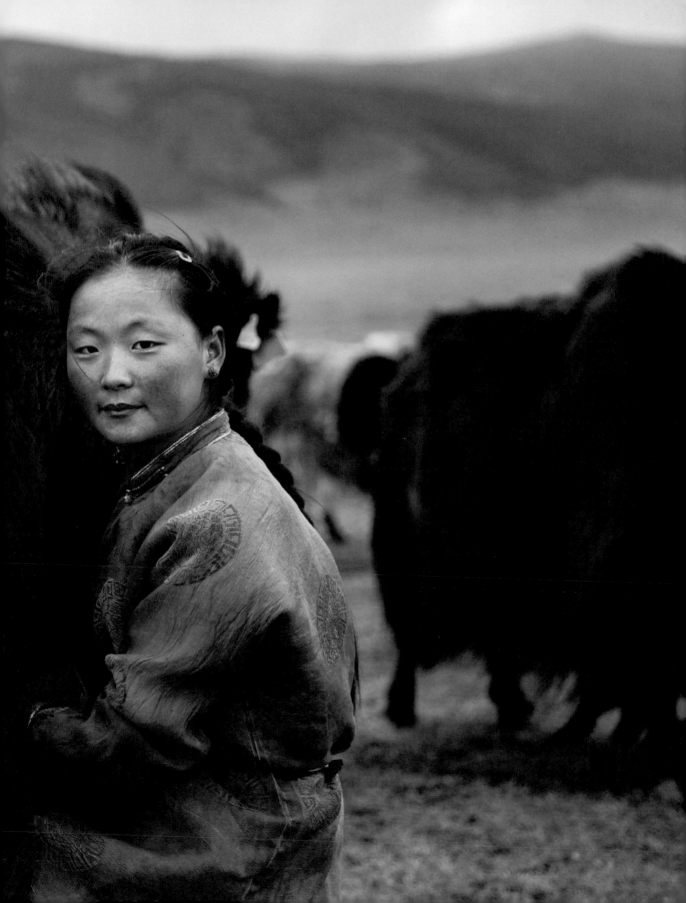

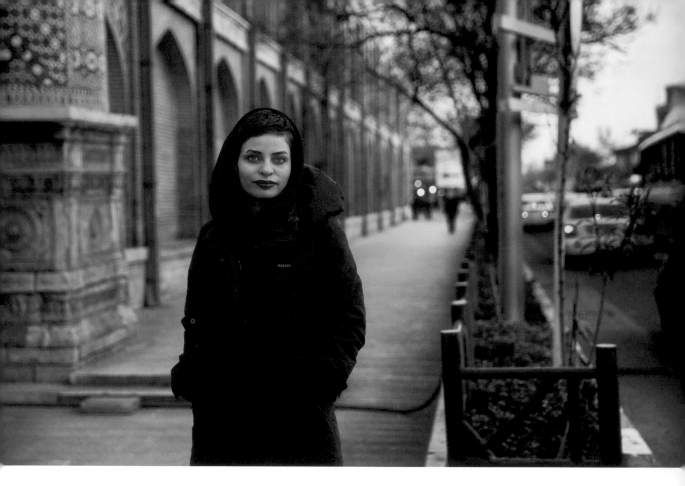

TEHRAN, IRAN

Mahzad studied anthropology and now practices it on the road. Two years ago she was working for a magazine and decided to write an article about hitchhiking. She began by hitchhiking through Iran, without realizing how it would change her life. She loved it so much that traveling became her existence; and the road, her home.

Today she's a travel writer. In a conservative country, Mahzad is the kind of person who doesn't obey the norms.

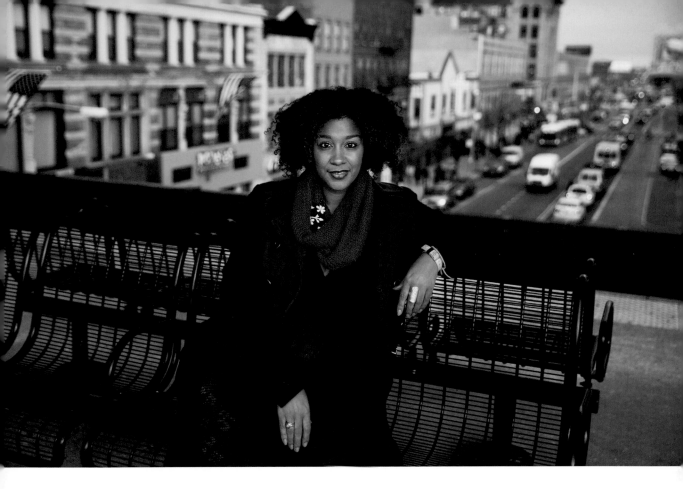

NEW YORK, USA

Evita is the founder of Nomadness Travel Tribe, an online group that inspires thousands of African American women to follow their dreams and travel abroad.

In high school, most of her classmates were from wealthy families. Evita remembers that they were always talking about their amazing travel experiences. Although she was fascinated, she couldn't be part of the conversation because she simply didn't know much about it. After college, she took out a loan and moved to Paris to continue her studies. While in Europe, wanderlust became her way of living. Later she found a job as a teacher in Japan and discovered another fascinating continent.

Today she organizes group journeys, offers a platform where members can share stories and advice, and makes traveling more accessible. Often the members of the community find themselves to be the only people of color that locals from some areas have ever met. But this doesn't discourage the travelers. On the contrary, it motivates them to represent their culture with pride and dignity, wherever they go.

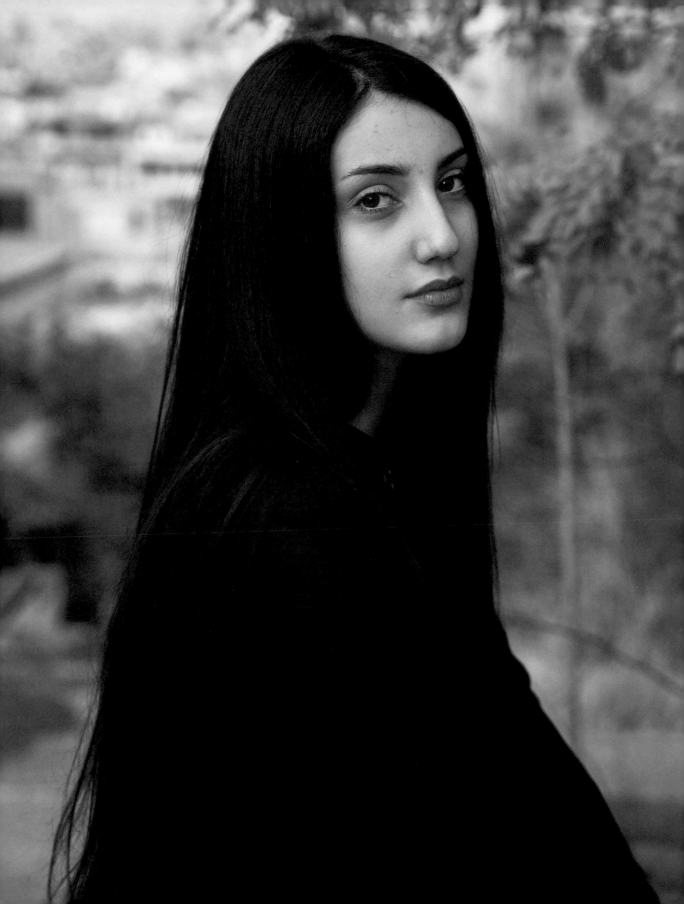

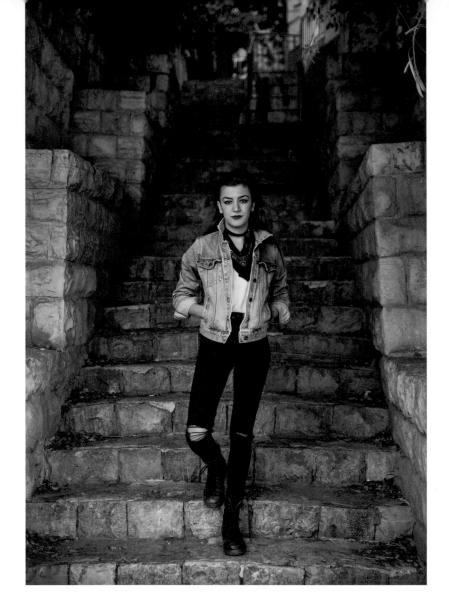

HAIFA, ISRAEL *(Above)*

Sahar was born in a Druze Village in Israel. The Druze people speak Arabic and typically live in homogenous communities where they practice their own religion, the Druze faith. Sahar always felt that she didn't belong to the conservative village where she grew up. Her rebellious nature caused her to be expelled from the community. Now she enjoys life in this liberal place, working as a bartender, singing and painting in her free time.

SULAYMANIYAH, IRAQ *(Opposite)*

A while ago Nma converted to Zoroastrianism, one of the oldest existing religions, a belief based on the teachings of the Iranian prophet Zoroaster.

"Zoroastrianism was our ancient religion and for me, as a Kurd, this is like a return to origins."

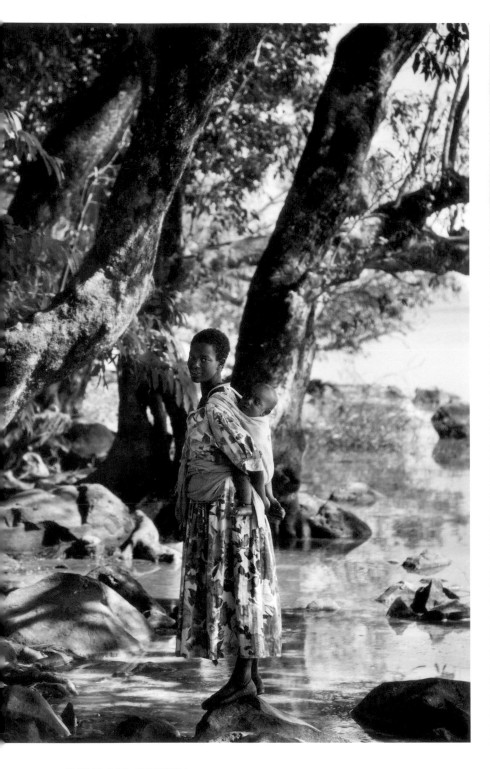

BAHIR DAR, ETHIOPIA

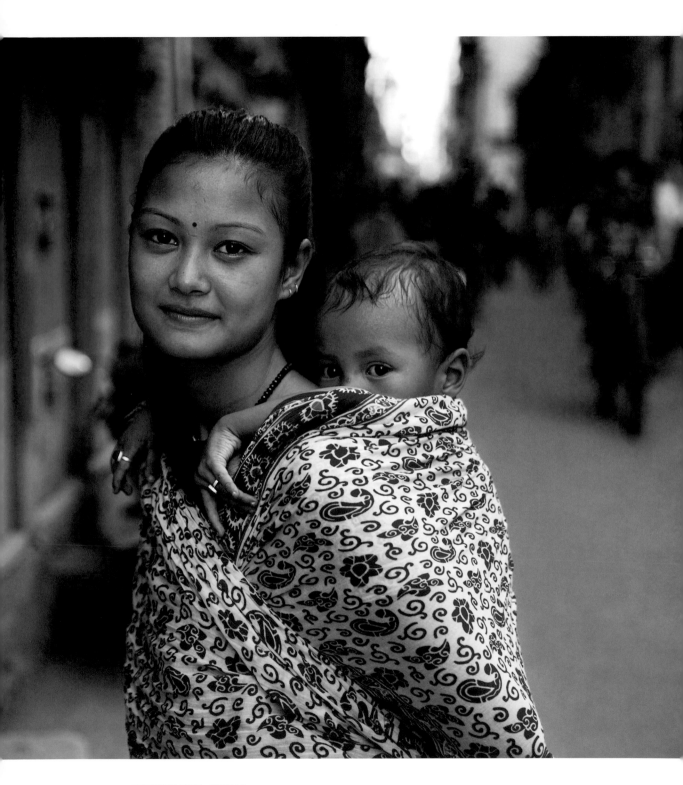

KATHMANDU, NEPAL

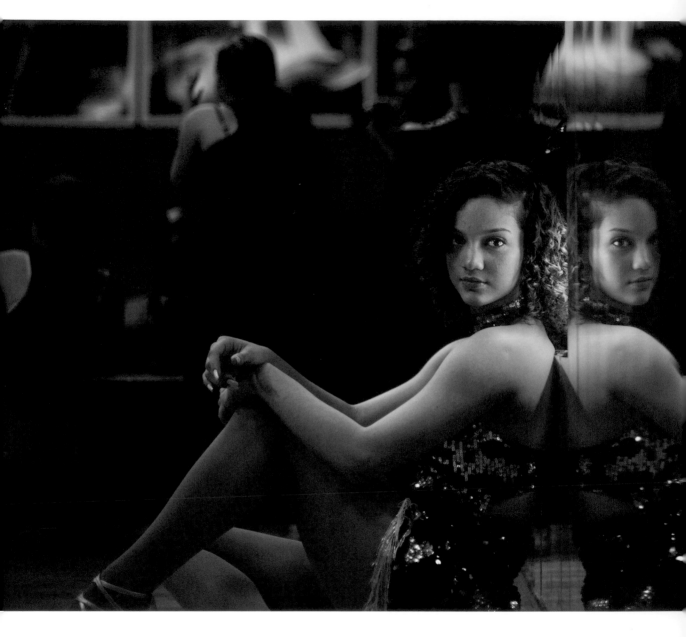

CALI, COLOMBIA

If salsa dancing had a capital, it would probably be Cali—everybody here grows up learning it. Helen, who started to dance when she was five, has become a professional.

"I dream of becoming the best salsa dancer in Colombia."

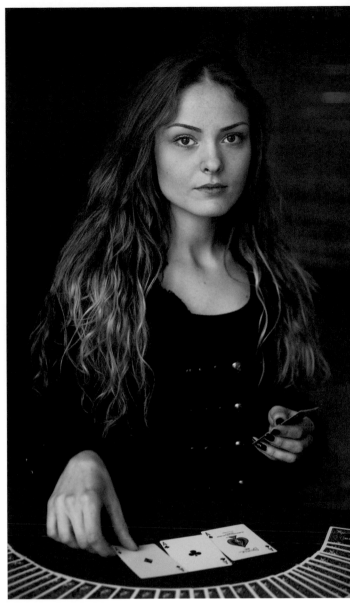

BUCHAREST, ROMANIA

Cristina followed her dream into a field dominated by men, and became one of the first female illusionists in her country.

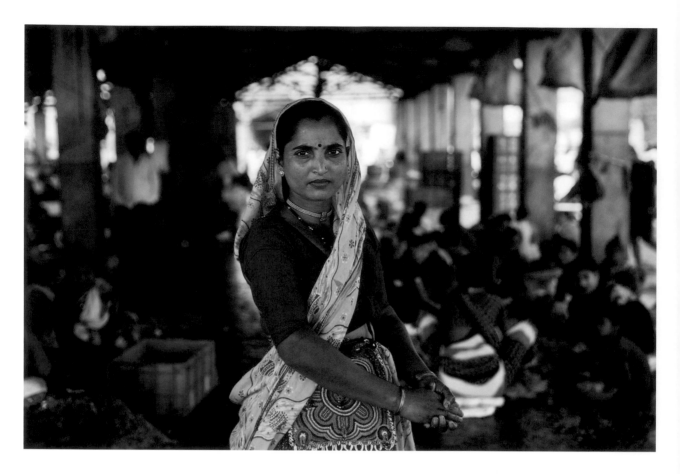

MUMBAI, INDIA

Each day at 5 a.m., this Banjara woman starts work in one of the largest fish markets of the city. Along with other women and girls, she peels shrimp for very little money. It's a hard life but she doesn't complain at all. A few years ago her life was even harder. That's why she came all the way from southern India to find a job like this and more opportunities for her children. Despite all the problems, the Indian women I encountered walk through life with courage and dignity, and the way they deal with their daily challenges, combining strength with grace, is remarkable.

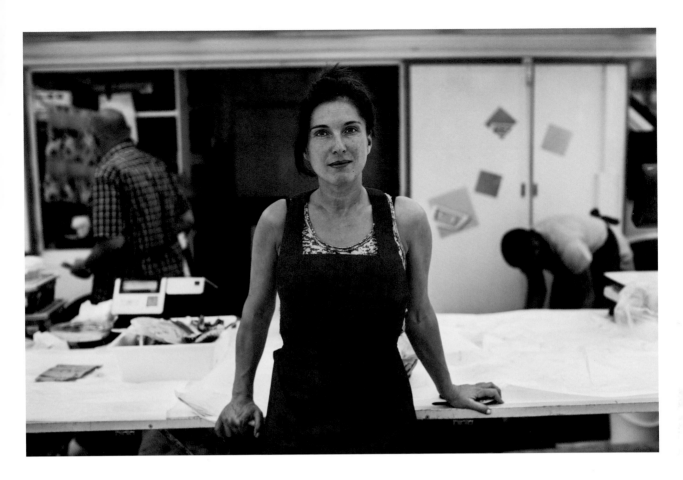

MILAN, ITALY

I met Daniela in one of the city's markets, where she was working twelve-hour days. She shared some painful experiences: she had suffered three miscarriages and one divorce. But all the pain and hard work didn't stop her from being an optimistic and warm person.

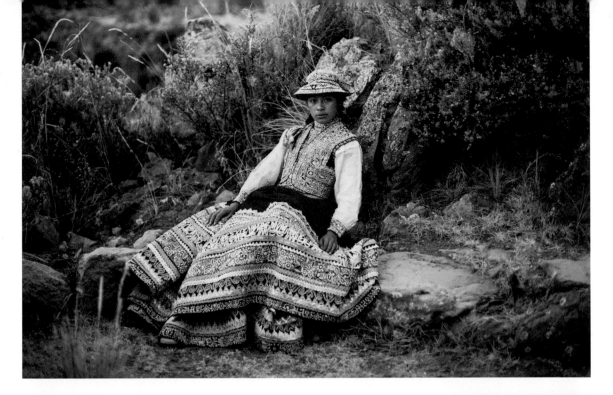

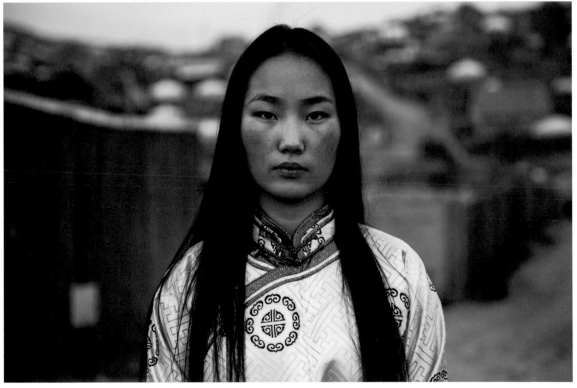

COLCA VALLEY, PERU *(Top)*

MEDELLIN, COLOMBIA *(Opposite)*

NEAR ULAANBAATAR, MONGOLIA *(Bottom)*

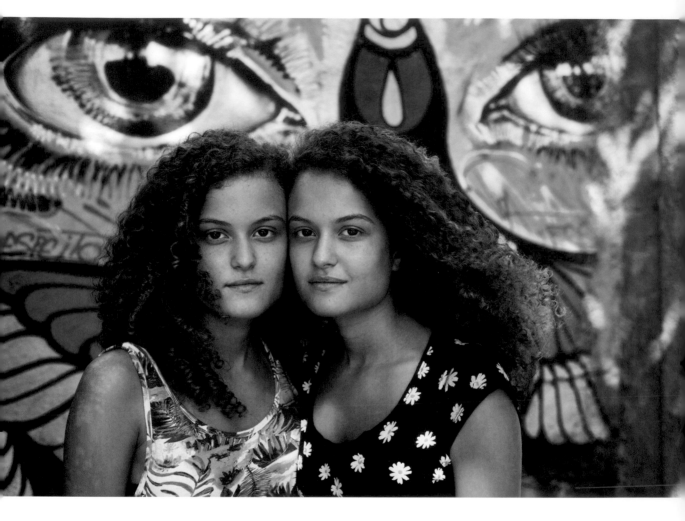

RIO DE JANEIRO, BRAZIL

Sisters Camila and Bruna

"We have very different personalities. But when one of us is really sad or really happy, the other one feels that instantly."

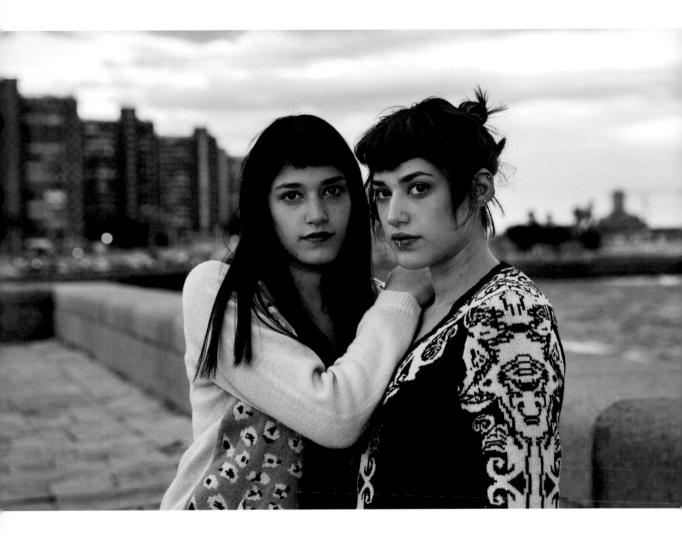

MONTEVIDEO, URUGUAY

Camila and Maria are identical twins but their paths in life were opposite. Maria told me she was always a positive person, who sees the bright side of life, while Camila had been through many periods of depression.

"There was a very difficult moment in my life when I wanted to commit suicide. But my sister supported me a lot and I can say that she was the one who saved me."

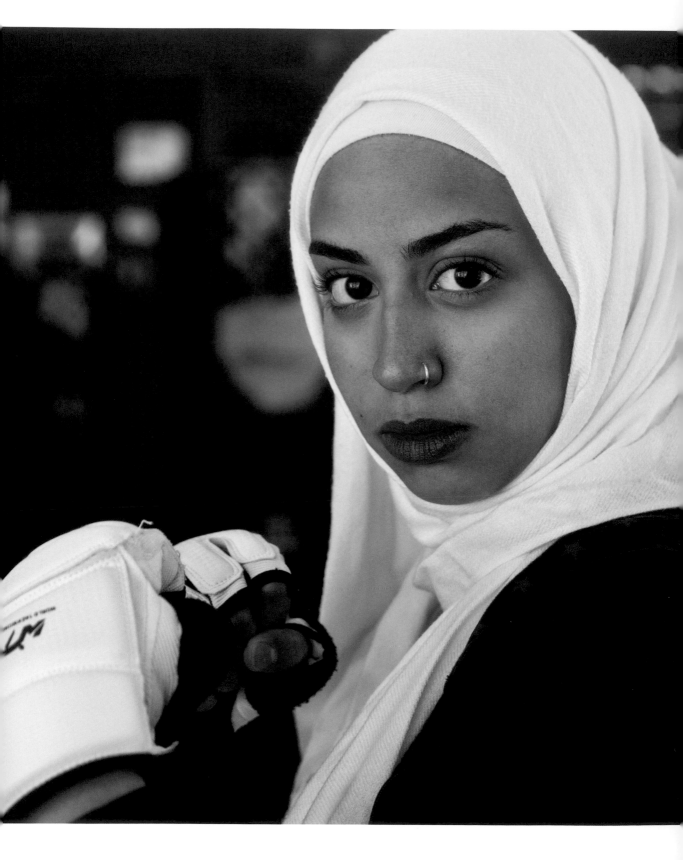

AMMAN, JORDAN

Ala is a student at She Fighter, the first self-defense school for women in the Arab world. In a country where many women face violence in their own homes, and where street harassment is common, this school is changing the norms.

When I entered their studio, I discovered an amazing initiative and a splendid sisterhood between women from different environments. All of them told me they gained a lot of confidence after starting these courses. That's real empowerment, not just words.

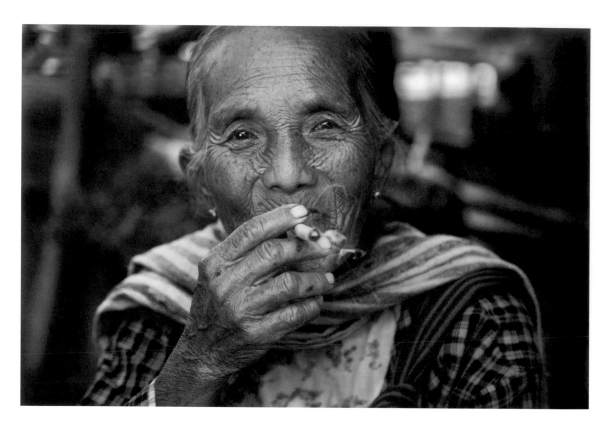

INLE LAKE, MYANMAR *(Above)*

This is a common scene in a place where cigarettes are hand-rolled in tobacco leaves and don't come with health advisories.

OMO VALLEY, ETHIOPIA *(Opposite)*

The stick in her mouth is used by the Hamar tribe instead of a toothbrush. Is it effective? Seems so, as I've seen so many beautiful smiles here.

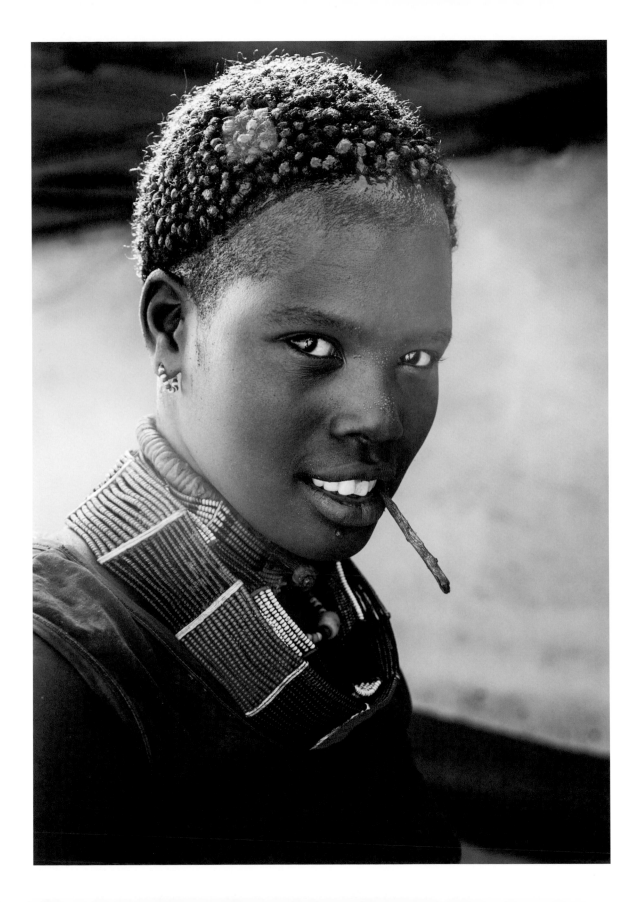

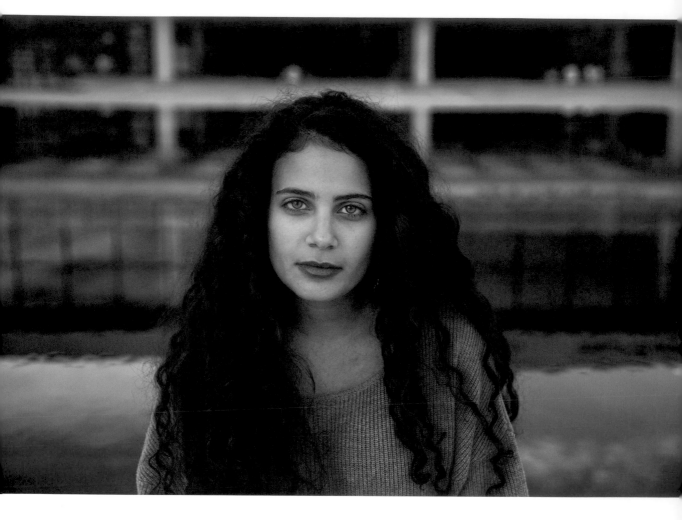

TEL AVIV, ISRAEL

Where are these soulful eyes from? Shir's Jewish parents moved here from Morocco and Yemen.

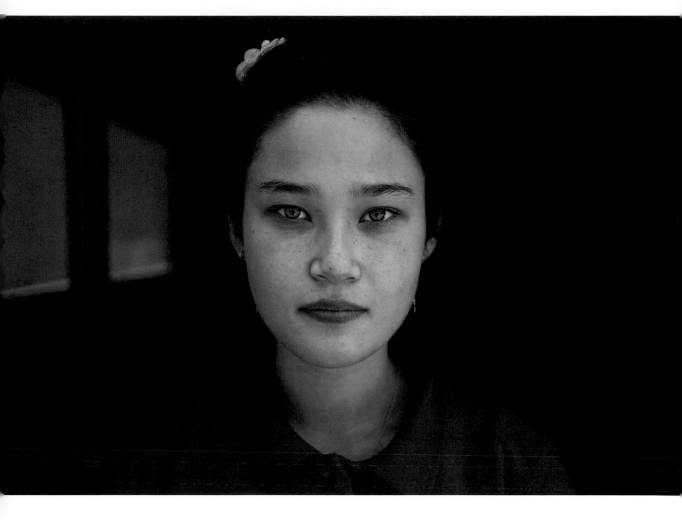

BISHKEK, KYRGYZSTAN

While passing by, I saw these two bright eyes inside this dark donut kiosk.
Kanyshay asked if I wanted a donut, I asked if I could take her photo.

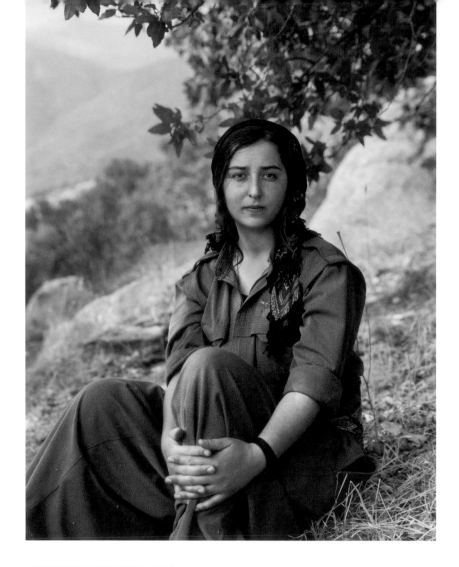

KURDISTAN REGION, IRAQ

Ezdah is part of an all-women unit that fights ISIS in Iraq and Syria to protect Kurdish communities. Along with other units, they form the military wing of Kurdistan Worker's Party, which is listed as a terrorist organization by Turkey and the United States. They often change location because they're targeted by Turkish jets. When I met Ezdah's unit, they were hidden in the mountains of northern Iraq. During my stay, they showed a lot of kindness and compassion, which surprised me given their harsh and dangerous lives.

The day before each battle, the women celebrate life through dancing. Most of them, like Ezdah, felt discriminated and marginalized as women, before joining the guerillas. They dream about a land where men and women will be equal and they are ready to sacrifice their lives for that.

"I would love to see your book. But I don't know if I will still be alive when you publish it."

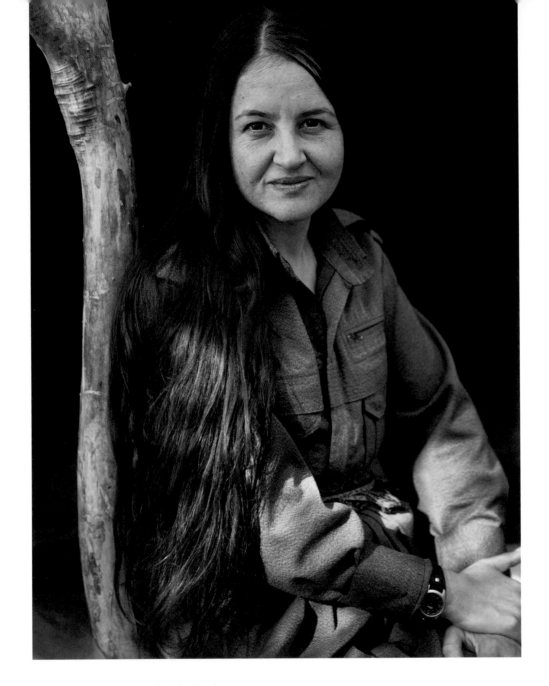

KURDISTAN REGION, IRAQ

Newroz, forty-eight, is the commander of the same all-women unit that protects Kurdish communities. She joined the guerilla fighters when she was only thirteen, after most of the people from her Kurdish village in Turkey were killed. She says that the cries of the children and mothers have remained with her for life. Recently, in the fight against ISIS, she lost some of her sight due to a chemical attack. She's been shot several times, but never thought to give up.

"I'm a peaceful person, but here we need to fight two battles: To be Kurdish and to be a woman."

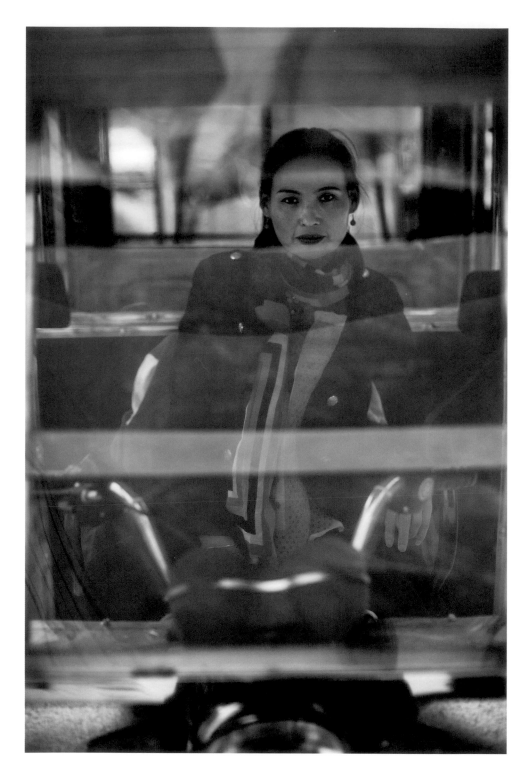

CHENGDU, CHINA

A rickshaw driver.

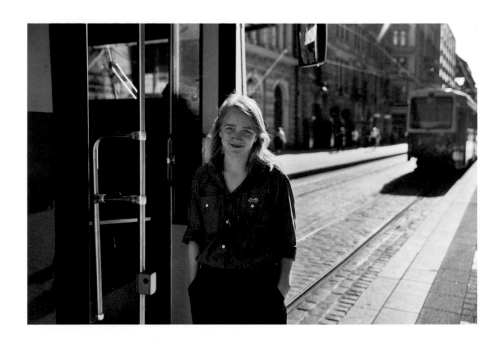

HELSINKI, FINLAND

A tram driver.

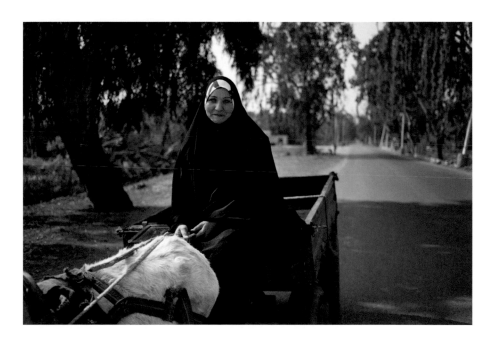

NEAR CAIRO, EGYPT

A carriage driver.

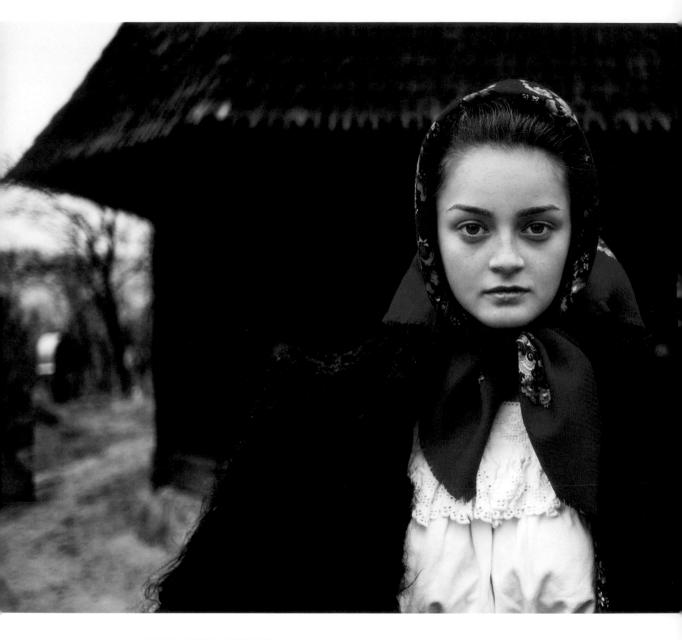

MARAMUREŞ, ROMANIA

On a normal day, Maria dresses like any other adolescent. But it was
Christmas when I met her, a magical moment when most women from
this picturesque village wear traditional clothes.

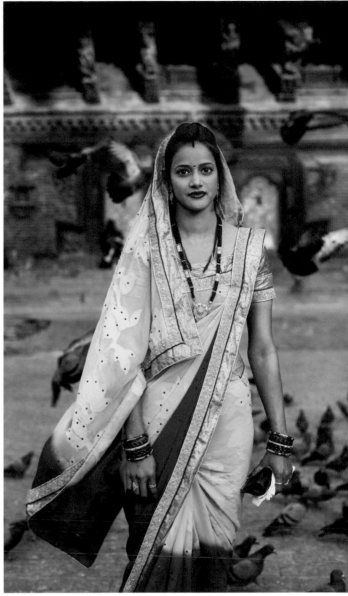

KATHMANDU, NEPAL

Dressed in this splendid sari, Laxmi was on the way to meet her family and celebrate Holi, one of the biggest Hindu festivals.

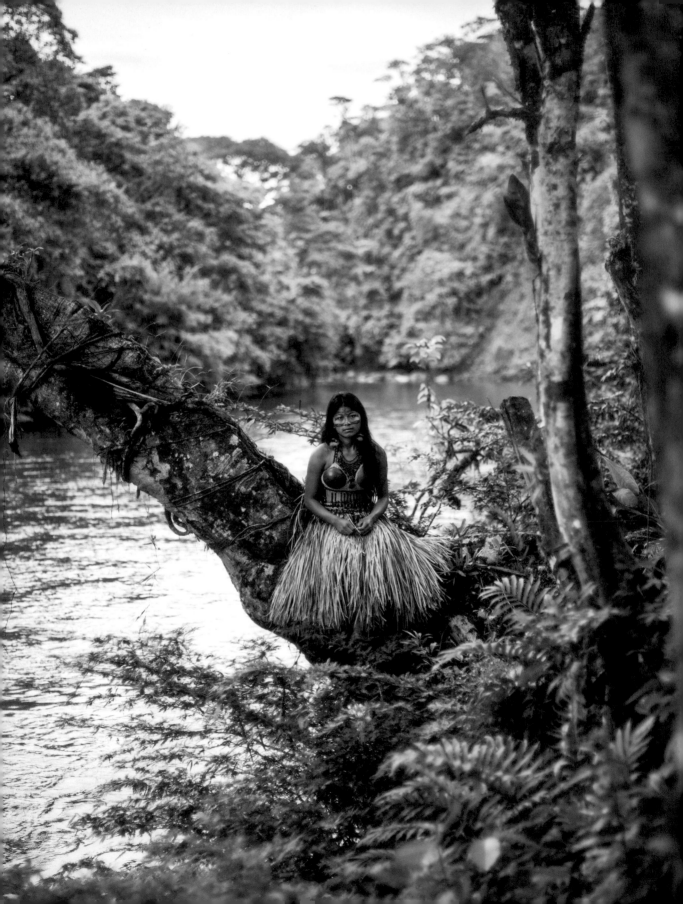

SALVADOR, BRAZIL

A young fast-food worker.

AMAZON RAINFOREST, ECUADOR *(Previous spread, left)*

More and more tribes of Amazonia are starting to adopt modern clothes for everyday life. But they are still keeping their traditional clothes for important events. I photographed this young woman in her wedding outfit

REPUBLIC OF NORTH OSSETIA-ALANIA, RUSSIA *(Previous spread, right)*

I'm fascinated by the Caucasus, a mountainous region where Europe and Asia converge, with many distinctive ethnic groups and an incredible variety of faces. It's where I met Delyara, who is Ossetian.

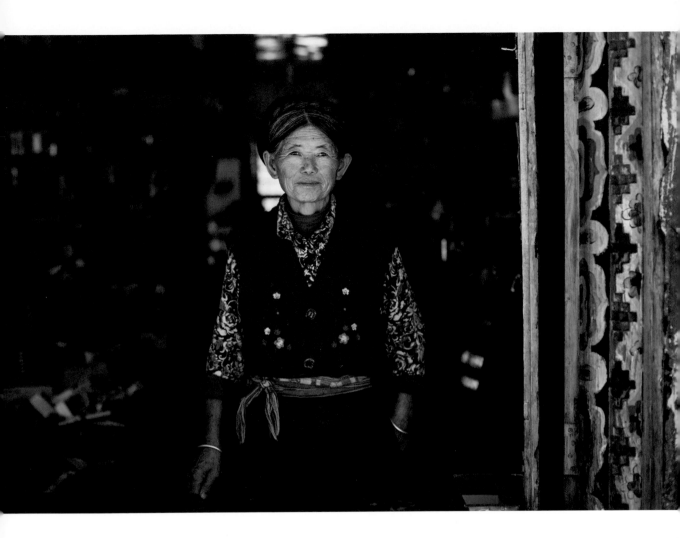

SICHUAN PROVINCE, CHINA

This woman runs her own shop in a small village.

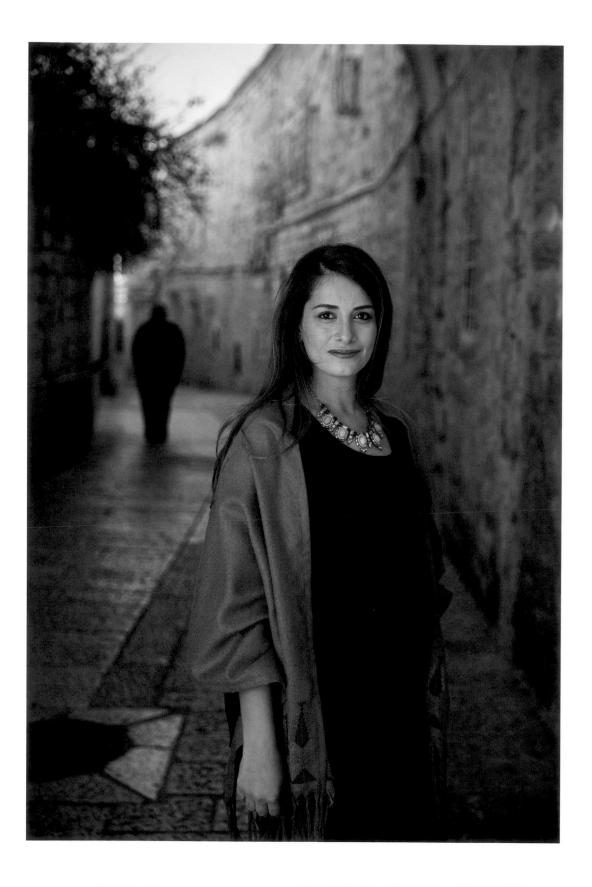

HELSINKI, FINLAND *(Above)*

After her mother was diagnosed with cancer, Katariina started to see life in a different way. For years she had worked in the perfume industry, but her mother's illness made her think more about health issues related to beauty products, and to want to do something. She gathered a team of specialists and created an amazing free phone app that scans the barcode of a cosmetic product and informs the user about the safety of the ingredients.

EAST JERUSALEM, DISPUTED TERRITORY *(Opposite)*

After studying in the United States and England, this young Palestinian returned home to put her knowledge in the service of Palestinian people. Raya was pregnant with her second baby when I met her, but besides becoming a mother for the second time she was also on a mission to empower Palestinian women.

As a young entrepreneur, Raya started a cosmetic company, and most of her employees are Palestinian women from marginalized communities. She also works for Palestine's largest bank, and one of her main projects is to increase the percentage of female employees in all ranks at the bank.

"Supporting so many women is what keeps me going, and gives me the passion, enthusiasm, and energy to have two jobs at a time when I have two young children."

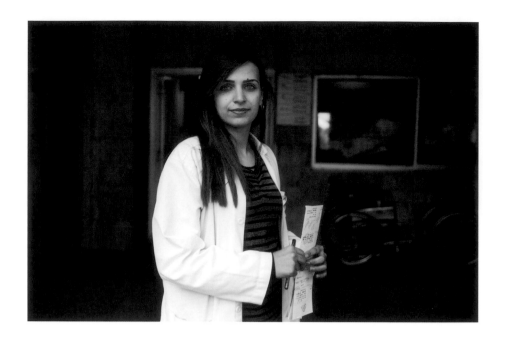

AMMAN, JORDAN

A general practitioner.

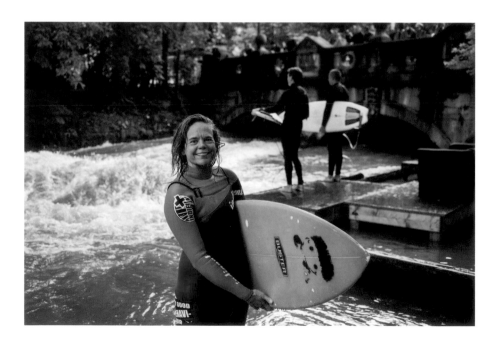

MUNICH, GERMANY

She surfs, which takes a lot of bravery in this narrow river.

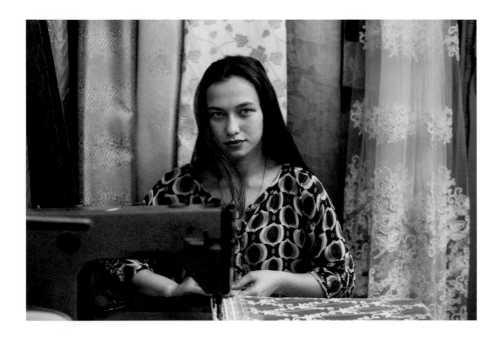

THE REPUBLIC OF NORTH OSSETIA-ALANIA, RUSSIA

She makes curtains.

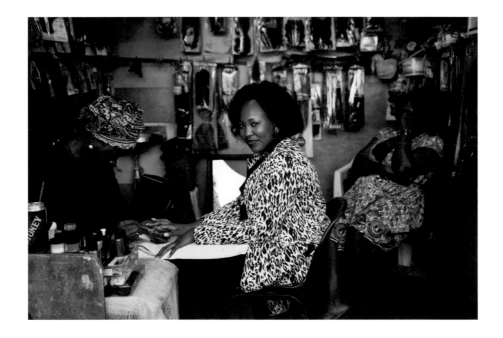

CAPE TOWN, SOUTH AFRICA

At the beauty salon.

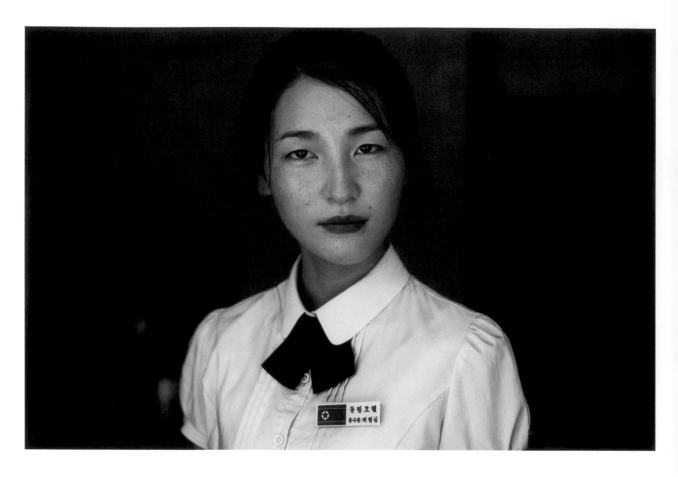

SINUIJU, NORTH KOREA

For over seventy years, North Korea has isolated itself. Traveling there is like stepping into another world. There isn't even Internet as we know it, but a national network with websites owned by the government. So I felt privileged to photograph a few North Korean women and talk a bit with them. It was fascinating to feel that, although we live in different worlds, with different mentalities, there was something deeper that connected us as women and as human beings. There's beauty and humanity in North Korea, and I discovered it among the ordinary people.

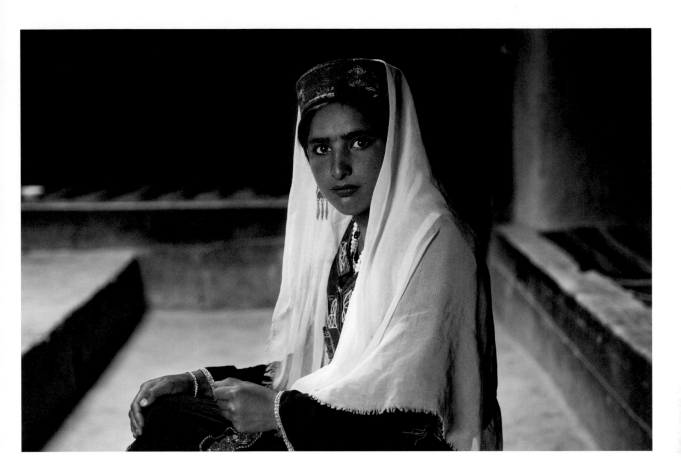

WAKHAN CORRIDOR, AFGHANISTAN

There have been nearly forty years of continuous war in Afghanistan; a whole generation here has never lived in a time of peace. Fortunately, this corridor surrounded by majestic mountains remained untouched by conflict because of its isolation. But war was always very close. When I visited, there were heavy fights between the Taliban and the Afghan Army just fifty kilometers away. If someday the Taliban reaches her village, all its residents would likely be killed because of their beliefs. What impressed me most in this part of the world were the piercingly clear eyes, expressing the struggle inside each person.

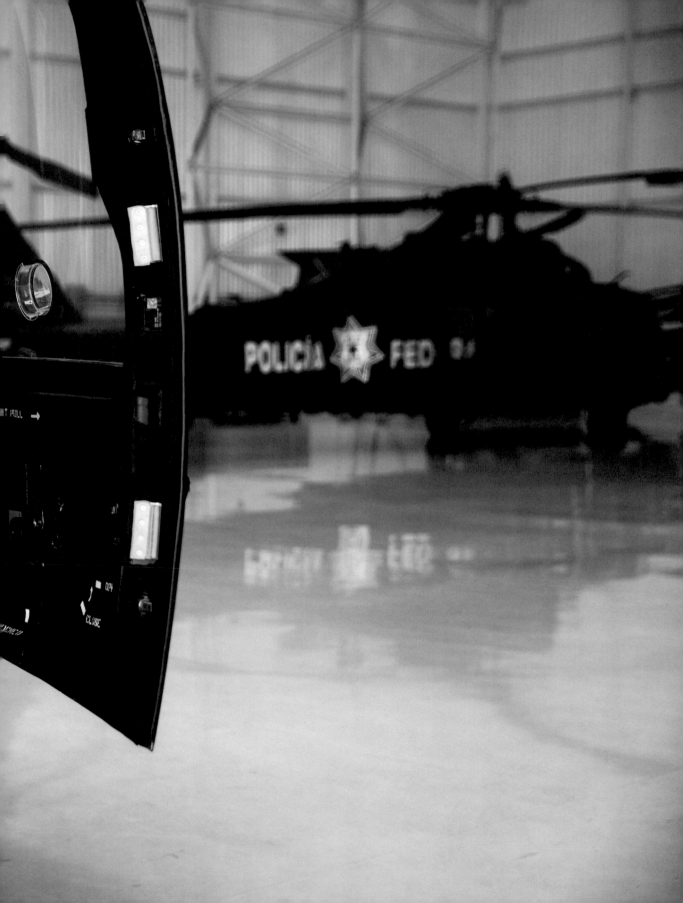

MEXICO CITY, MEXICO *(Previous spread)*

Captain Berenice Torres is a helicopter pilot for the Mexican Federal Police. This brave woman, who is also a mother, is part of a special forces unit to fight drug cartels, or to rescue people from natural disasters. When she talks about her work, the passion in her eyes is impressive.

"I always dreamed of flying. Even though I'm involved in many risky operations—I survived two accidents—I love every single second in the air. The fact that I can help people in need and I can inspire my daughter motivates me every day."

ZURICH, SWITZERLAND *(Opposite)*

Patricia and Rebecca are sisters. Their striking hair color caught my eye at the train station; it seemed magical, but I learned that they didn't always love it as kids.

"When we were small, most of the kids laughed at our red hair. But that brought us closer to each other."

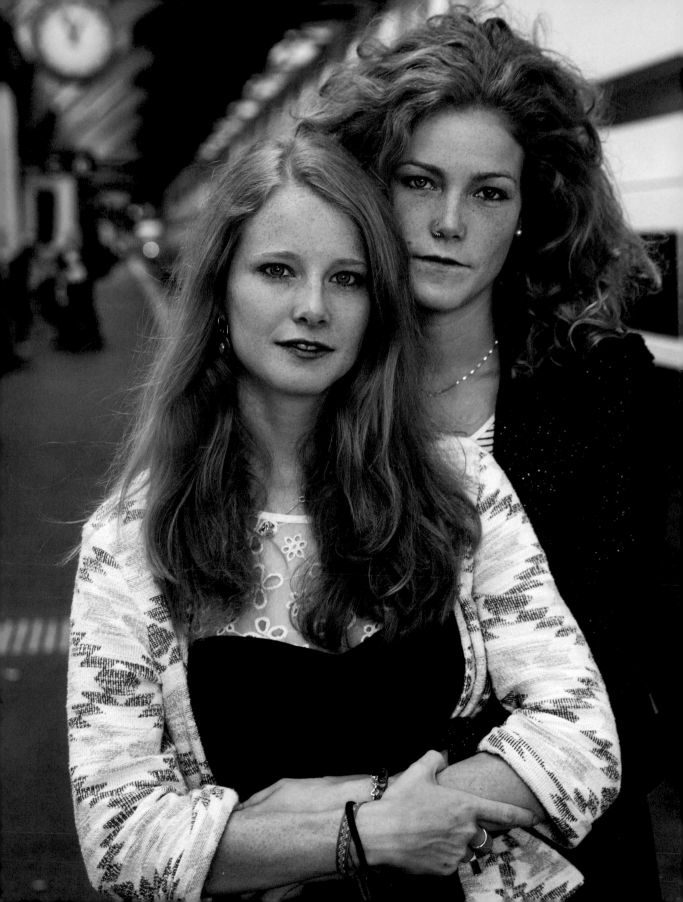

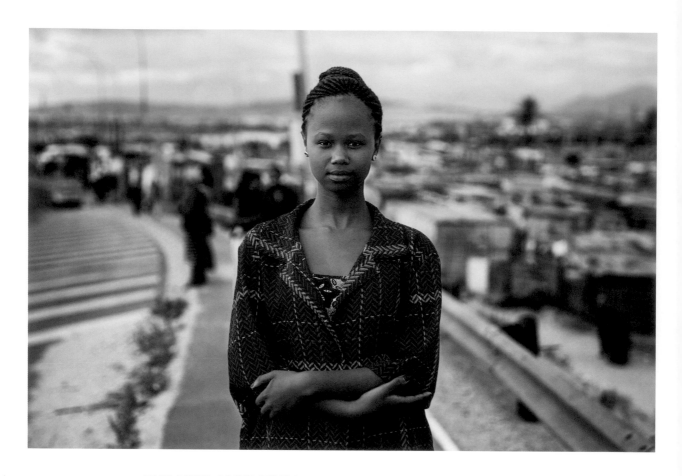

CAPE TOWN, SOUTH AFRICA

Yandiswa lives in Khayelitsha, a large slum where, she said, drunk or drugged-up men often try to enter her shack during the night. She was raised here by her mother who died a few years ago. Now she lives with her young cousin, who is also an orphan. Yandiswa was recently admitted to the university and she received a place to live on campus. But she cannot escape this dangerous place because there's nobody else to look after her cousin.

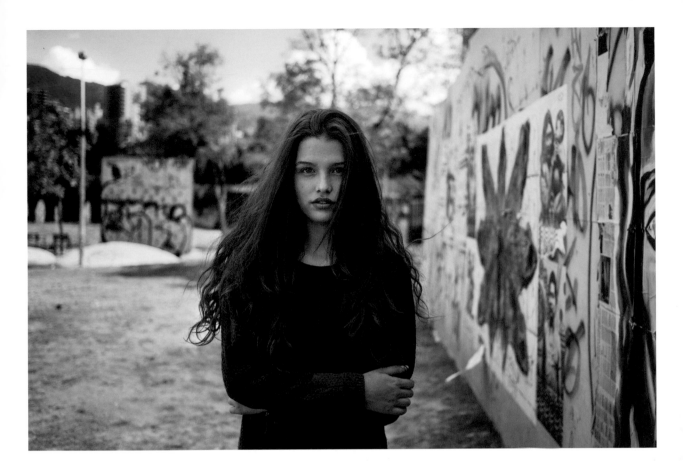

MEDELLIN, COLOMBIA

Medellin is a splendid city, but it's known outside of Colombia mostly for its drug gangs, violence, and its most notorious gangster, Pablo Escobar. It took a while for me to convince Karen of my good intentions when I asked to take her photo.

"I'm always very suspicious when a stranger approaches me in the street. I grew up in this city and I saw its worst faces. My father was murdered by somebody from the Escobar gang, and I grew up being always very cautious."

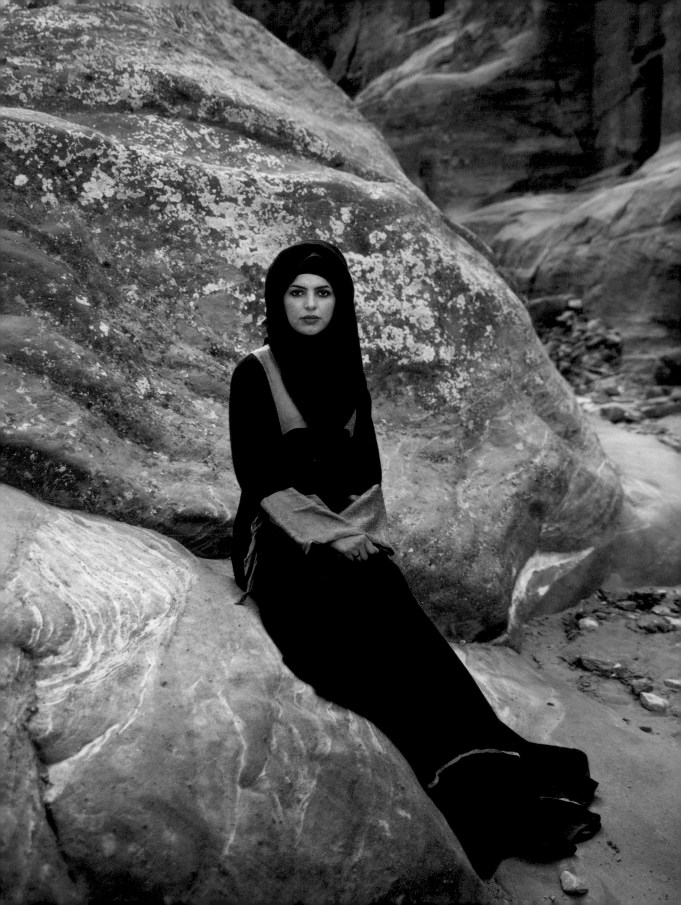

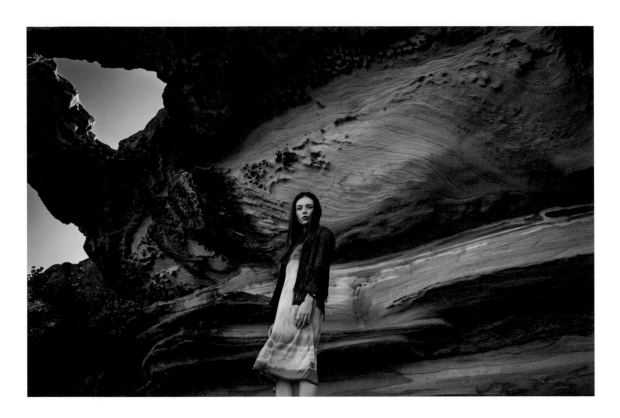

SYDNEY, AUSTRALIA *(Above)*

Claudia, in the beautiful environs surrounding her city.

PETRA, JORDAN *(Opposite)*

This marvelous city was built in the walls of a spectacular canyon more than twenty-three hundred years ago. Over time it has been ruled by many civilizations; its last inhabitants were the Bedouins. When it became a World Heritage Site, all the Bedouins here moved to other locations.

"My parents and grandparents used to live here. My sister was actually born in one of these caves."

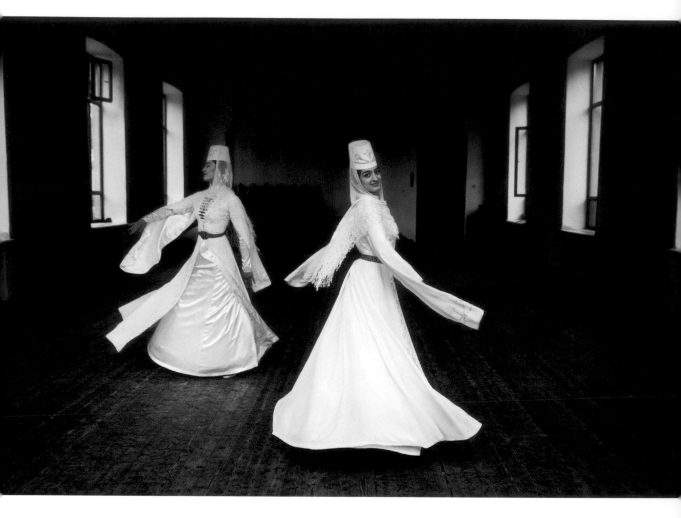

VLADIKAVKAZ, RUSSIA

Traditional Ossetian dance is characterized by smooth circular motions.

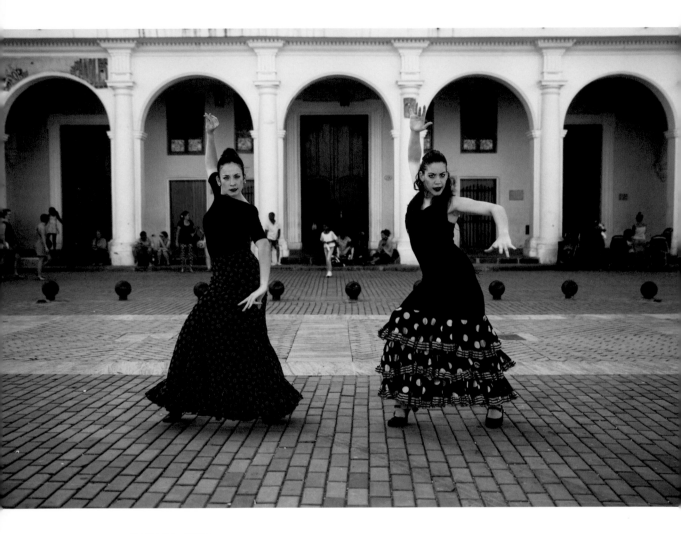

HAVANA, CUBA

Flamenco is a dance with vigorous moves and intense gazes.

EAST JERUSALEM, DISPUTED TERRITORY

Lisa, who is Jewish, teaches in a school for Palestinian chidren. She dreams
of opening her own school someday where both Palestinians and Jews will
learn together.

KURDISTAN REGION, IRAQ

Goshan's parents were Kurdish freedom fighters during the reign of
Saddam Hussein. They immigrated as political refugees to England, where
Goshan was raised. After graduating with a master's degree, she gave up
her life in England to return to the Kurdistan region in Iraq, where she is
now a biology teacher.

*"I grew up feeling a sense of responsibility to help the development of
Kurdistan after such a long period of war and unrest."*

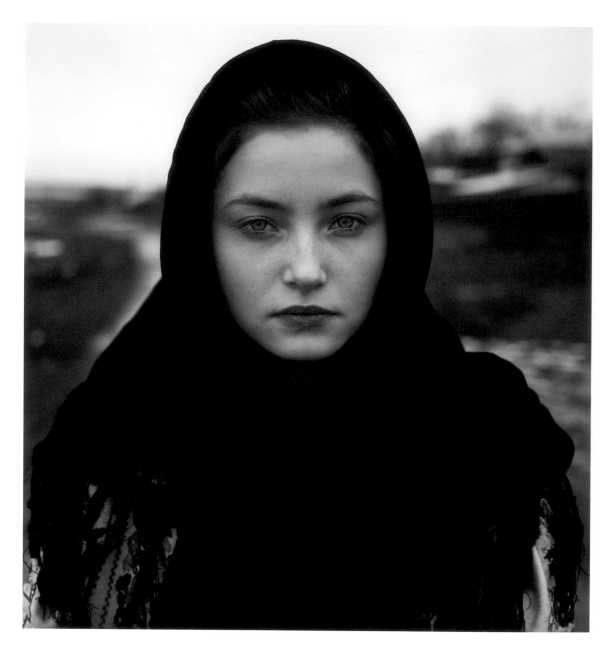

BOTOŞANI COUNTY, ROMANIA

Before each Christmas in this small village, young women like Ema put on traditional dress and join the local folkloric music group. They go into the surrounding towns to sing carols. It's freezing cold, but their voices bring a lot of warmth.

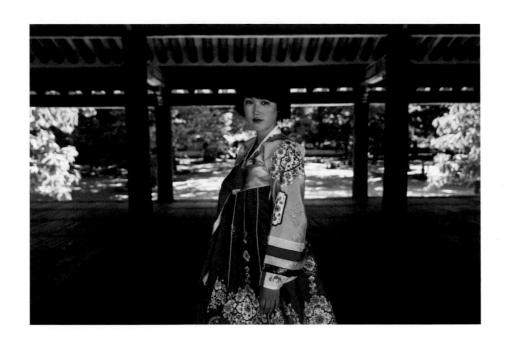

KAESONG, NORTH KOREA

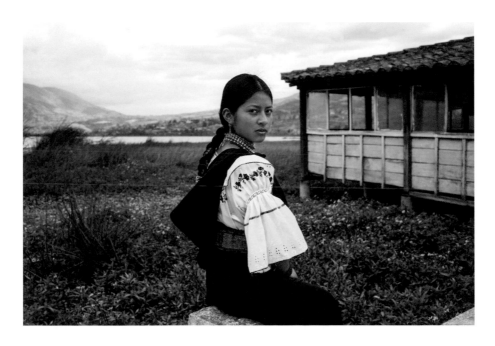

OTAVALO, ECUADOR

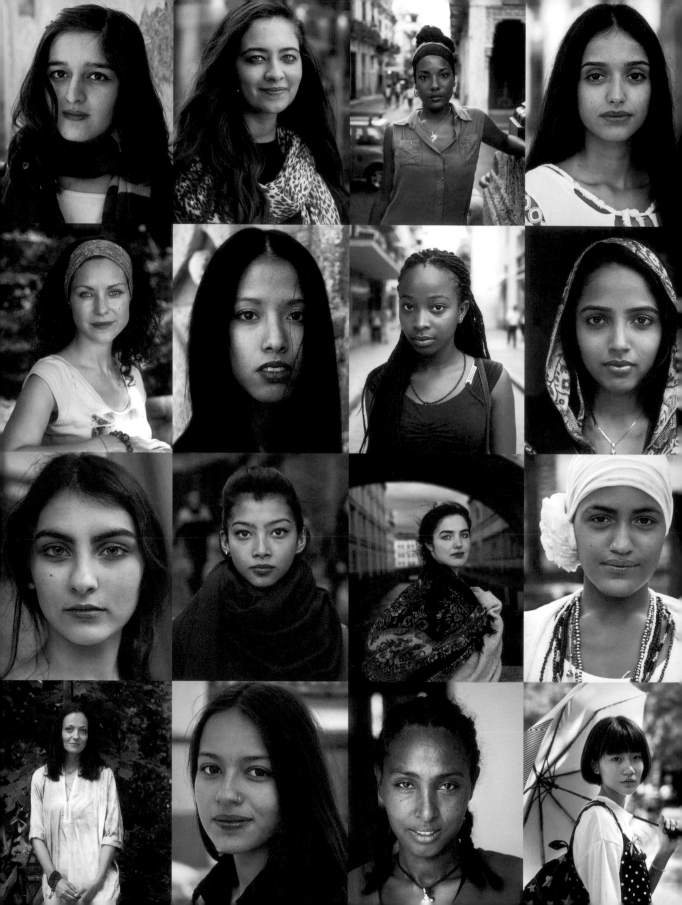

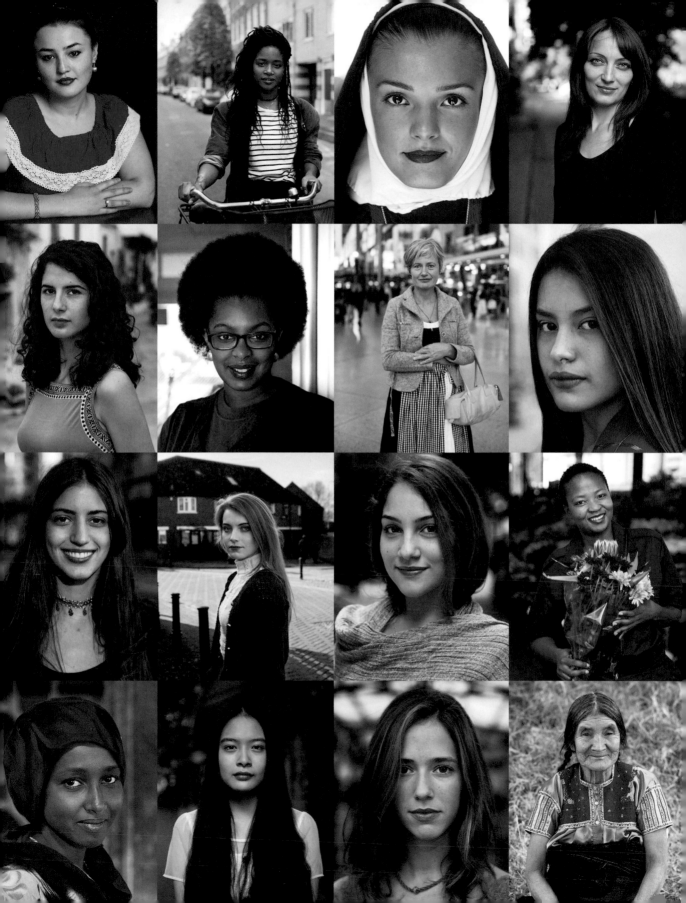

MONTEVIDEO, URUGUAY *(Above)*

Mariana, seventy-three, owns an art gallery. She also has a black belt in martial arts. Very different kinds of art, coexisting in one woman.

BERLIN, GERMANY *(Opposite)*

For many years, Jessica studied and performed ballroom dance. But she felt that both in her life and in the dance hall she needed more freedom from rules and formality. So she started contact dance, a form of movement based totally on improvisation. Now, through this new art, she has freed herself from the pressure of perfectionism.

LOS ANGELES, USA

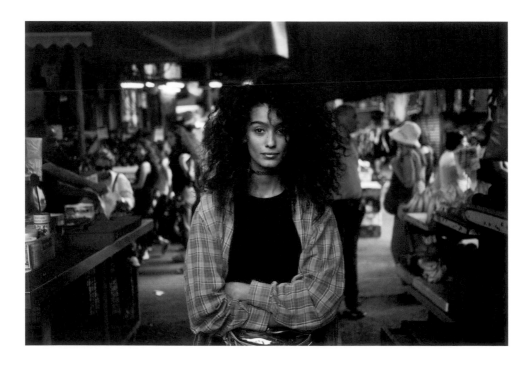

TEL AVIV, ISRAEL

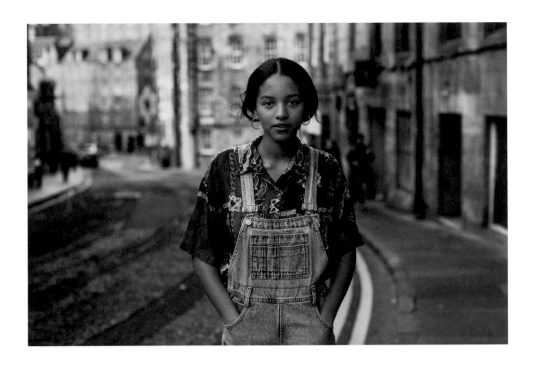

EDINBURGH, SCOTLAND

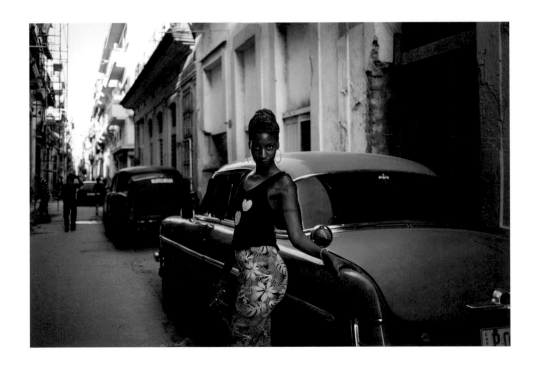

HAVANA, CUBA

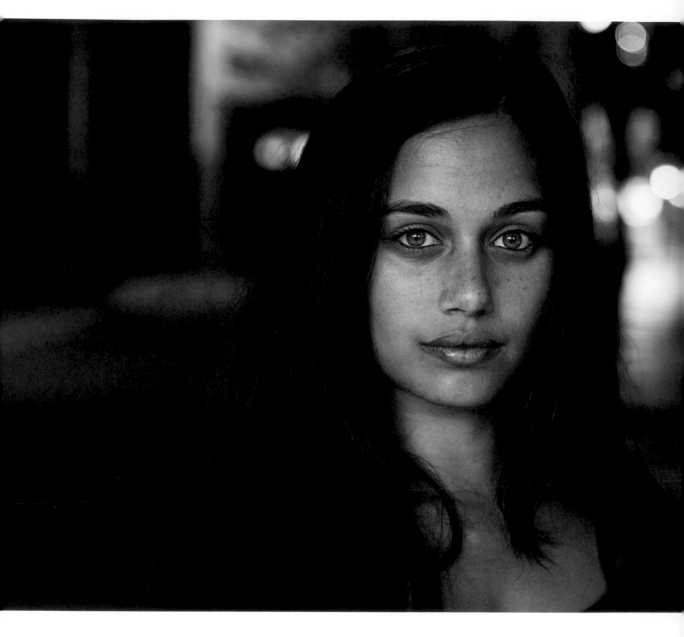

CAPE TOWN, SOUTH AFRICA

A while ago, Jade took out a loan, bought a professional camera, and started to learn photography. She dreams of traveling and taking photos all over the world. I had the same dream—and it came true.

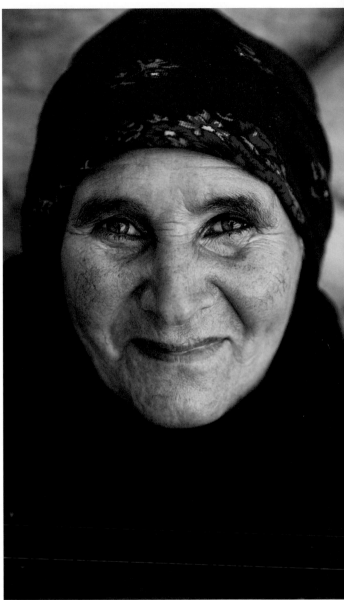

PETRA, JORDAN

Rakhaya, a Bedouin woman, has never left her region. But she has traveled virtually, through the stories of the thousands of foreign tourists that she's met during the past sixteen years. She sells souvenirs in the ancient city of Petra, one of the seven wonders of the modern world.

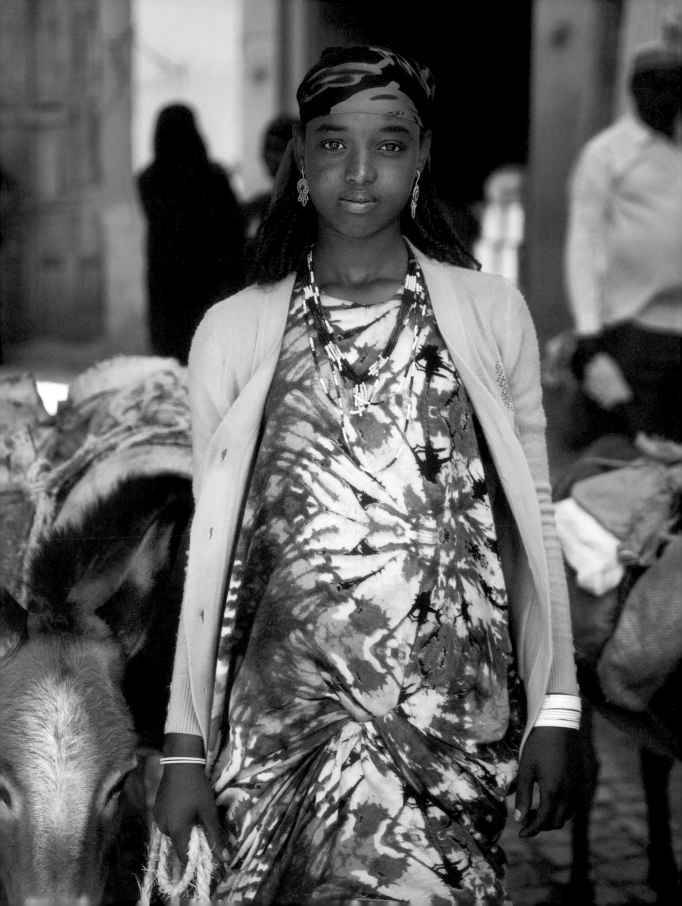

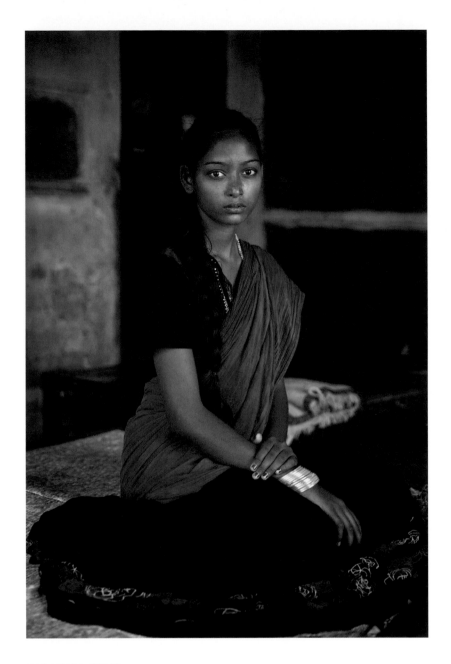

VARANASI, INDIA *(Above)*

I photographed her after a long day of work. She comes each morning from her small village to sell vegetables in this big city. Although she's only fifteen, her family found her future husband two years ago, and the arranged marriage will take place soon. In many parts of the world, girls have to become women at a very early age, without passing through adolescence. You can see the maturity in their grown-up gazes.

HARAR, ETHIOPIA *(Opposite)*

TEHRAN, IRAN *(Previous spread)*

Her name is Mahsa, which means "like a moon" in Persian. When she was an adolescent, her father insisted that she study to become a doctor, but Mahsa was more interested in the arts and she chose to become a graphic designer. She is proud that from the time she turned eighteen, she has been financially independent, and soon plans to open her own firm.

IDOMENI REFUGEE CAMP, GREECE *(Opposite)*

While visiting this camp, I was deeply impressed by the relationship between volunteers and refugees: people from different cultures proving that there need not be any barrier between them, as long as tolerance and kindness are embraced by both sides. I met many amazing people who left their comfortable lives to come and help other people who are in a desperate situation. Alice is a volunteer from the United Kingdom, and this Kurdish little girl is from Syria. Moments like this give me hope for the world.

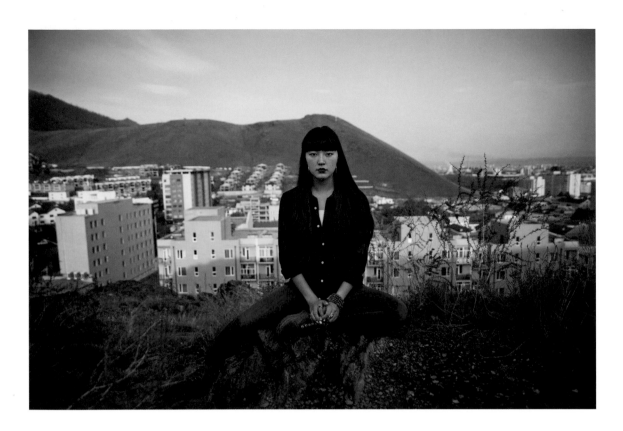

ULAANBAATAR, MONGOLIA *(Above)*

When thinking about this country, you might imagine yurts and herds.
But there is also modern Mongolia with people like Namoon, who
studies philosophy.

SULAYMANIYAH, IRAQ *(Opposite)*

Rawesht, who works in a local television station, is also the embodiment
of the young modern generation of her country.

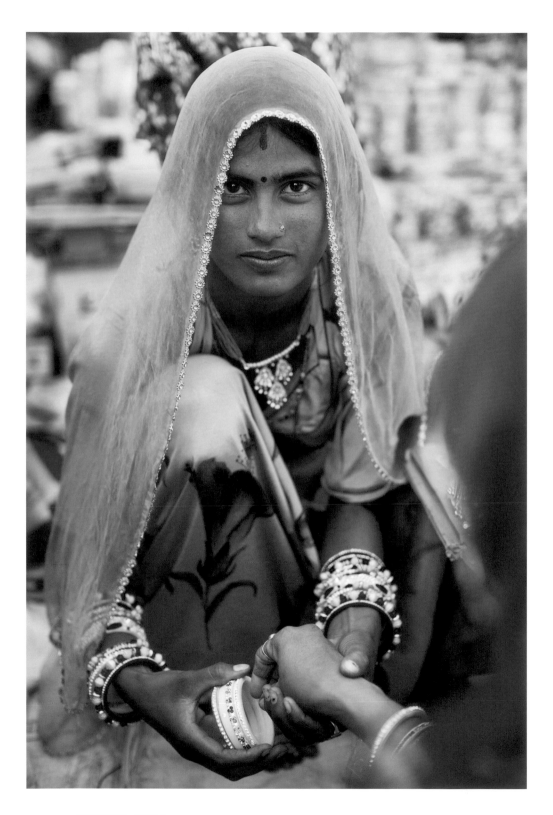

JODHPUR, INDIA

AWASH, ETHIOPIA

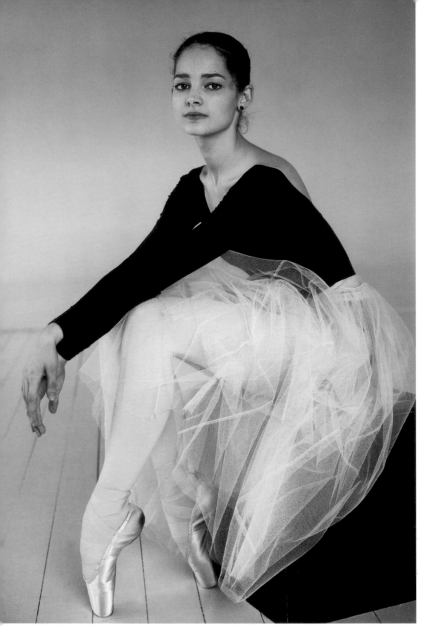

SAINT PETERSBURG, RUSSIA

Eleonora studies ballet at Vaganova Academy, which is among the world's most prestigious. Her extreme effort and willingness to forgo free time is not typical for an adolescent. But when she dances, she soars. Her colleagues and professors told me she is considered the best in the school and could someday be among the top ballerinas of her time. But Eleonora is too modest to agree with them.

"I don't want to think about how good I am. In ballet, everything is so fragile. A simple injury can end your career in a second."

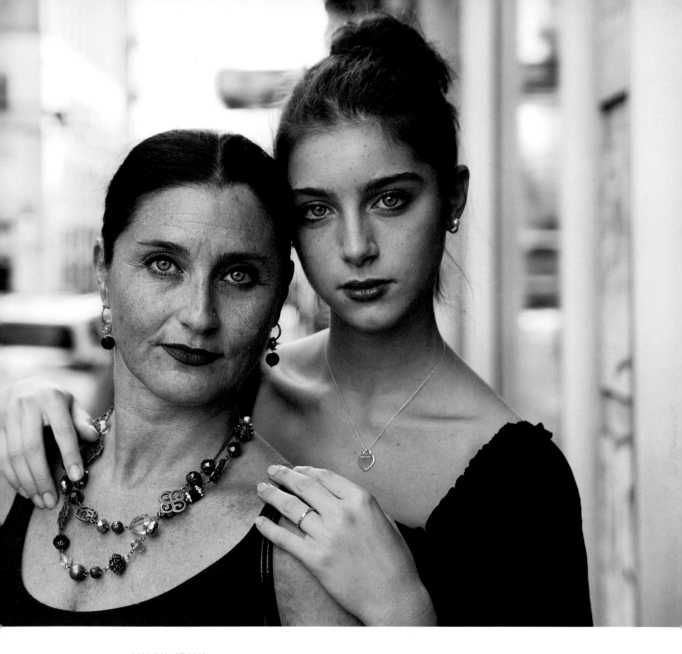

MILAN, ITALY

Caterina began dancing when she was three years old. Her mother, Barbara, was supportive, but knew that there were few opportunities to study ballet in their small town so, although her husband and son stayed behind, she moved with Caterina to Milan, where her daughter could fulfill her dream and attend one of the most esteemed schools in the world. Art requires huge sacrifices, but imagine how Barbara feels today seeing Caterina dancing on the celebrated stage of La Scala.

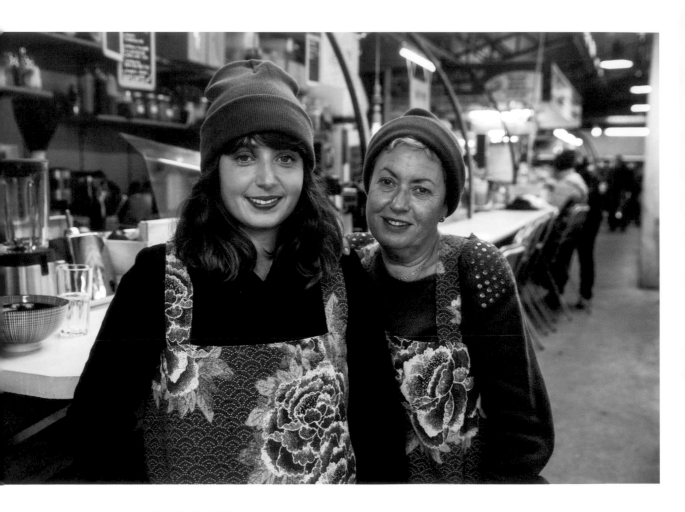

PARIS, FRANCE

At this vegetarian food stall, Tatiana, the mother, cooks the savory foods, while Tonia, her daughter, prepares the sweets. At the end of the day, they are both exhausted, but appeared genuinely happy to be working together in such a complementary way.

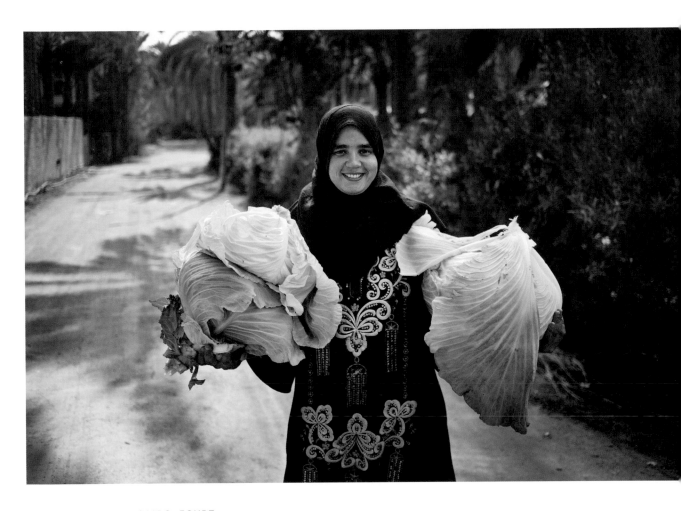

CAIRO, EGYPT

She was going home to prepare stuffed cabbage rolls, known here as
mahshi kromb, for her large family.

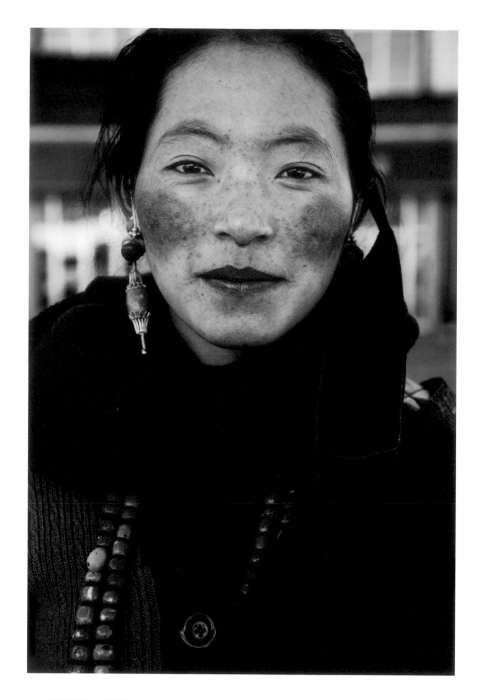

SICHUAN PROVINCE, CHINA

Most Tibetans live at high altitude, where flushed cheeks are common because of the harsh climate. To me, this looks like stunning natural makeup.

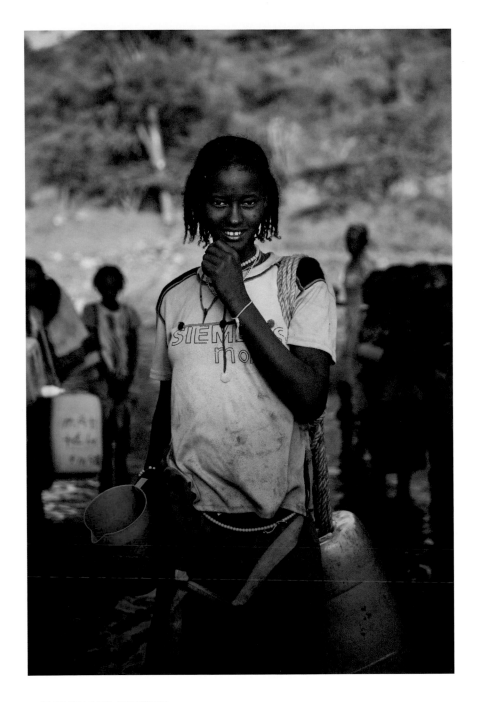

OMO VALLEY, ETHIOPIA

She walks for many miles every morning to get water from the river, a job that falls to the women in this region. But she is grateful; in other parts of the country, the drought has had dramatic consequences. There are places on our planet where water is pure gold and people struggle to have it. To me, it's incredible how much humanity and beauty can be found inside these hardworking people.

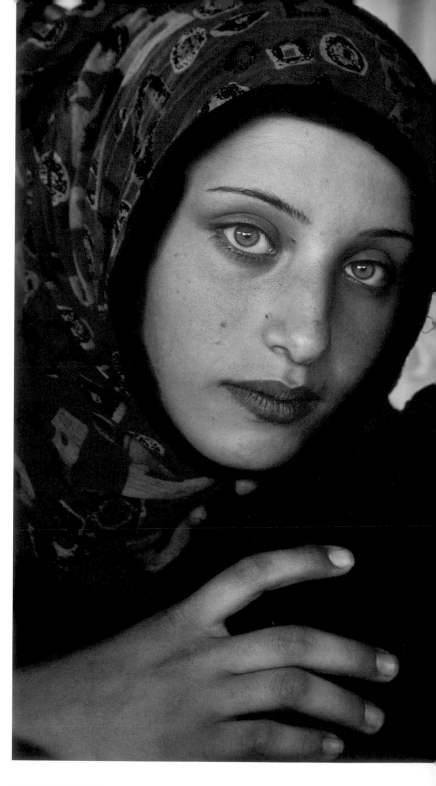

IDOMENI REFUGEE CAMP, GREECE

This woman and her daughters fled the war in Syria.

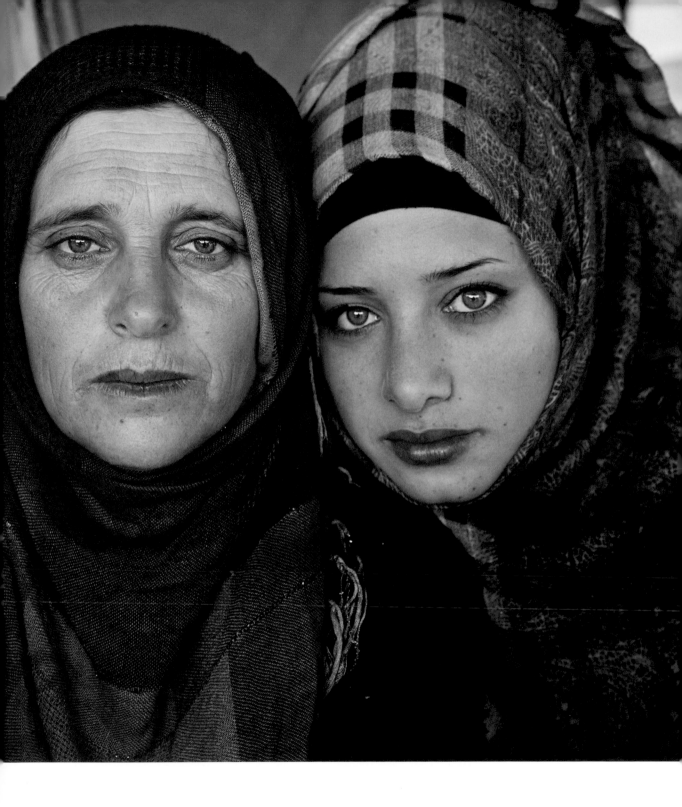

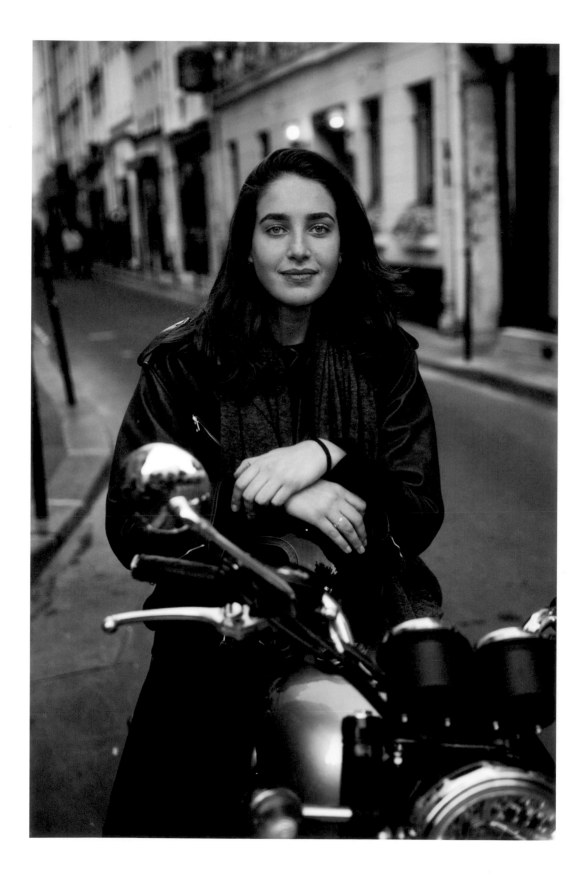

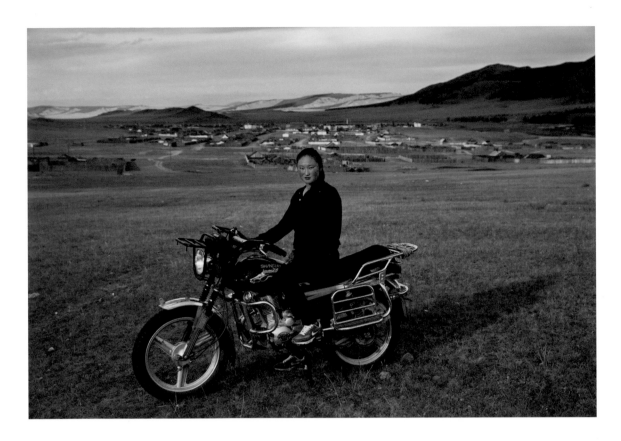

CENTRAL MONGOLIA *(Above)*

When I asked to take her picture, she told me to jump on the back of the motorcycle (see page 4) to show me the best view over her small town.

PARIS, FRANCE *(Opposite)*

Camilla recently became a motorcycle rider, a fact she is trying to keep her father from finding out. I asked if I should keep her photo off of my Facebook page.

"I love riding, but I think my father would be very angry if he knew. Don't worry, he's not on Facebook."

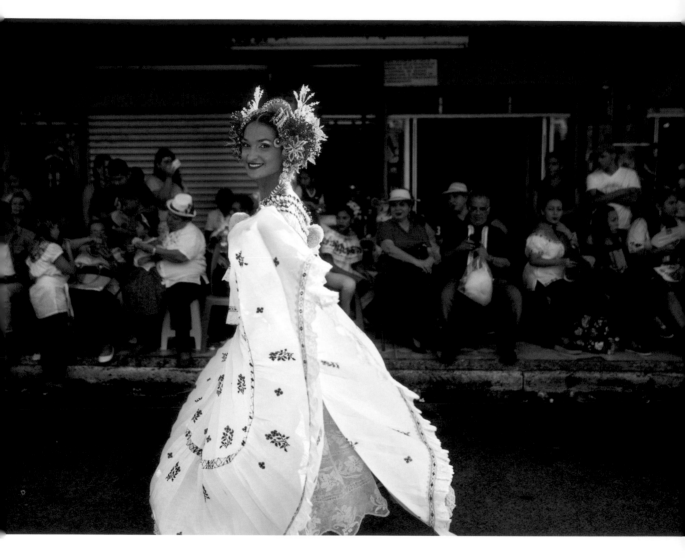

LAS TABLAS, PANAMA

Panamanian women are really proud of their traditional dresses called *polleras*. The most beautiful can be seen during popular festivals. The diversity is huge and some *polleras* can cost many thousands of dollars and take up to a year to create.

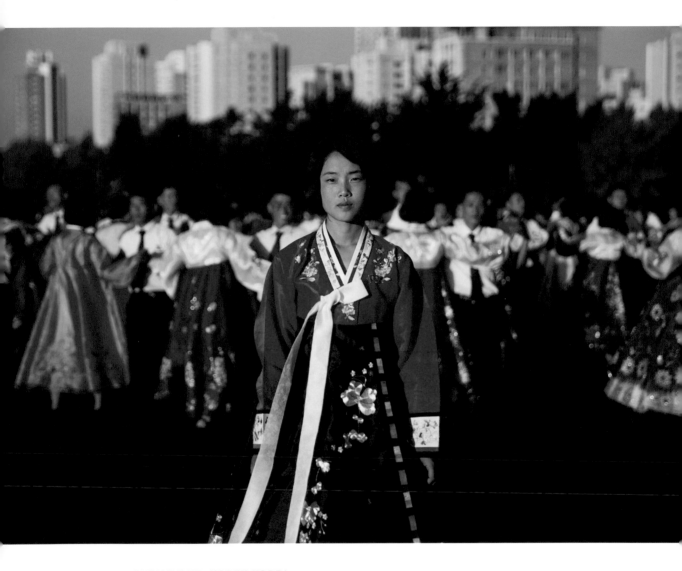

PYONGYANG, NORTH KOREA

During national celebrations, hundreds of people gather in huge squares all over the country and dance in a perfect synchronization. In a society without a lot of media and modern forms of entertainment, dancing remains a popular activity for leisure, and as a form of connection.

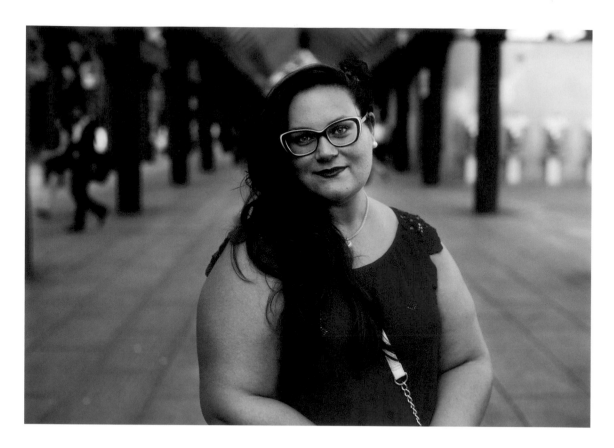

MILAN, ITALY *(Above)*

At first, Laile didn't want me to photograph her because she said she is not beautiful enough. Once she agreed, I posted this photo online hoping to show her how beautiful she is; it got more than twenty-two thousand "likes." These were just a few of the comments:

"She's a heartbreaker"

"Sister, you are strikingly beautiful"

"You're rocking it, girl"

KATHMANDU, NEPAL *(Opposite)*

She was walking with her son. She didn't speak English, but he did. So I told him I wanted to photograph his mother. And he asked me why. "Because she's beautiful."

He proudly smiled and looked at his mother. "Yes, she is."

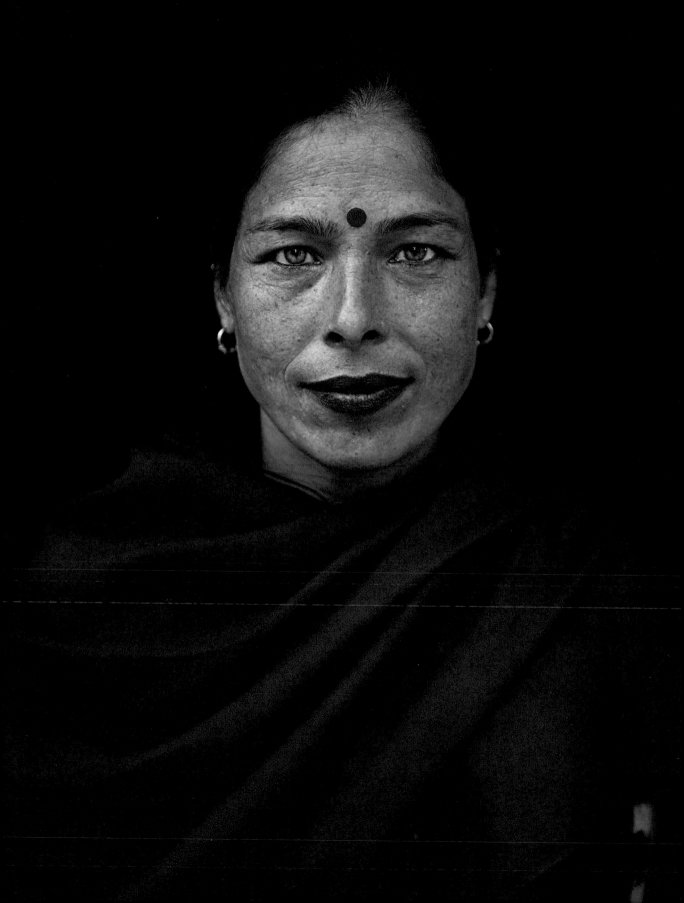

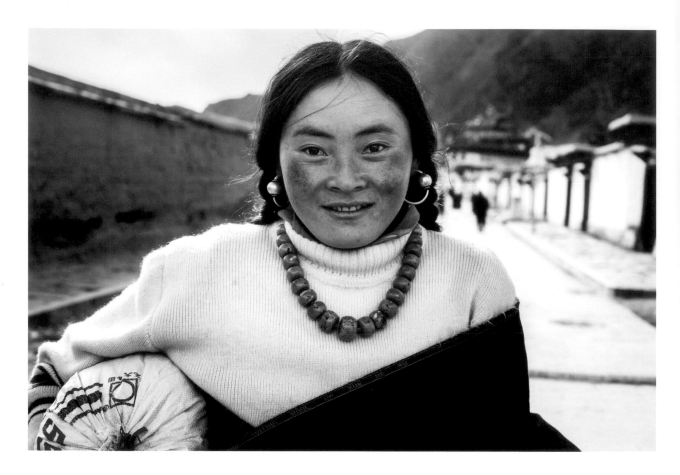

XIAHE, CHINA

This Tibetan woman made a long trip to visit Labrang Monastery,
one of the most important sites for Tibetan Buddhism.

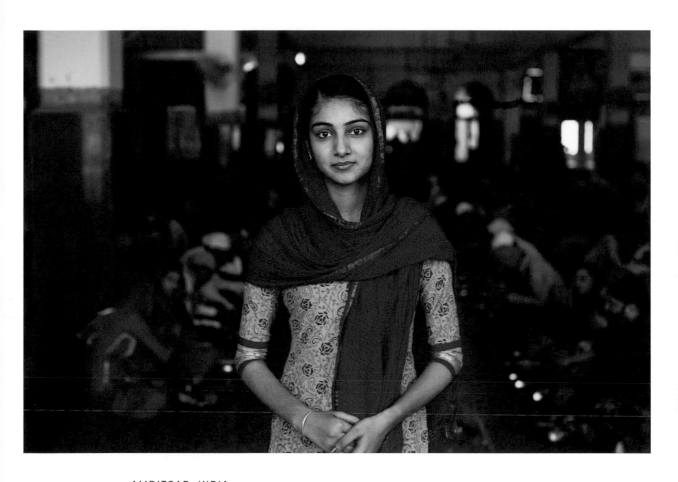

AMRITSAR, INDIA

This woman was on a long trip to visit the Golden Temple, a holy site of her religion, Sikhism.

PARIS, FRANCE *(Top)*

Léonie is from Germany but moved to Paris
to become a chocolatier.

BYRON BAY, AUSTRALIA *(Bottom)*

Saisha is from Hawaii but was living in Australia
in order to study sustainable agriculture.

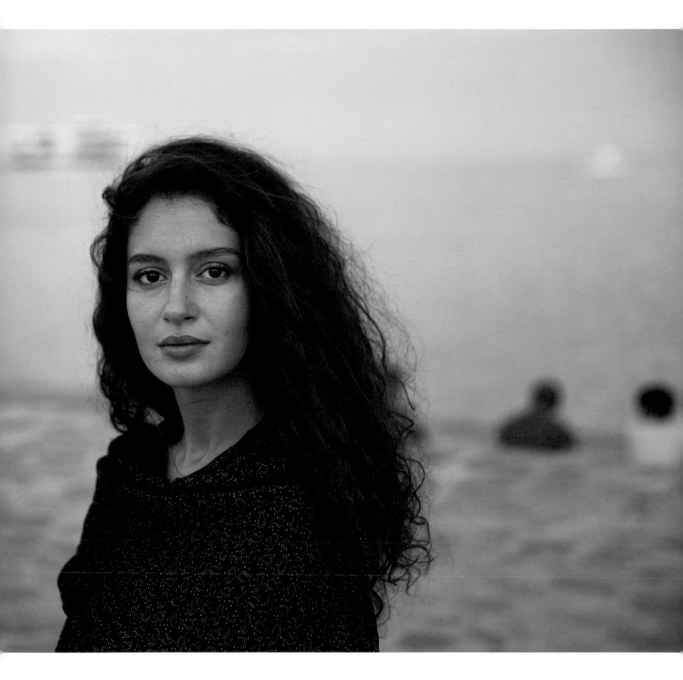

BAKU, AZERBAIJAN

Azerbaijan law grants equal rights between men and women, but in reality there are still many couples where the husband decides things for his wife. Some women told me that they would need permission from their husbands if I wanted to photograph them. But Fidan is one of the amazing women who is helping to change cultural norms there.

"I would never be in a relationship where I wasn't treated equally and respected."

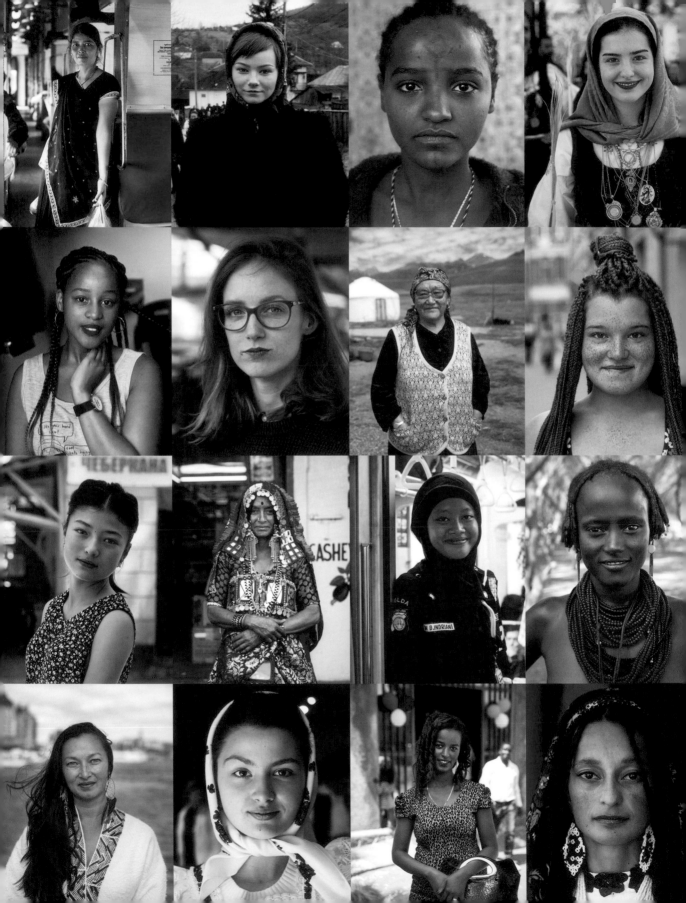

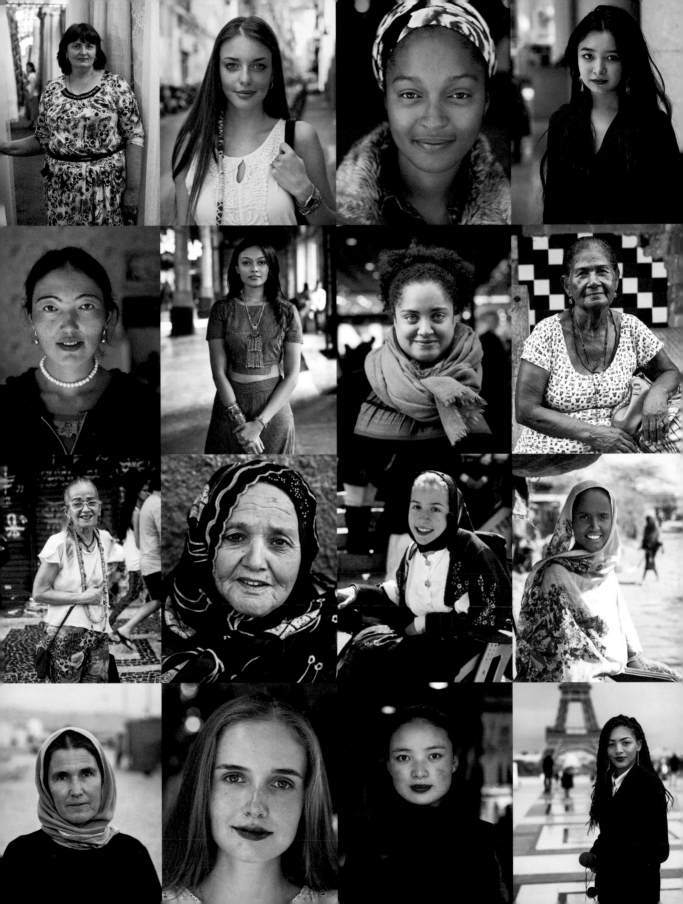

AMSTERDAM, NETHERLANDS *(Above)*

Meike is a medical student.

"My grandfather was a doctor, my father is a doctor, and I will also be a doctor. Not because it is a family tradition, but because I believe this is the best way to help people."

MUMBAI, INDIA *(Opposite)*

Stella was close to her one-hundredth birthday when I met her. Imagine a century of history seen through these beautiful eyes.

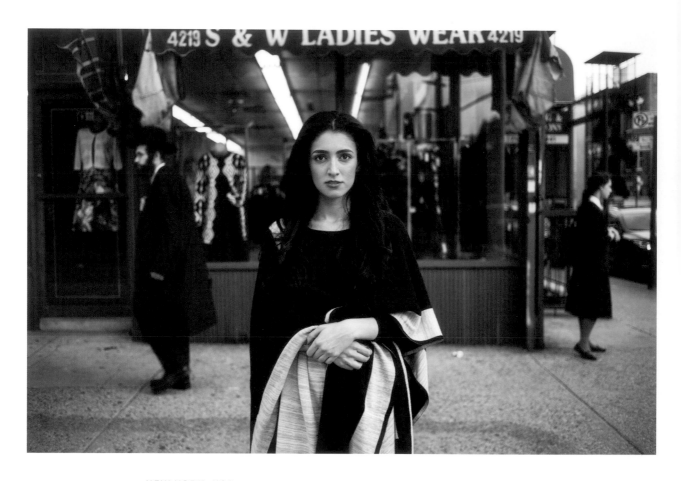

NEW YORK, USA

Mushkie comes from a traditional Jewish family. After studying sociology, she became a pre-kindergarten teacher.

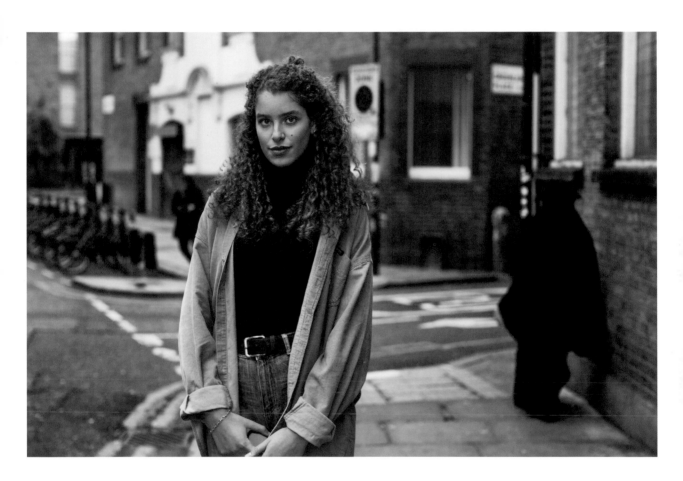

LONDON, ENGLAND

Mena studies genetics, and is proof of how small the world has become.

"I was born in Egypt, I live in Netherlands, I study in Wales, and now I am traveling in England."

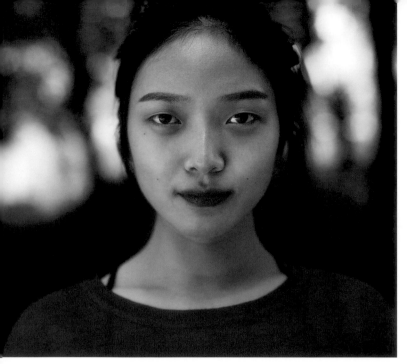

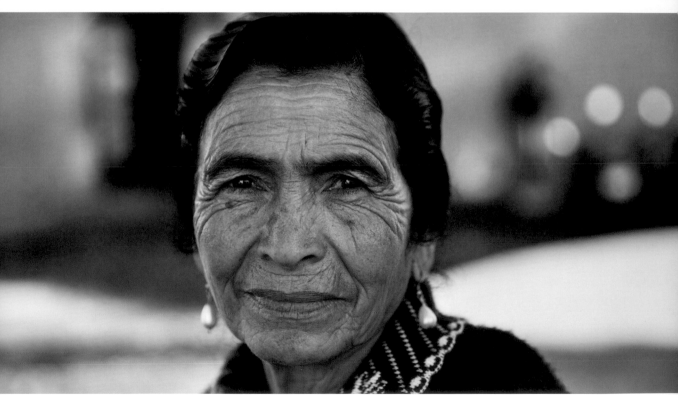

CHENGDU, CHINA *(Top left)*

HAVANA, CUBA *(Top middle)*

ANTIGUA, GUATEMALA *(Bottom)*

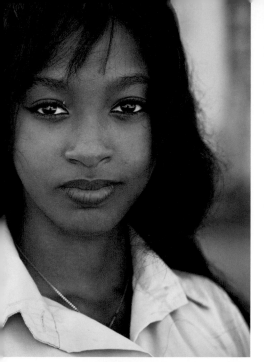
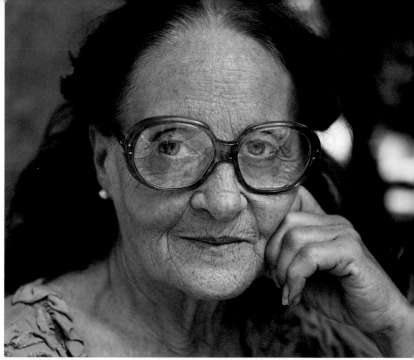
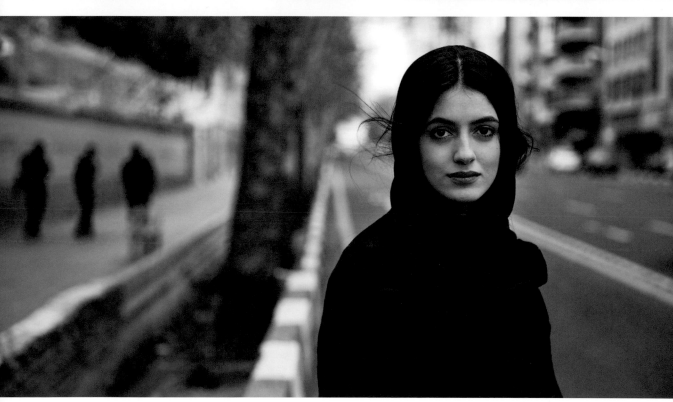

BUENOS AIRES, ARGENTINA *(Top right)*

TEHRAN, IRAN *(Bottom)*

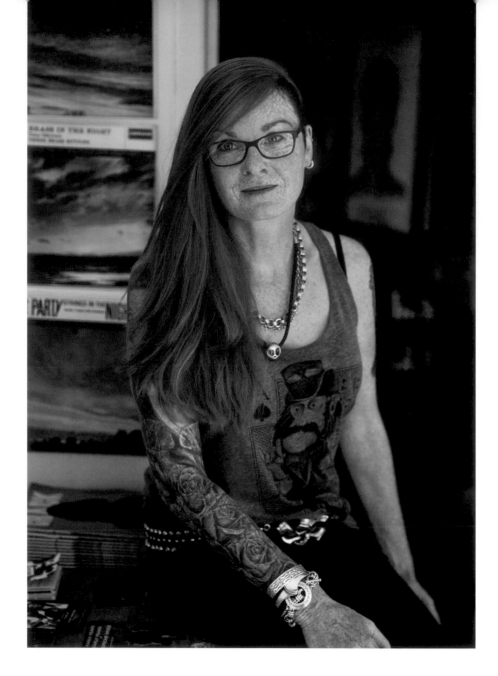

BERLIN, GERMANY *(Above)*

Grit became a punk in the 1980s, growing up in East Germany. Today she works as an accountant, but music is still her greatest passion. She is proud of her tattoos, especially the ones on her arms of David Bowie and Nick Cave.

ISTANBUL, TURKEY *(Opposite)*

On Istiklal Avenue, a busy pedestrian shopping street, you can see every type of outfit, from the most modest religious covering to piercings and tattoos, as on this young woman.

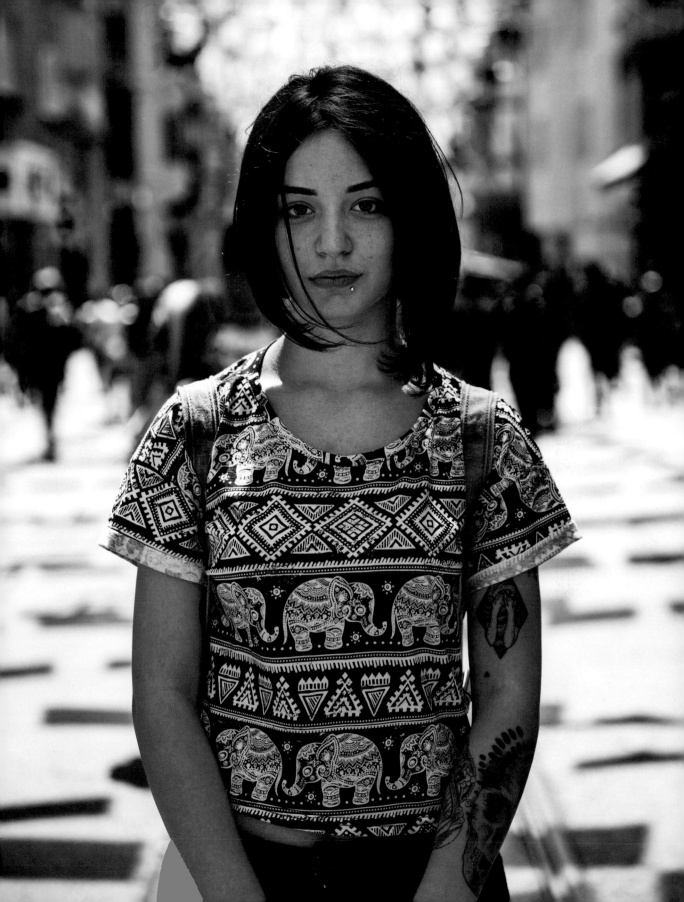

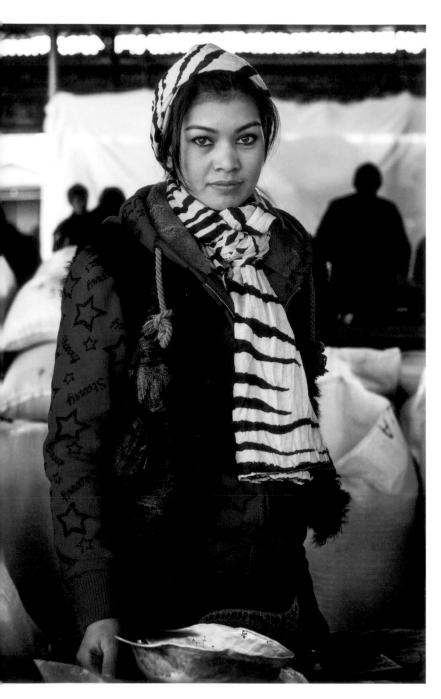

TASHKENT, UZBEKISTAN

I love to wander the markets of the world and see the beauty that can go unnoticed. She was selling rice in the central market of her city.

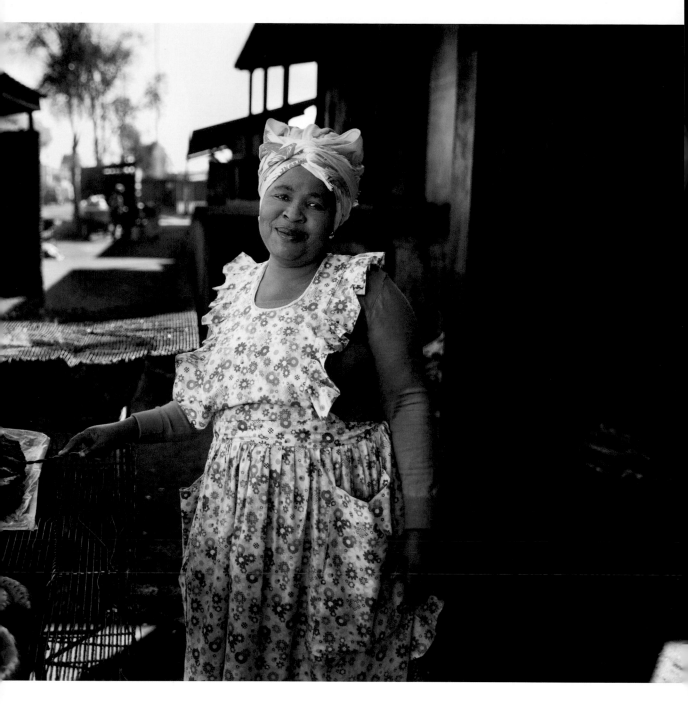

CAPE TOWN, SOUTH AFRICA

While visiting one of the slums of the city, I was fascinated by the gentleness
of this lady in such a rough environment. For nearly thirty years, she has been
selling meat every day, in exactly the same place.

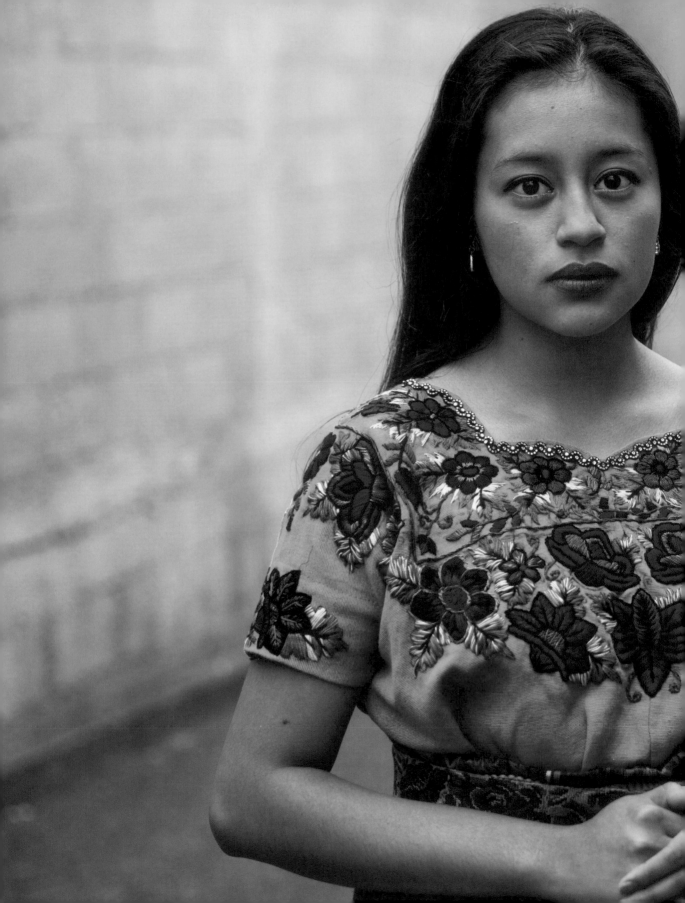

RIO DE JANEIRO, BRAZIL

Caroline is a graphic designer. I noticed her next to a group of homeless people. They were talking and having fun together, like very good friends. Even in what seemed to be difficult situations, I often saw Brazilians smiling.

"I visit them every day. I bring them food, clothes; I try to make their life better in any way I can. We live hard times in Brazil and I know tomorrow it could be me in their place."

SAN ANTONIO AGUAS CALIENTES, GUATEMALA *(Previous spread)*

Marcy is from a small town, renowned for its weavers. These proud descendants of Mayan civilization have a great sense of color and a strong desire to keep their culture alive through their clothing.

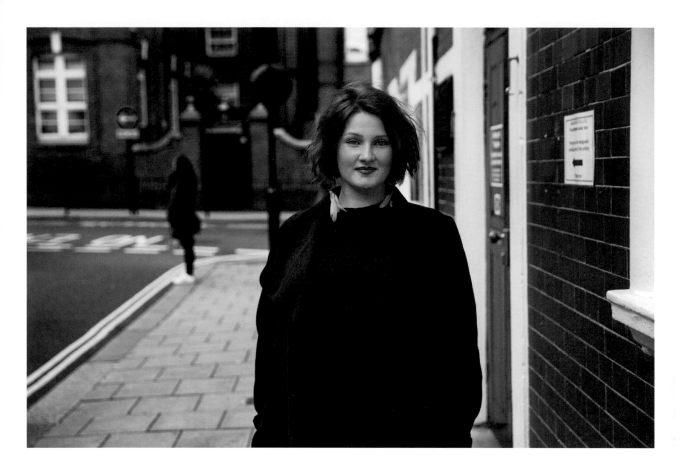

LONDON, ENGLAND

Antonia is a cancer survivor.

"I was twenty, and a workaholic. I was super-ambitious, but at the same time really exhausted. I was working hard at two different jobs to have a luxurious lifestyle and afford expensive vacations. But I wasn't actually enjoying life at all. Then I started to feel ill. I was initially misdiagnosed but then the terrible news came: cancer.

The following months were very painful, but my family was incredible and supported me a lot. After I was cured, everything changed. Now I wake up happy and appreciate every single moment of my life. I spend much more time with my family. I'm still busy, but I'm enjoying my new activities. I started to study again, I'm involved in many charities, and I try to give back to life. This disease actually opened my eyes."

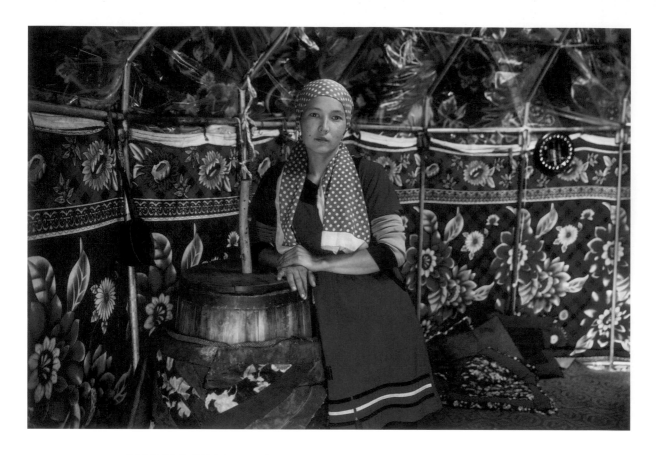

SUUSAMYR VALLEY, KYRGYZSTAN *(Above)*

This young woman is a nomad living in a yurt. She and her family raise horses in the wilderness to produce *kumis*, a fermented dairy product made from mare's milk. For me, horse milk tasted very strange, but it has a great reputation in Central Asia as a panacea.

NAPLES, ITALY *(Opposite)*

Serena makes these little horns, "Cornicelli," which are ancient good-luck charms popular in Naples and parts of southern Italy. Here, I discovered a fascinating city full of traditions, where most people have strong ties to family.

"This small workshop was opened by my parents. Now my sister and I continue the tradition. I make the horns here and she sells them downstairs, where we have a store."

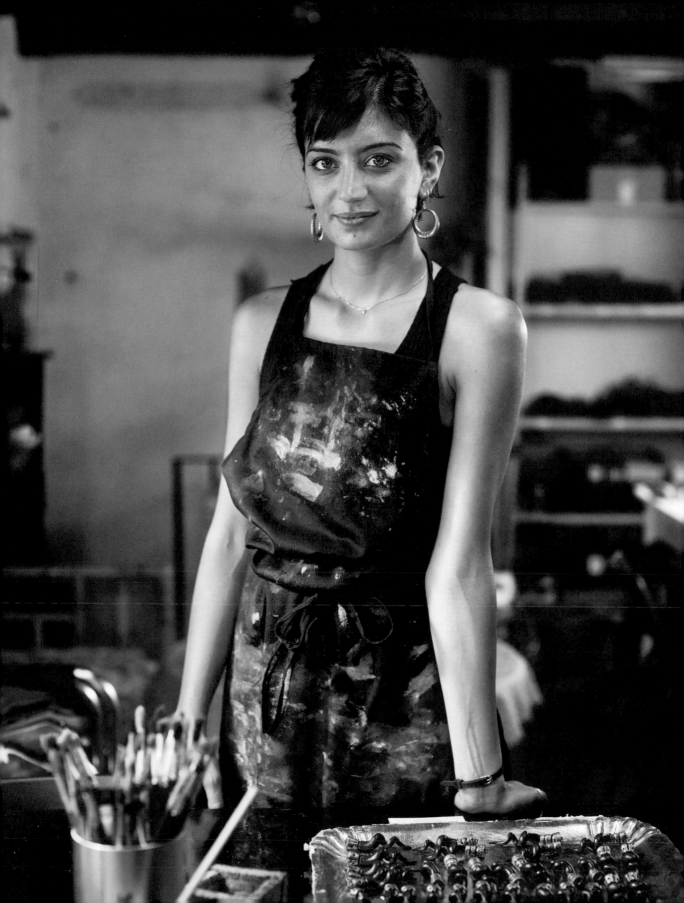

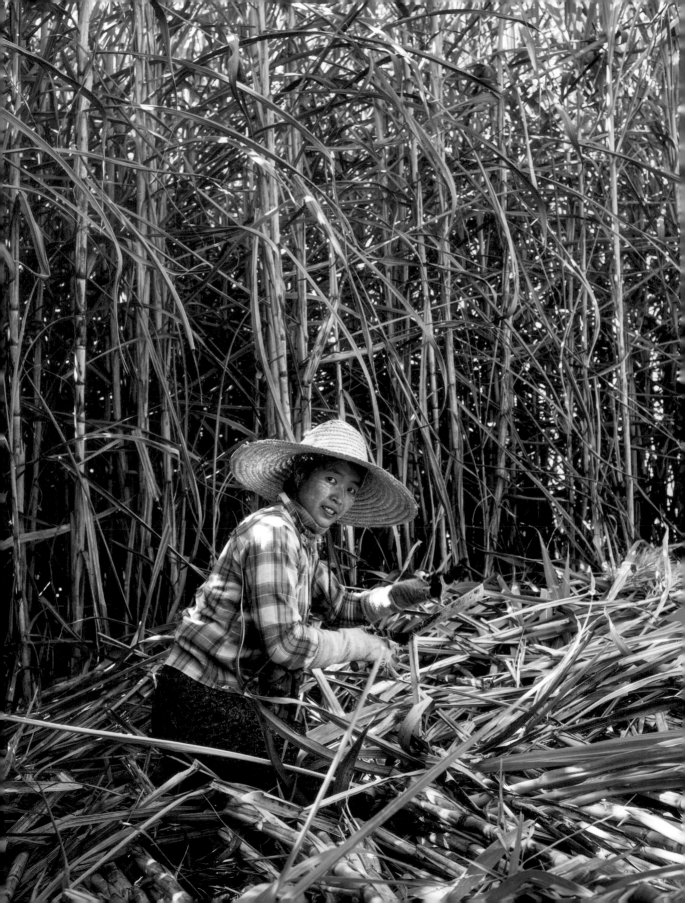

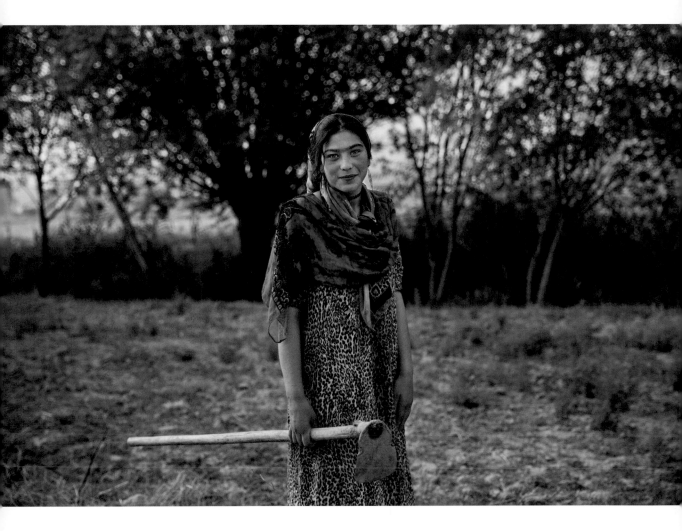

NEAR DUSHANBE, TAJIKISTAN *(Above)*

INLE LAKE, MYANMAR *(Opposite)*

RIO DE JANEIRO, BRAZIL

Vera was running along Copacabana beach. At age seventy-six, she runs between six and ten miles every two days.

"I started only four years ago, and it changed my life. Really sorry, but I have to go now."

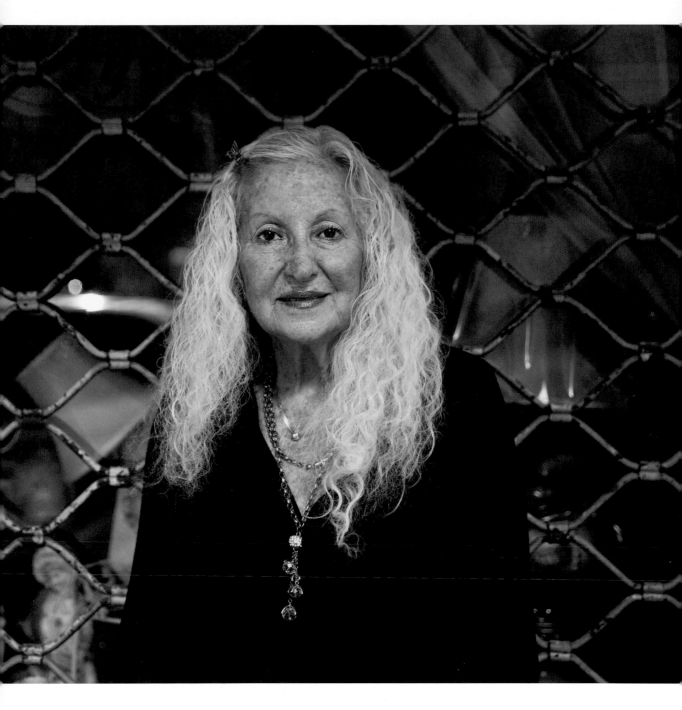

HAIFA, ISRAEL

In the golden stage of life, Ilana is fascinated by old objects and has a cozy antique store.

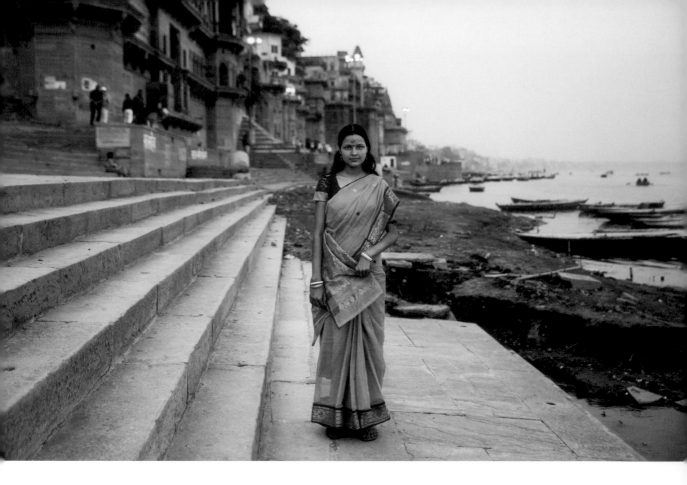

VARANASI, INDIA

Nowhere else have I seen so many colorful outfits. Saris are worn every day by most Indian women.

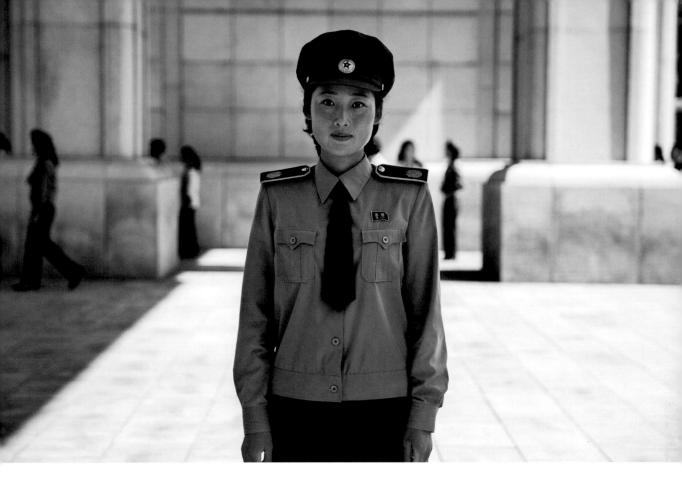

PYONGYANG, NORTH KOREA

Rarely have I seen such a concentration of uniforms; they are everywhere in this society. This woman was a guide at a military museum.

CAPE TOWN, SOUTH AFRICA *(Next spread, left)*

After years of practicing, Emma believed her dream of becoming a professional dancer was in reach. So singularly focused on her art, she had long ignored a pain in her neck, but when it became unbearable she went to a doctor. The diagnosis ended her career path. But nothing can take her passion from her.

"I know I will still dance eventually, although just for fun!"

DELHI, INDIA *(Next spread, right)*

In the streets of this city, traditional India, where women wear colourful saris, meets contemporary India with women, like Sneha, dressed in modern clothes.

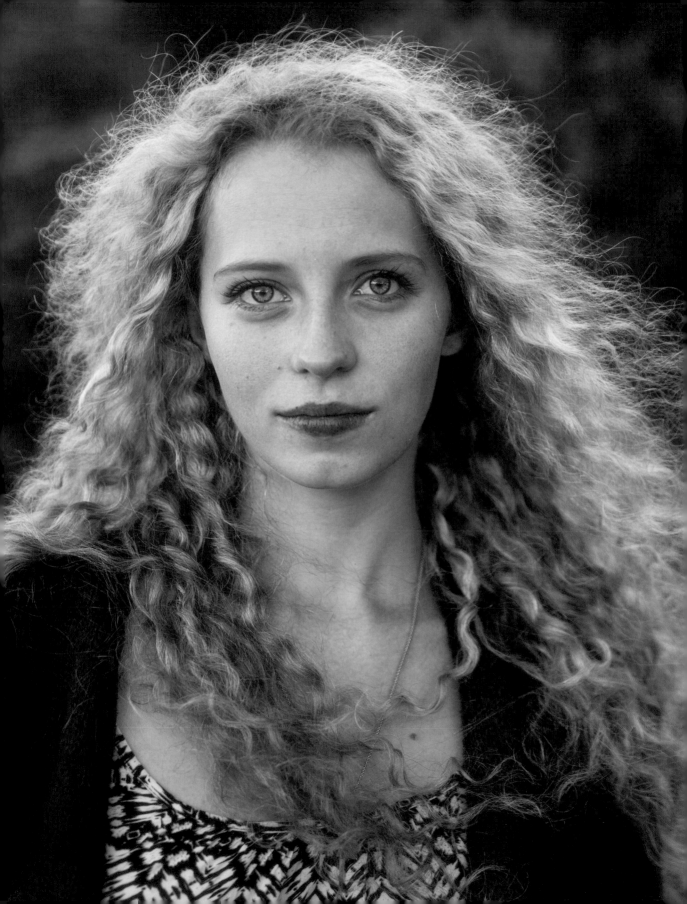

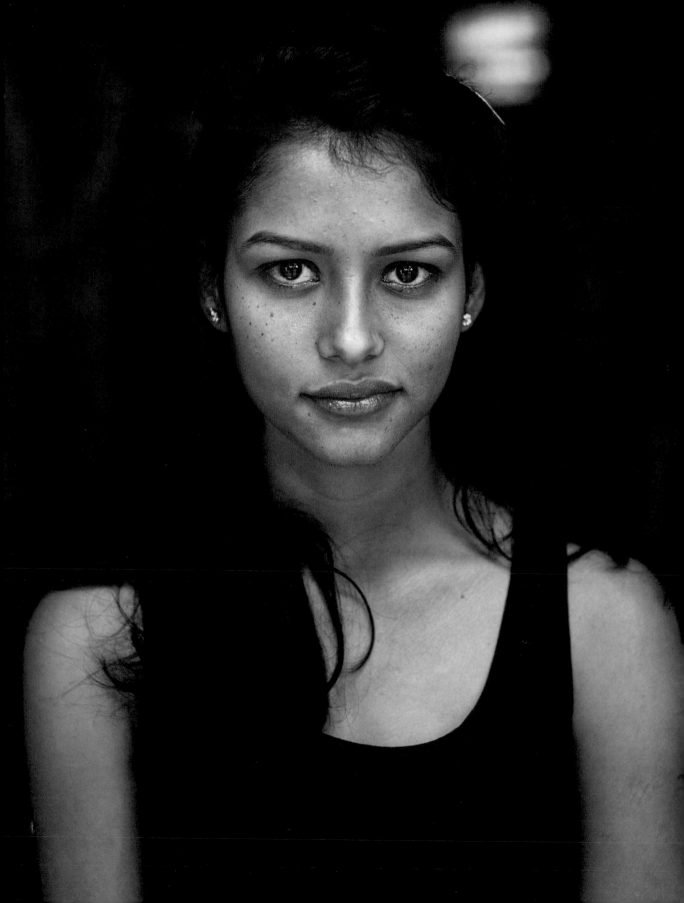

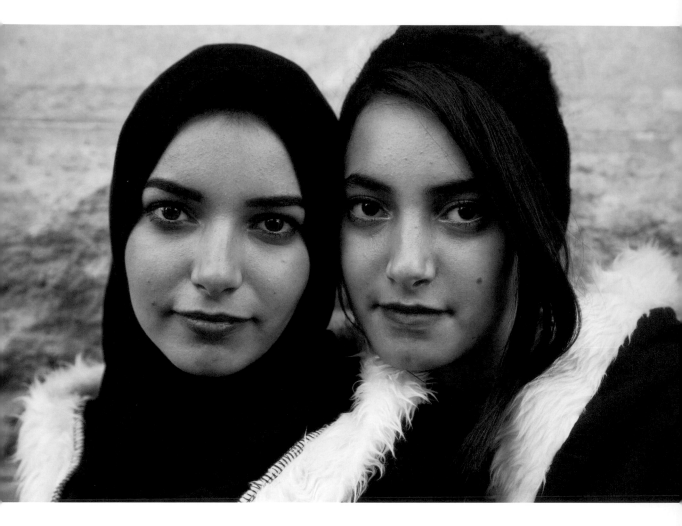

AMMAN, JORDAN

Rawan and Razan are sisters. They are Muslim, and while Rawan chooses to wear the hijab in her daily life, Razan prefers not to. In the end, it should be a matter of free choice for every woman.

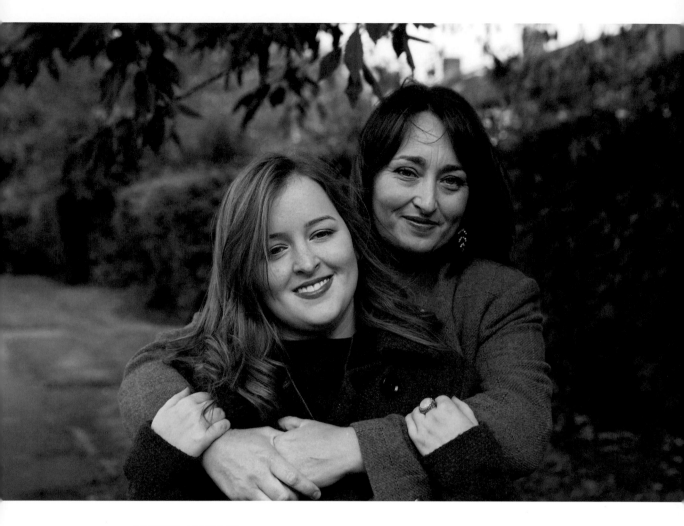

LONDON, ENGLAND

Emily, Emma's daughter, was diagnosed as an infant with a rare congenital condition called septo-optic dysplasia, which affected her endocrine system and left her virtually blind. She also suffered from anorexia as a teenager. But she had an optimistic personality and, with the help of her mother, Emily excelled in school and now is studying English literature on a scholarship. She also runs a blog to combat myths about people with vision loss. Most of the stories that she shared were life lessons for me.

"Once, in school, when a group of girls who used to bully me were struggling to study for a test, I offered to help. We reconciled, worked together, and they passed. At the prom, we all danced and had a great time."

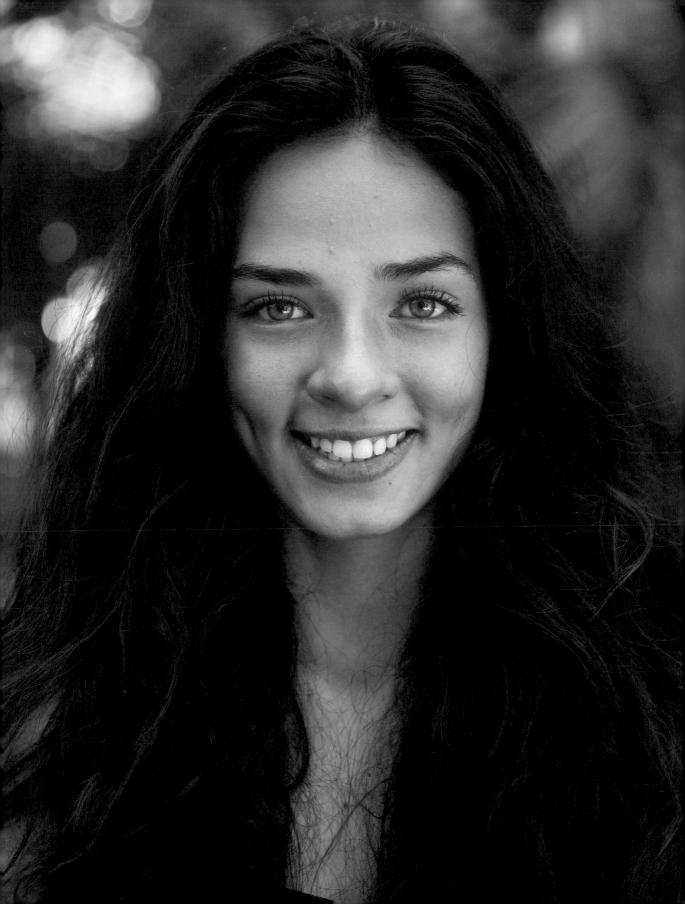

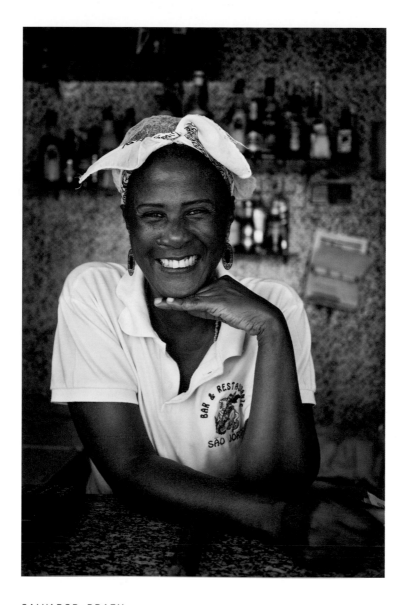

SALVADOR, BRAZIL *(Above)*

RIO DE JANEIRO, BRAZIL *(Opposite)*

Traveling here was a real life lesson for me. The country has so much poverty, violence, and suffering, but Brazil doesn't forget to smile, to dance, to be kind and warm-hearted, even in the most difficult moments, like the economic crisis that followed the boom years. Suelem was born in a Rio de Janeiro *favela* (slum), then sent to live with her aunt in São Paulo to escape the poverty. She moved back, and now works seven days a week in an accessories shop, but hopes for more in her future.

"I dream of moving to the United States to become a cheerleader."

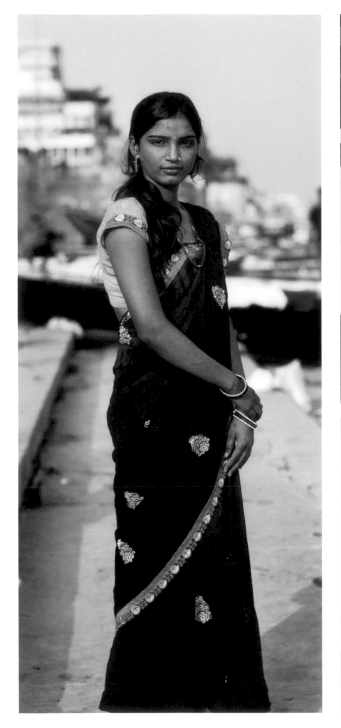

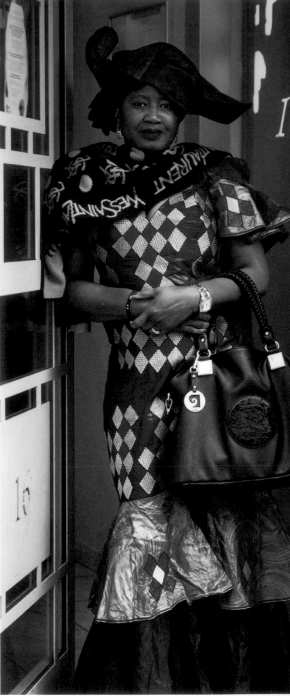

VARANASI, INDIA

PARIS, FRANCE

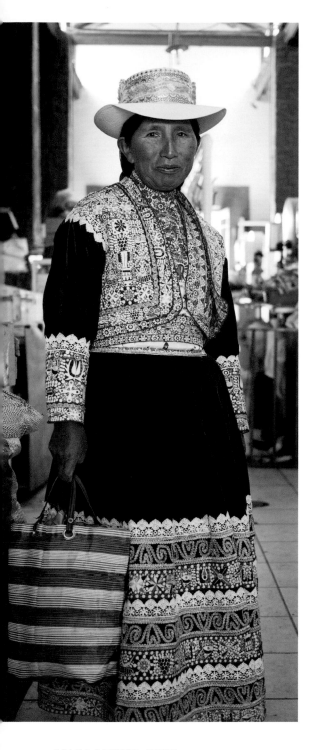

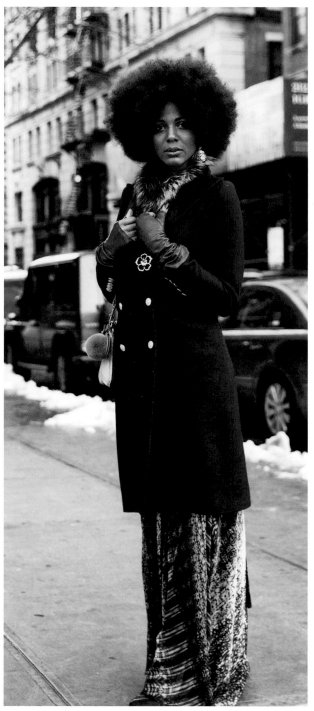

COLCA CANYON, PERU

NEW YORK, USA

STOCKHOLM, SWEDEN

Gita is a life coach and the proud mother of two daughters. At fifty-four years, she feels young and she told me that she is enjoying the best time of her life. I was having a bad day until I met her, but her serene presence and wisdom put me in an optimistic mood.

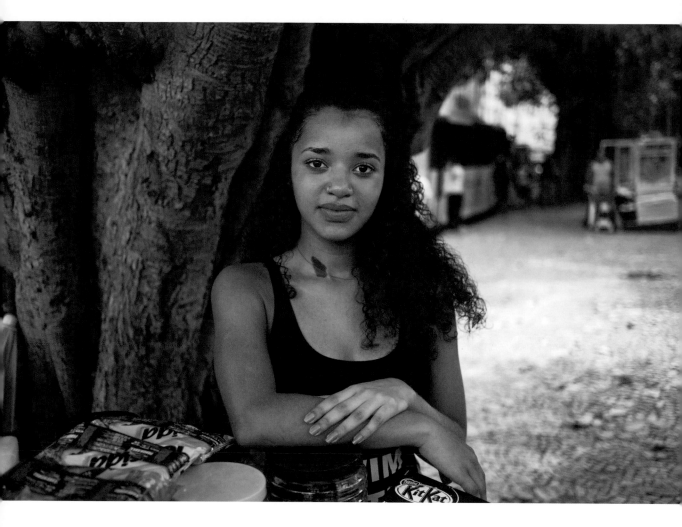

RIO DE JANEIRO, BRAZIL

Luoana recently started this small business, selling snacks in a small park.

CHICHICASTENANGO, GUATEMALA *(Next spread)*

Maria, in a quiet moment in the Iglesia de Santo Tomás, a Roman Catholic church built almost 500 years ago.

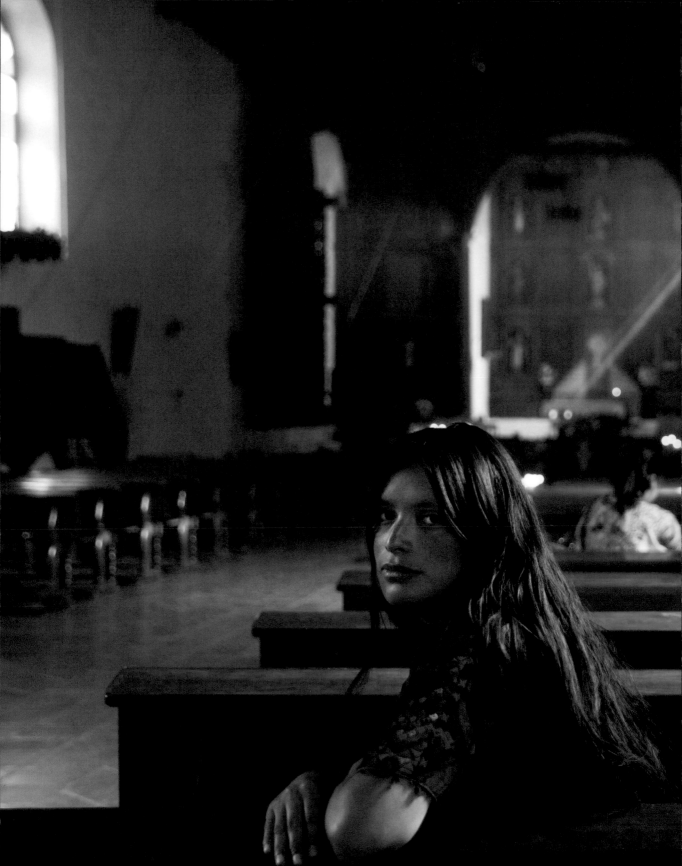

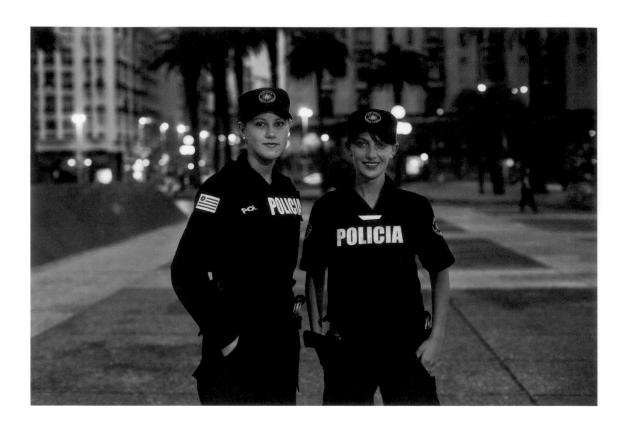

MONTEVIDEO, URUGUAY

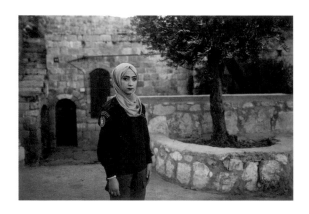

RAMALLAH, PALESTINIAN TERRITORIES

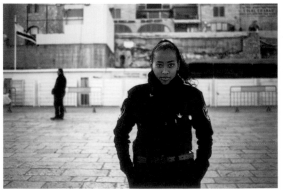

EAST JERUSALEM, DISPUTED TERRITORY

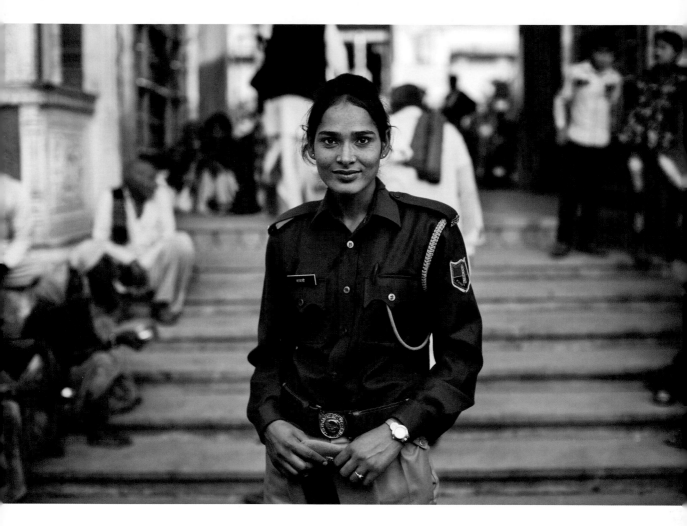

PUSHKAR, INDIA

While traveling from city to city, I was happy to see that
women have joined public forces all over the world.

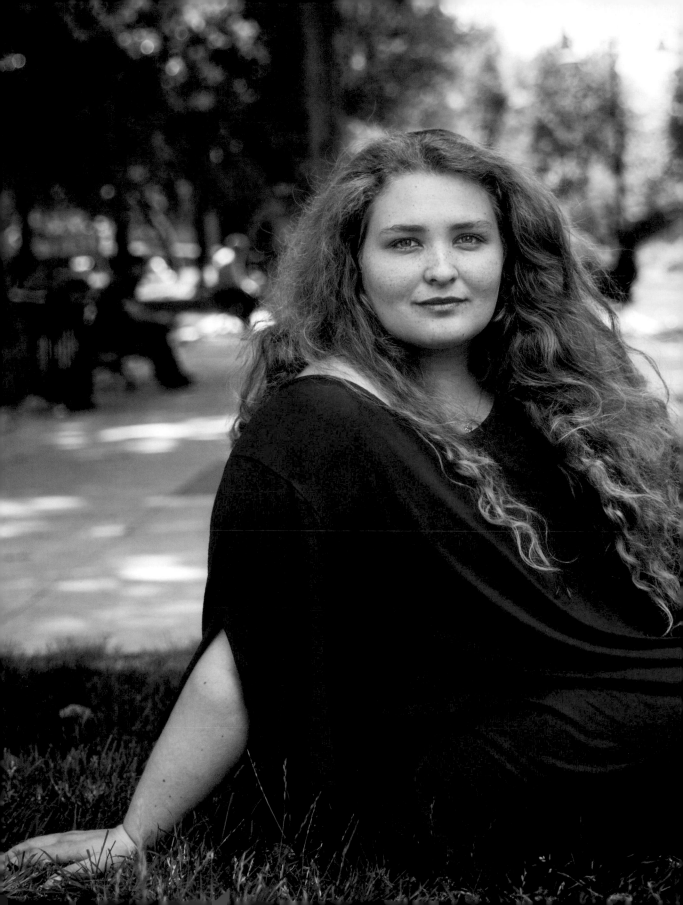

ISTANBUL, TURKEY

During my travels, I've met so many stunning women who told me they don't feel beautiful at all. Influenced by the way the media depicts beauty, many people feel pressured to follow a certain standard of beauty. But that's not the case with Pinar.

She is Turkish Cypriot and has long dreamed of becoming a theatre actress. So, she moved from Cyprus to Turkey, worked hard and fulfilled her dream. While she loves playing different roles on stage, in real life, she adores being herself, natural and free. In the end, beauty is about being yourself, something people like Pinar prove to be true.

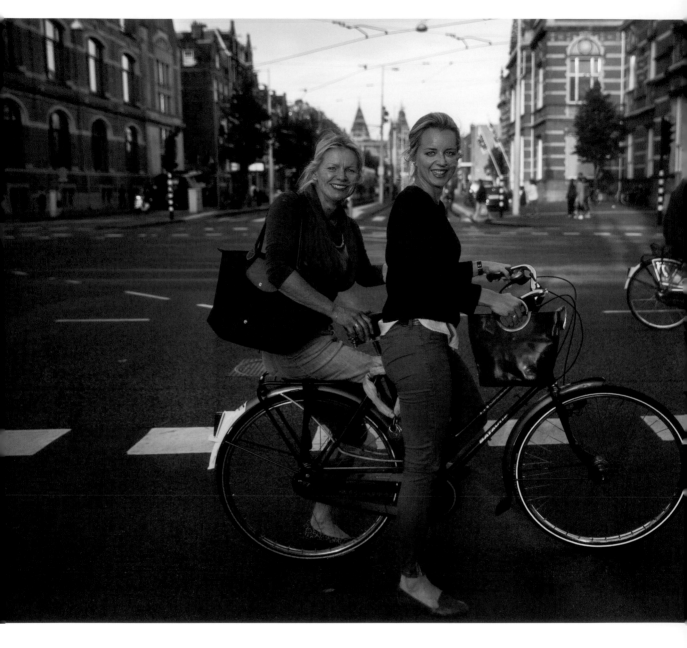

AMSTERDAM, NETHERLANDS

This is a city of bicycles. Ans and Marloes, mother and daughter,
were in a hurry on their way to the movies.

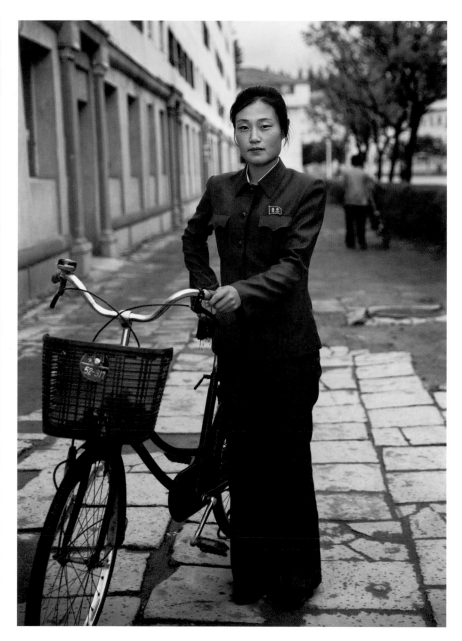

PYONGYANG, NORTH KOREA

This is another place where bicycles can be seen everywhere. In a country where cars are rare and public transportation is undeveloped, bicycles are the most popular way to get around.

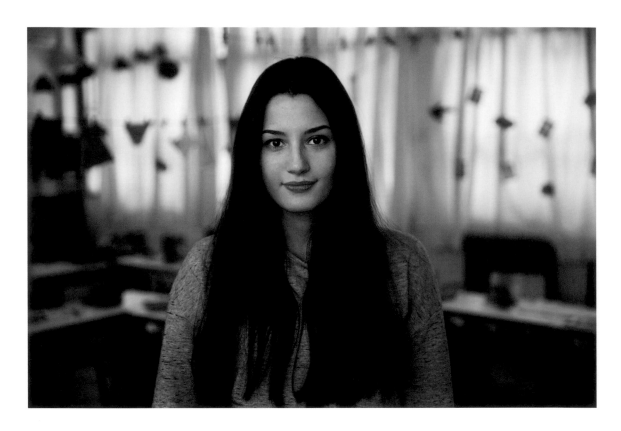

MEGARA, GREECE *(Above)*

Almost every day, Vivi wakes at 5 a.m. to make the two-hour trip to Athens, where she is studying to be a teacher. She especially loves to work with children who have disabilities.

"They make you see the world completely differently and realize how little things can make you happy."

TEHRAN, IRAN *(Opposite)*

A heartwarming moment: Leila holding her son, Abtin.

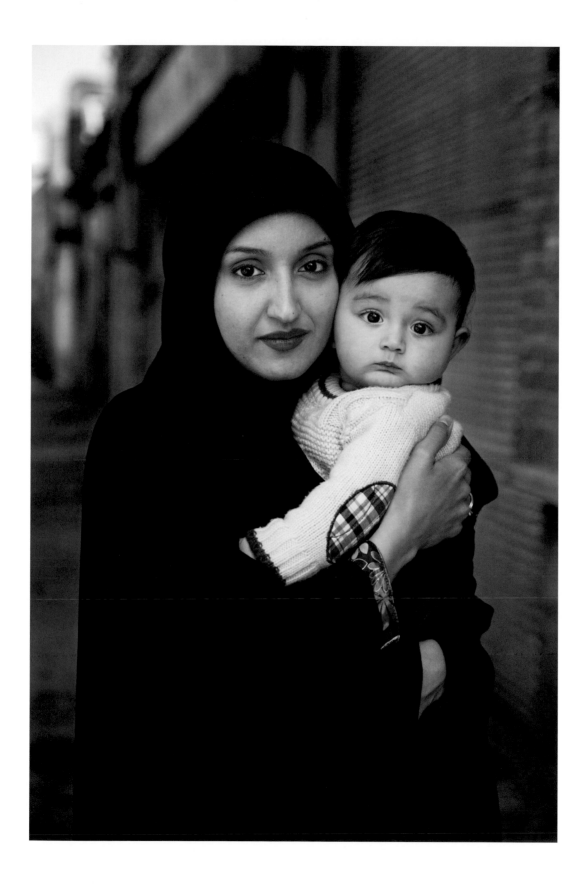

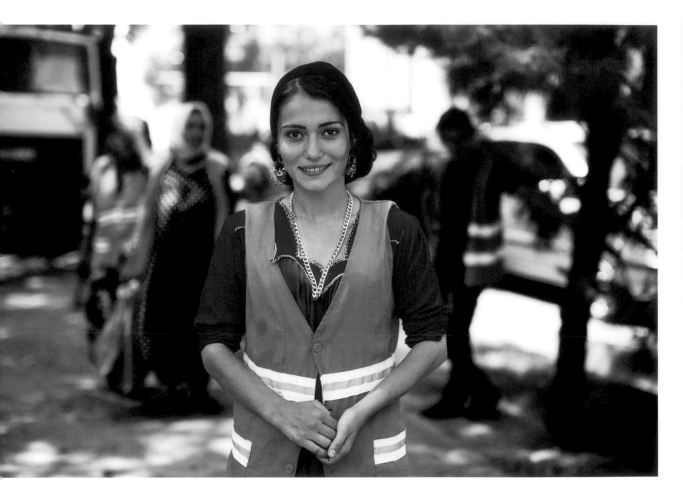

DUSHANBE, TAJIKISTAN

Munira was planting flowers when we met. When she was a student, she aspired to one day be a doctor. But her family is very poor; she was one of five children raised in a one-room apartment. So instead of staying in school, she had to give up her dream in order to start working at an early age. After her photo appeared on my blog, she became a sort of local celebrity. I hope this bit of fame can lead her back on her chosen path.

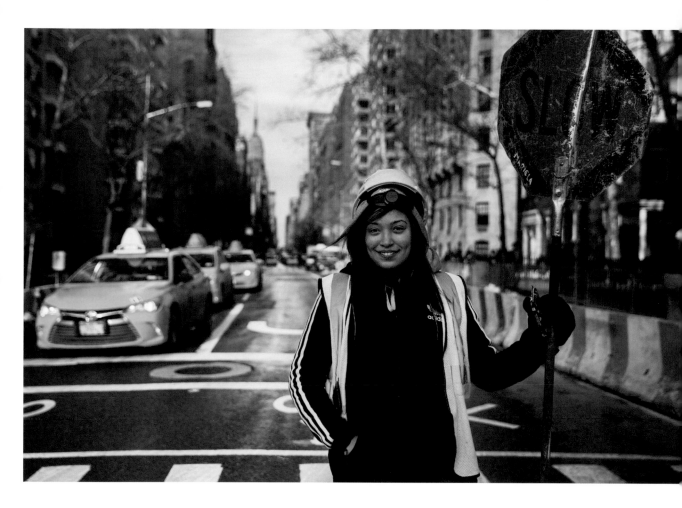

NEW YORK, USA

Mariela is Dominican and moved here a few years ago. She is a nursing student and also works to make a living on the city's busy streets.

JODHPUR, INDIA *(Next spread)*

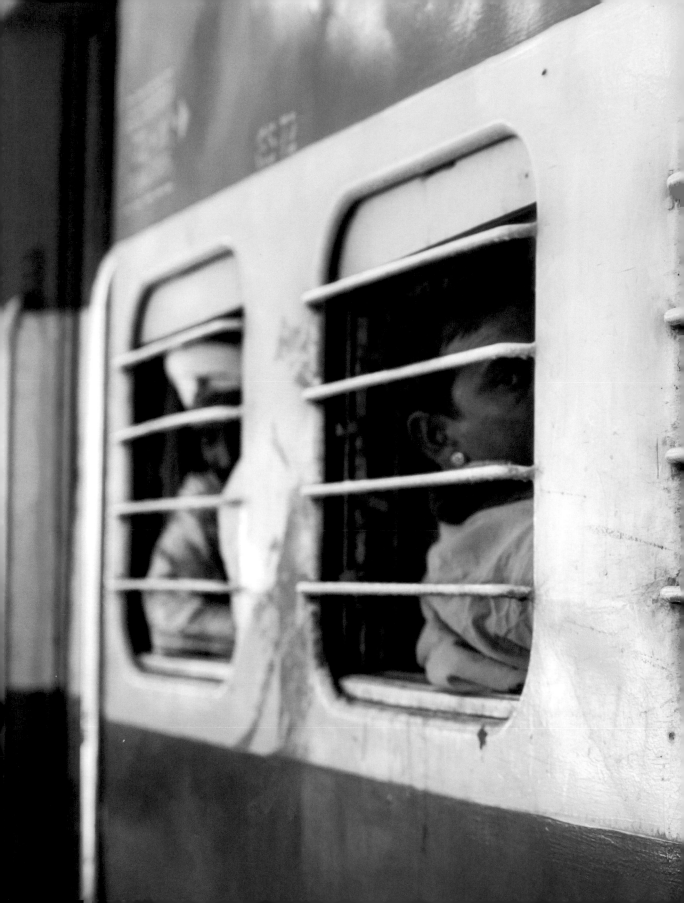

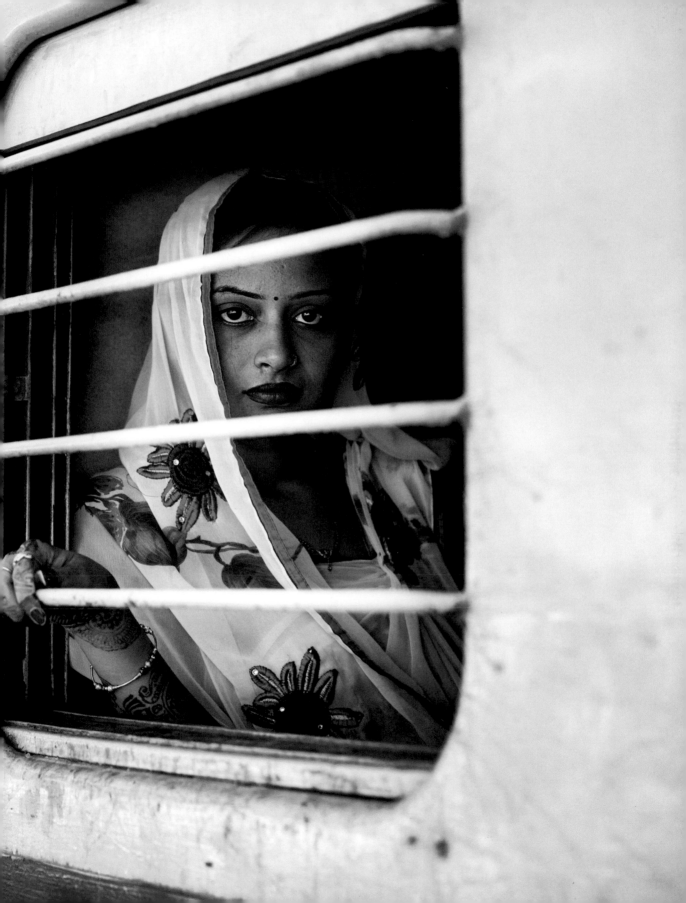

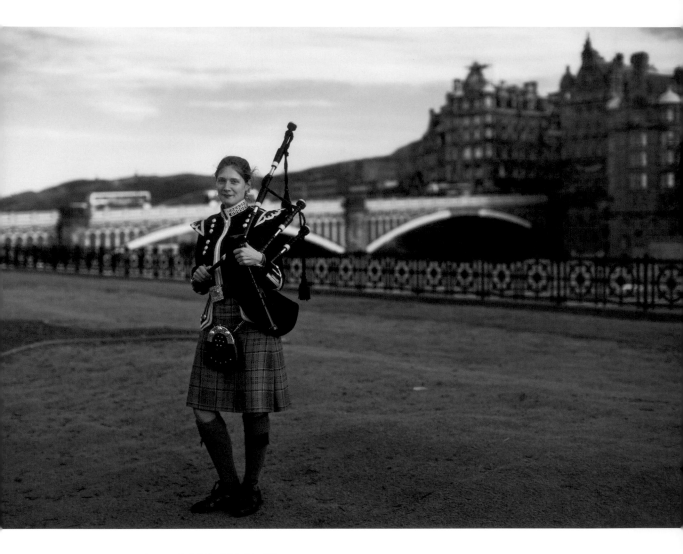

EDINBURGH, SCOTLAND

Born in America, Willa fell in love with the sound of bagpipes when she first heard them at eight years old and immediately wanted lessons. She found a half-Scottish teacher who lived in the States, and devoted herself to the instrument. Years later, attending her teacher's wedding, she met a Scottish man who would become her husband. That's how she came to move here, where she now makes her living playing the music she loves. Looking back, it seems like everything happened for a reason.

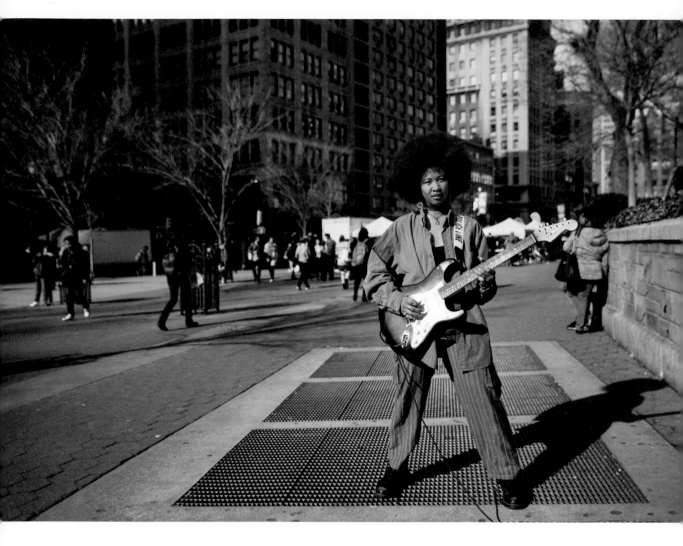

NEW YORK, USA

Looking like a female Jimi Hendrix, Mareko, who is Filipina and African American, was attracting a lot of attention in Union Square. She got started at age thirteen when her cousin was deported to the Philippines and left a basement filled with musical instruments. She is the rare street musician who doesn't ask for money, but just wants to rehearse in front of people to build up her confidence.

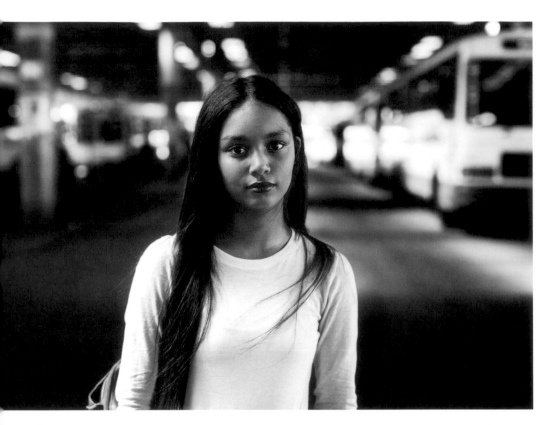
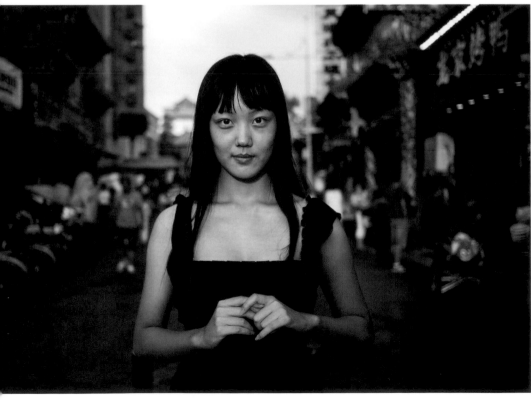

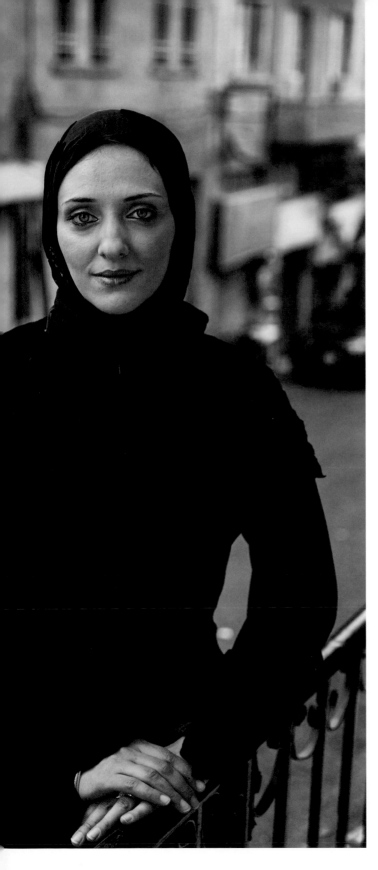

CAPE TOWN, SOUTH AFRICA *(Opposite top)*

A city once divided by apartheid has many beautiful biracial residents, like this young woman.

BEIJING, CHINA *(Opposite bottom)*

She is studying to become a Peking Opera performer. This complex Chinese art differs from Western opera, and mixes dance, mime, acrobatics, and singing.

AMMAN, JORDAN *(Left)*

We can all be guilty of judging people by what they wear. Even with my exposure to other cultures, I sometimes make this mistake. When I saw Hanna, I saw a modest Muslim woman and didn't expect to find out she was a big soccer fan.

"One of my biggest passions is to watch soccer every week. My favorite team is Bayern Munich and my favorite player is Thomas Müller."

295

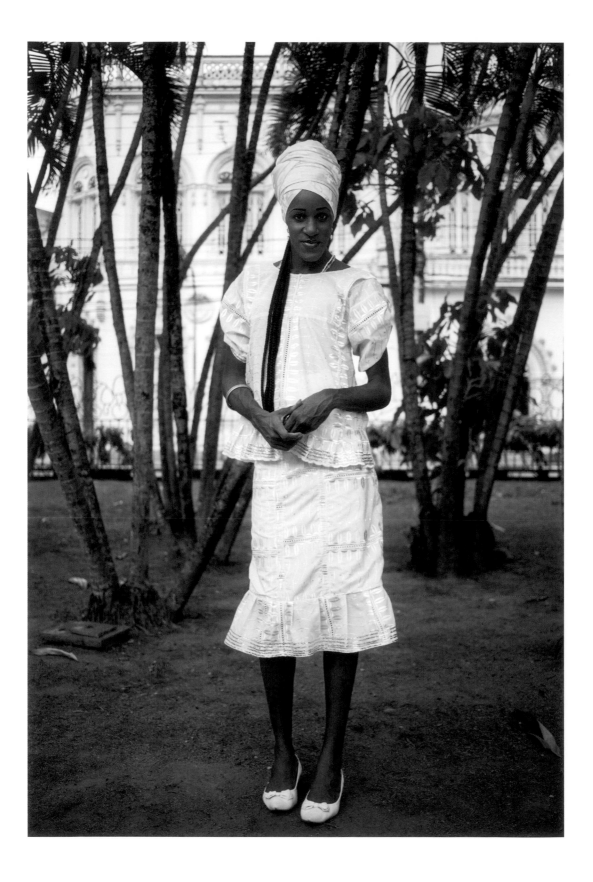

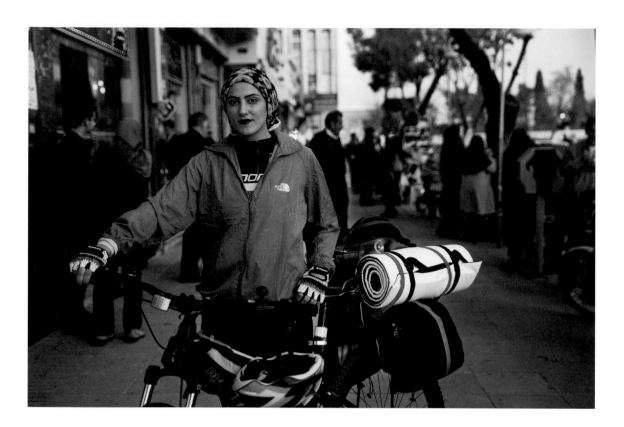

SHIRAZ, IRAN *(Above)*

It's rare to see women cycling in Iran, like Sayena does. Religious authorities strongly discourage it. But this courageous woman from Tehran was taking a long bicycle tour around her country when I met her.

SALVADOR, BRAZIL *(Opposite)*

Dandara is a transgender woman. As an adolescent, she started to understand that she was very different from the other boys she knew, including her twin brother. She told me that although she was born a boy, her total essence is one of a girl. Growing up in a traditional environment, Dandara was always surrounded by misconceptions. But her passions for dancing and styling have helped her overcome many obstacles and become a confident and happy woman.

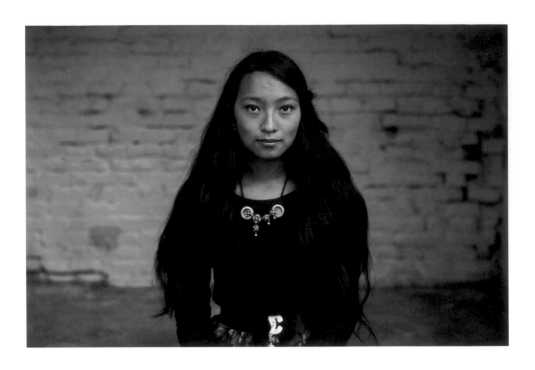

KATHMANDU, NEPAL

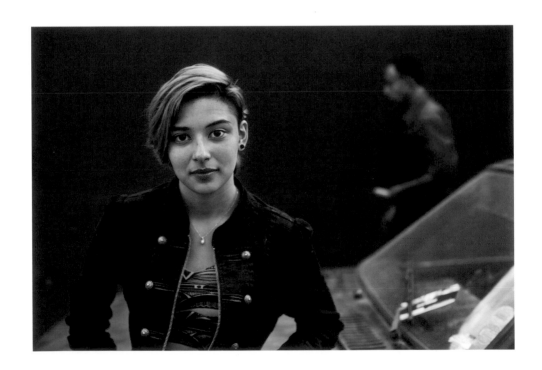

ANTIGUA, GUATEMALA

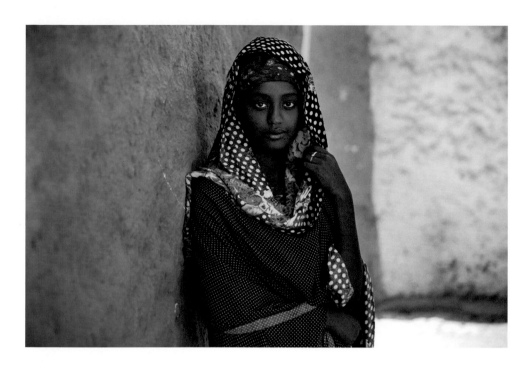

HARAR, ETHIOPIA

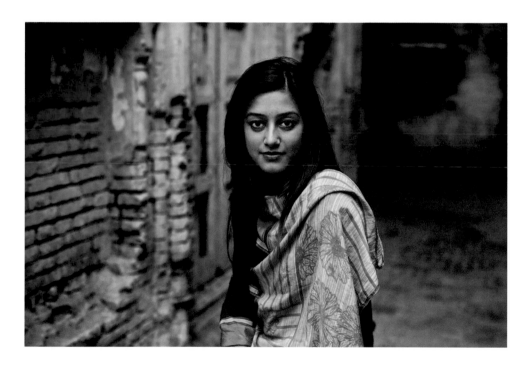

AMRITSAR, INDIA

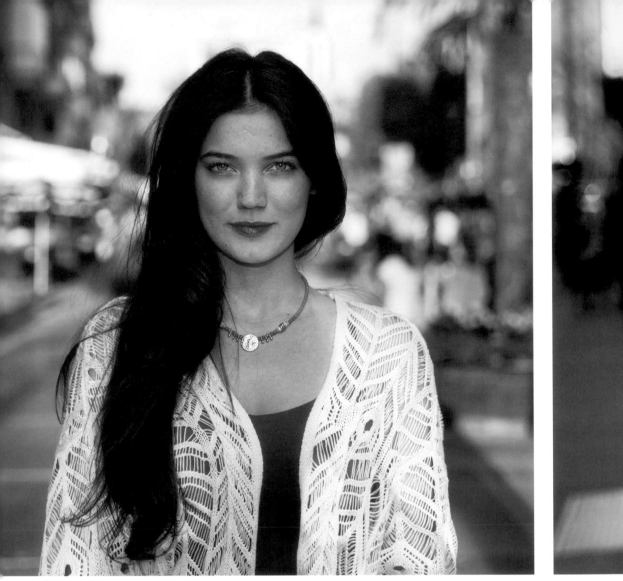

IZMIR, TURKEY

I met Pinar on the streets of this picturesque Mediterranean city. She told me she had just started her acting career. A few months later, I was happy to find out that she was cast in a lead role in a popular Turkish soap opera.

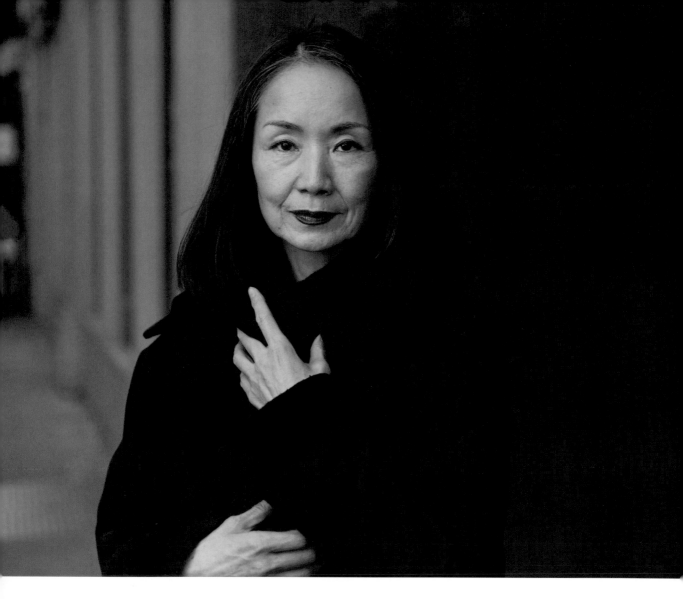

NEW YORK, USA

Mariko is an actress, originally from Japan, who first came here for vacation. She liked the city so much that she decided to move for two years. That was in 1981. Today, Mariko is a true New Yorker.

ANTIGUA, GUATEMALA

Lina has been selling different products in this small town for sixty-two years. She reminded me that everyone, even those leading quiet and anonymous lives, want to be remembered.

"Please send me this photo. I've gathered many pictures of myself over the years and I plan to put them all on the wall in my home, so people will not forget me after I pass away."

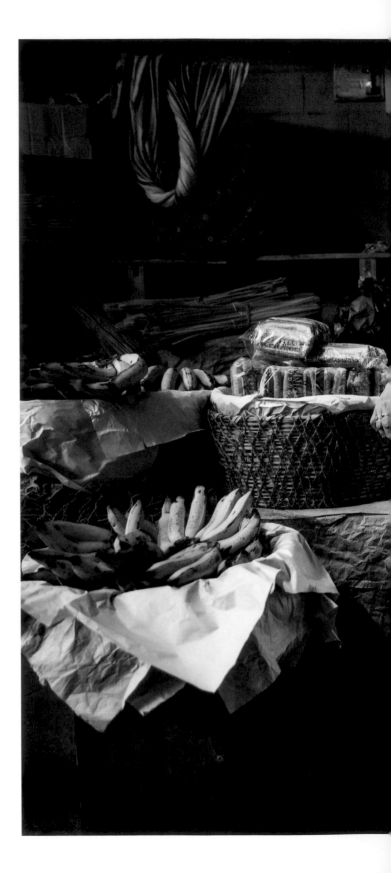

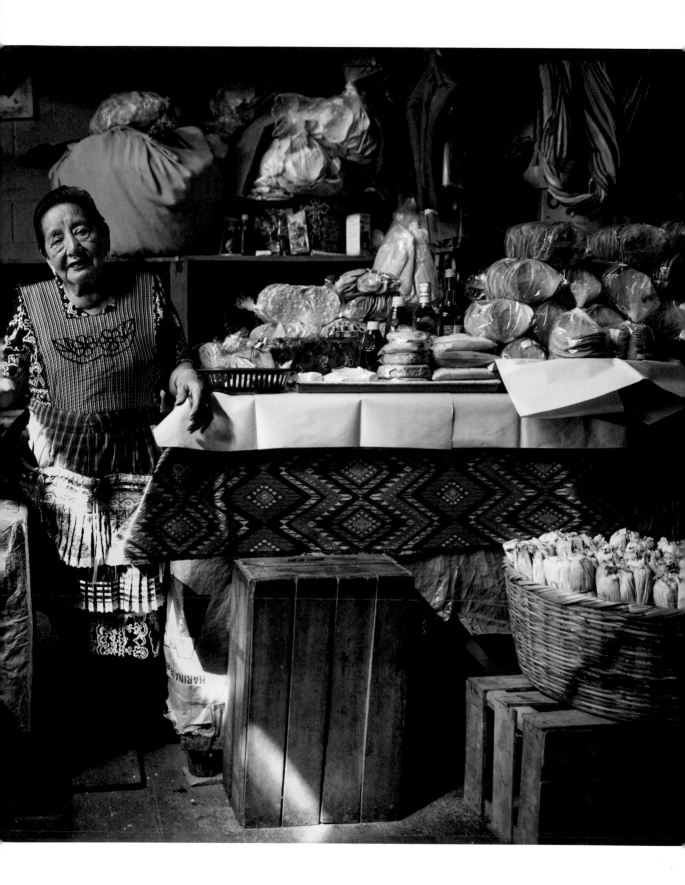

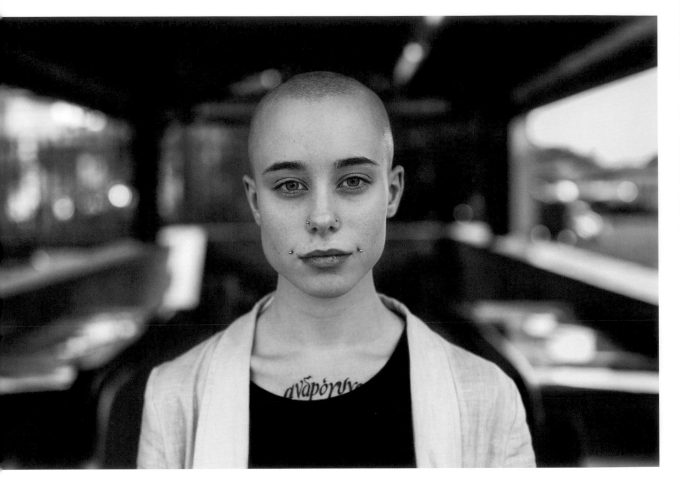

MILAN, ITALY

Giulia has felt androgynous—male and female—since she was a child.
Now she has this word tattooed on her chest, in Greek.

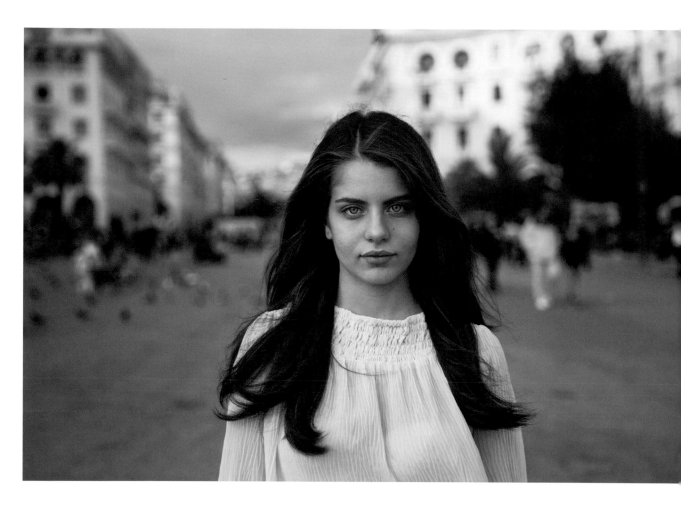

THESSALONIKI, GREECE

Theo loves to express her femininity through her outfits.

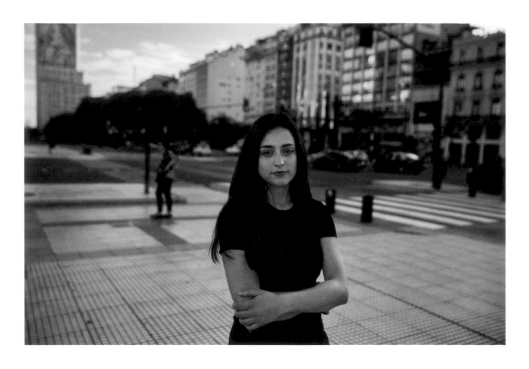

BUENOS AIRES, ARGENTINA

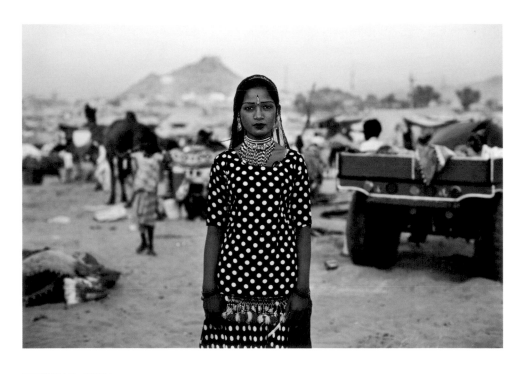

PUSHKAR, INDIA

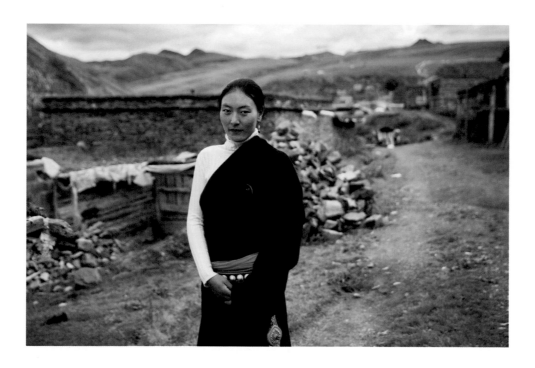

SICHUAN PROVINCE, CHINA

MOSCOW, RUSSIA

SOFIA, BULGARIA *(Above)*

Tzvetana is an amazing mix of grace and strength. Her name comes from the word "flower," in Bulgarian. She plays on the national ice hockey team. Although this sport is expensive and not very popular in her country, she made great sacrifices to follow her dream of playing. She succeeded at this tough sport, and did it without losing her innocent and beautiful smile.

BERLIN, GERMANY *(Opposite)*

Danielle has Mexican and German origins. She's doing office work now, but her greatest passion is soccer. She grew up in the United States, raised by a single mother, and suffered many financial difficulties, but told me that her love for soccer always kept her out of trouble.

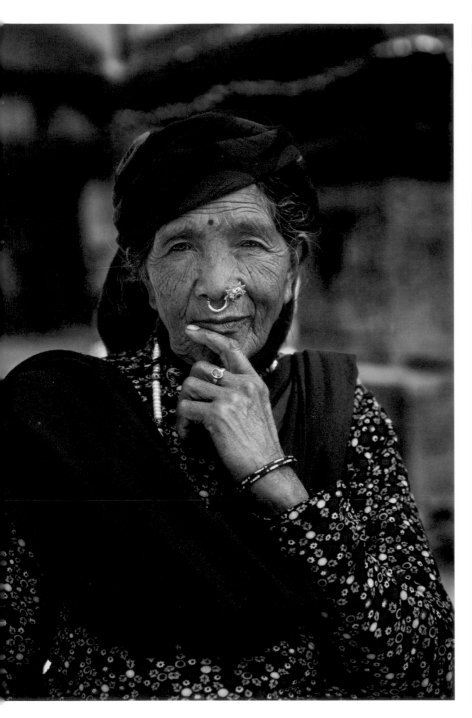
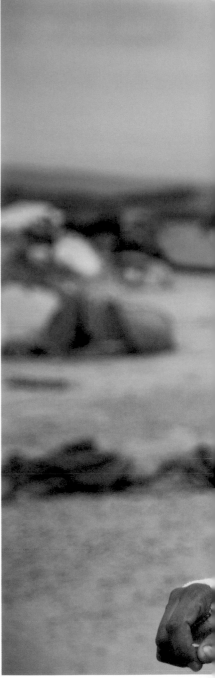

KATHMANDU, NEPAL

She came from her small village to the capital to help raise
her two grandchildren.

310

IDOMENI REFUGEE CAMP, GREECE

This brave woman escaped from her hometown in Iraq, which was under ISIS control.
She traveled a long road to Europe with her three children, in hope of a better life.

LISBON, PORTUGAL

When I saw Maria and her husband, Porfirio, walking slowly, hand in hand on an August day, I felt there was something special about them. When I approach older people for photos, they usually refuse. I don't speak Portuguese, just a bit of Spanish, so I assumed this would not work. But they were delighted to be photographed and invited me to their home where they shared stories. Each had had difficult lives. Both worked hard, and Maria never had the chance to learn to read and write. What they did have was love—and I was surprised to learn it was not a life-long romance. They had met ten years before, when Maria was seventy-seven, and their marriage was the first for each of them. Maybe they didn't have a fortune, but they had love filling their small flat. This, to me, is pure beauty.

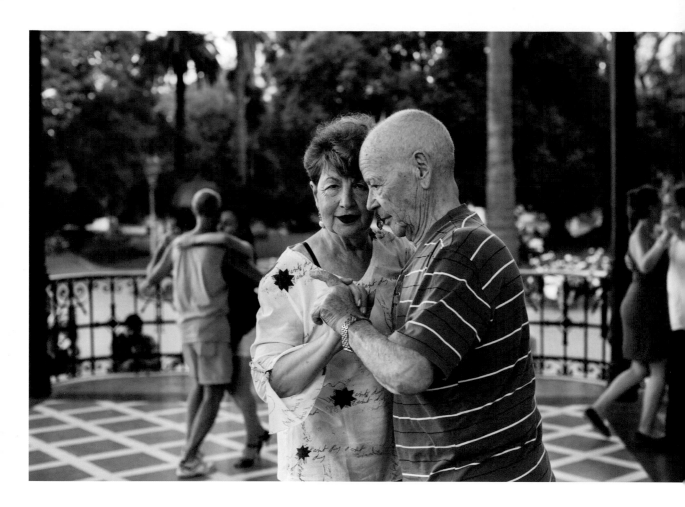

BUENOS AIRES, ARGENTINA

Ofelia (with Jesus)

"We both lost our spouses. Then tango brought us together. We met thirteen years ago at a tango gathering like this one. He invited me to dance and over the next years we danced together every single day."

STOCKHOLM, SWEDEN *(Next spread)*

In a hurry, Emilia stopped for a few minutes to tell me with great delight that she recently had performed at the Royal Swedish Opera, landing a major soprano part. Just twenty years old, she said she was thrilled to be surrounded both by the opera stars she shared the stage with and her family in the audience.

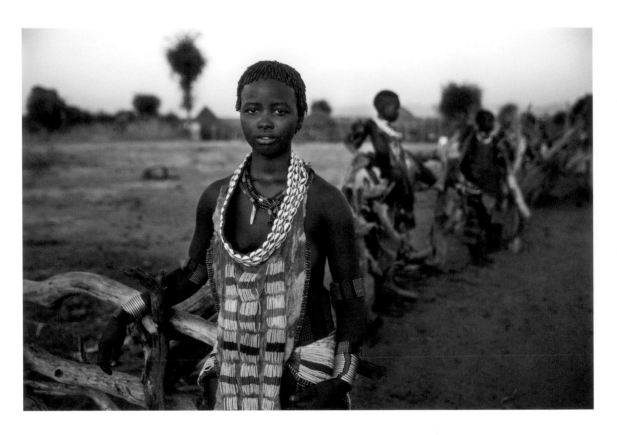

OMO VALLEY, ETHIOPIA *(Above)*

This Hamar tribeswoman wears traditional dress every day.

NEW YORK, USA *(Opposite)*

Ayade often tries to use African motifs in her daily outfits.

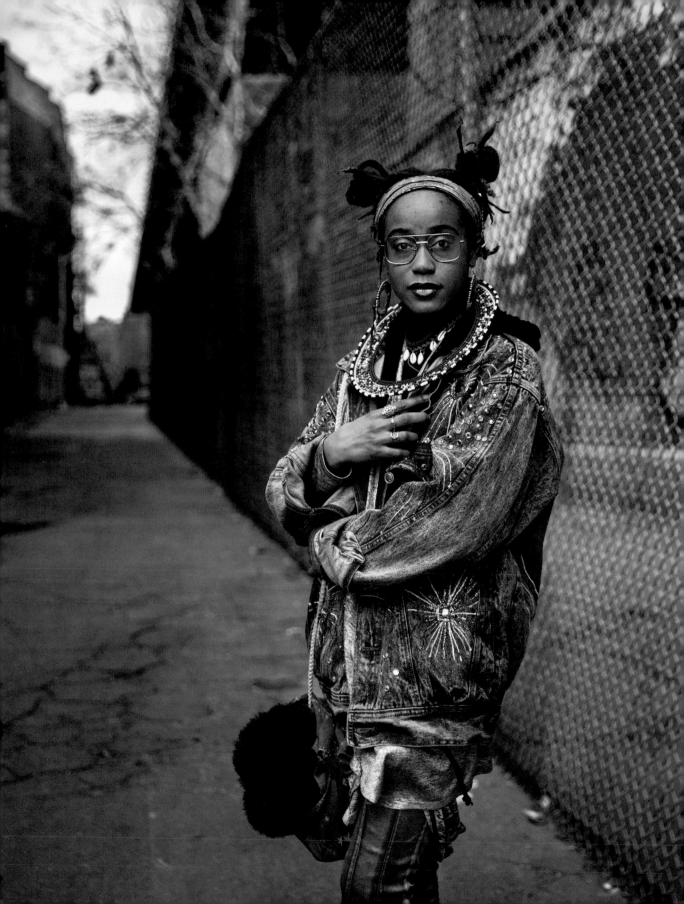

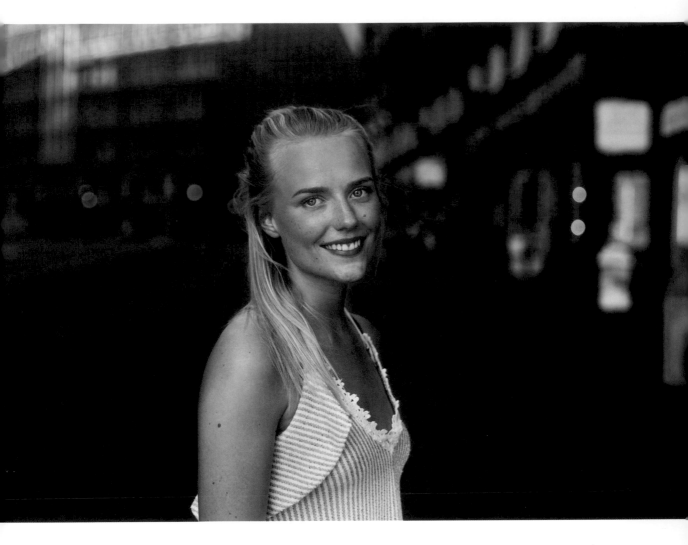

HELSINKI, FINLAND

Aliisa is originally from Lapland, in the northern part of her country, which legend has it is the home of Santa Claus. Like Santa, Aliisa loves to take care of children. She works assisting a little girl with disabilities, who cannot move without her help, but who inspires Aliisa with her positive outlook and natural joy in even small delights.

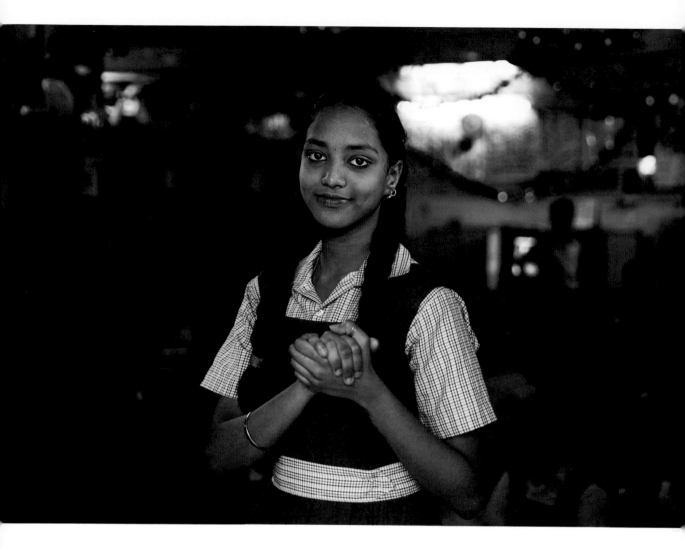

MUMBAI, INDIA

This deaf girl signs the word "friendship" in Indian sign language. I met her in a school run by a non-governmental organization in Dharavi, one of the largest slums in India. Without a voice to express yourself, life could seem hopeless. But education always gives hope, and this girl was really enjoying her time in school! Through sign language and writing, she will always have a voice.

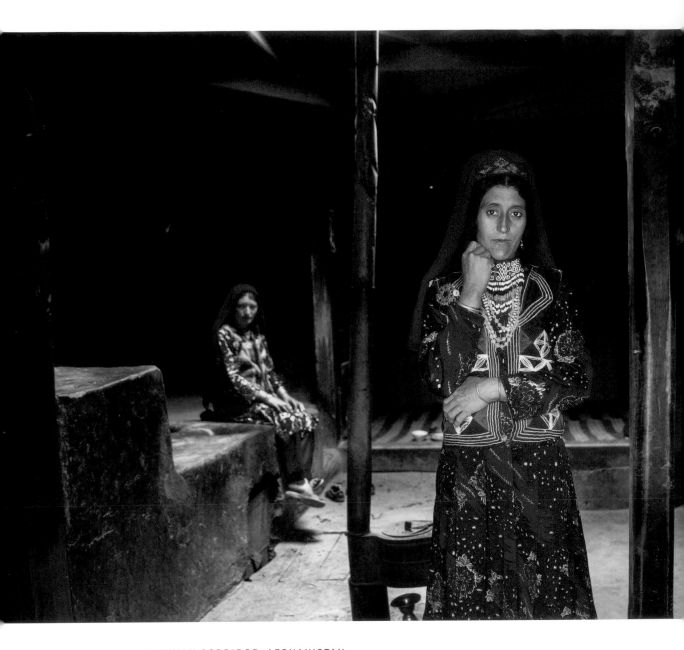

WAKHAN CORRIDOR, AFGHANISTAN

This isolated valley is one of the few places in Afghanistan where women don't cover their faces. I met these women at their home. And just as I was fascinated by their daily colorful outfits, they were fascinated to be photographed and see themselves in pictures.

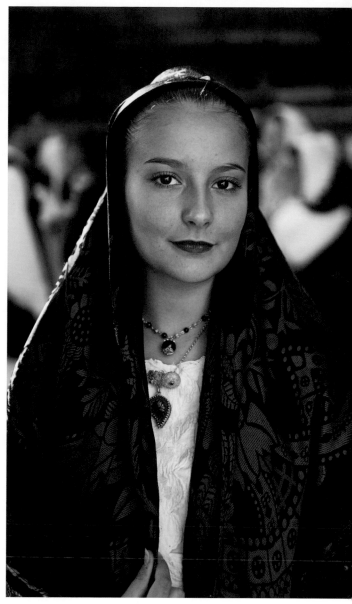

SARDINIA, ITALY

There's something magical about this Italian island. Sardinians gather often for festivals and parades, showing off beautiful outfits, dances, and music. Each village has its own costumes. Johara is from a small town called Ottana. I met her during the Feast of the Redeemer in Nuoro.

LISBON, PORTUGAL

I stopped Mafalda on her way to the tailor.

"I have a miniskirt that I really love in my bag. Now that I'm a mother, I want to make it a bit longer."

BUENOS AIRES, ARGENTINA

Maria, ninety-five, had no time to waste.

"Please take the photo quick. I'm late to the hairdresser."

PUSHKAR, INDIA *(Above)*

TEL AVIV, ISRAEL *(Opposite)*

COLCA VALLEY, PERU

She was riding proudly, in front of a group of men, on the way to a celebration.

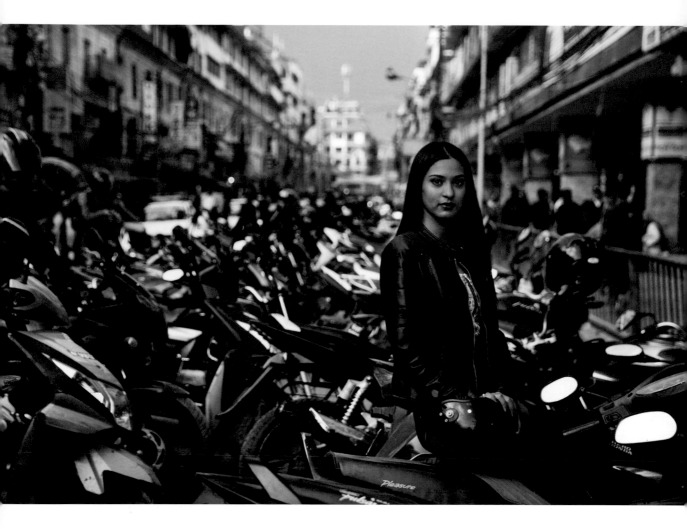

KATHMANDU, NEPAL

In this ancient capital city of more than a million people, Muskan has found that a motorcycle is the best way to get around.

"It took me two years to get used to this crazy traffic. Now I really feel confident"

WEST JERUSALEM, ISRAEL *(Top)*

Ayelet opened a pole dancing studio in the center of this conservative city. She receives threats sometimes but really believes in her mission, and this gives her strength. Women from all environments attend her courses and build their self-confidence. She told me that she has both Jewish and Palestinian students who are very supportive to each other in class.

CAIRO, EGYPT *(Bottom)*

Mint is also fighting preconceived notions by running a pole dancing studio in a conservative place. She trained and taught in the United Kingdom but then decided to return home and share her passion with other Egyptian women. At first, her students felt ashamed to admit to anyone outside the class what they were doing, but Mint told me that she has gradually seen more acceptance of the practice.

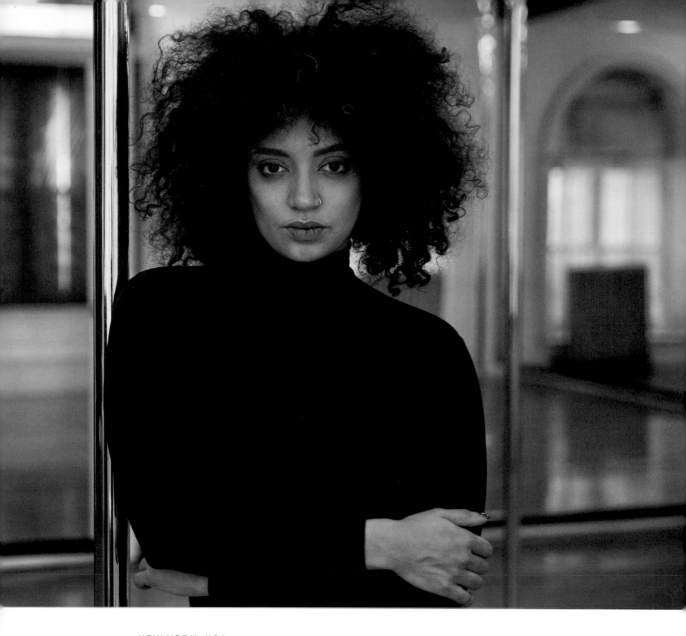

NEW YORK, USA

Brigitte has been a pole dancing instructor for a year. She noticed that even in this cosmopolitan city there are still many prejudices about this sport. Many people perceive it as striptease, although it is a challenging form of fitness requiring strength and flexibility. For many women, it is a great way to learn to be comfortable with their bodies.

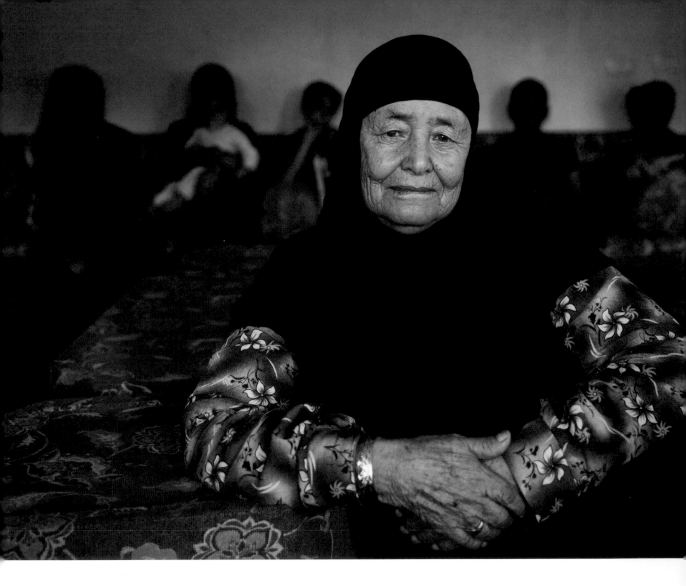

PETRA, JORDAN

Sara, Bedouin woman

"I was born in a tent. Back then we were nomads in the desert. We grew up in hard conditions, but we were happy. We were carrying heavy buckets of water every day for many, many kilometers. We didn't buy anything. In the 1980s, our community decided to move to modern homes. Life is much more comfortable here. We have shops, houses, water, furniture, electricity, TV, everything. Now when a baby is born, the mother goes to the hospital. Back then we didn't have doctors. But I actually really miss those times. I really miss that feeling of freedom in the desert. We were all the same, we were equal and selfless, not caring about money or other goods. We all shared the same home, the desert."

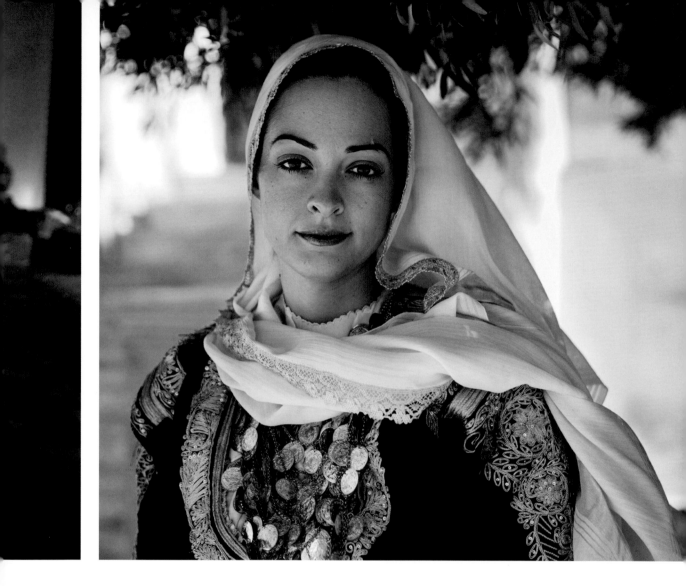

MEGARA, GREECE

Any other day you will find Kaliope wearing modern clothes at her family's business. But each year on the third day of the Greek Orthodox Easter, Kaliope goes back to another era by putting on the traditional dress that once belonged to her grandmother and dancing with other women in the old square of their town, just as their ancestors did.

NEW YORK, USA *(Next spread)*

I love to photograph mothers with their daughters. There's always an intimate chemistry between them. Jenny and Lily were having a walk around the neighborhood.

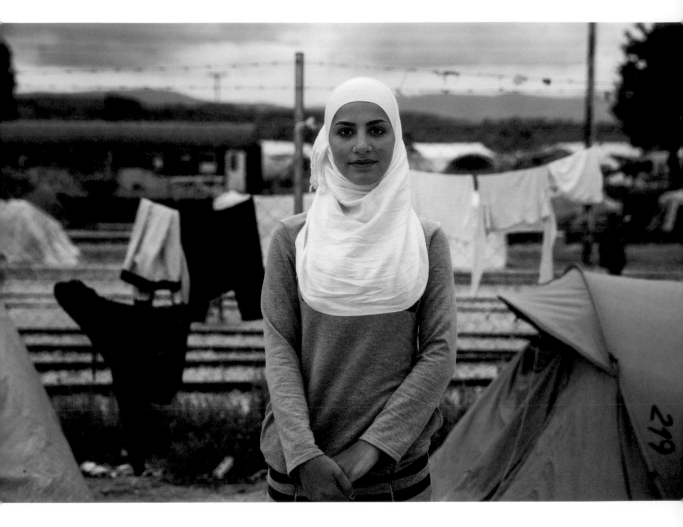

INDOMENI REFUGEE CAMP, GREECE

The love story of two Syrian refugees.

"I met him in a refugee camp, in Turkey. We fell in love, and a few days ago we married here. We went to the nearest city to celebrate. We spent our last money there, but we were happy. It was our one-day honeymoon."

AMSTERDAM, NETHERLANDS

Denice quit her job and started a school for refugees. She loves the diversity
of the planet and that's why she likes to wear this dress with a world map.

BEIJING, CHINA

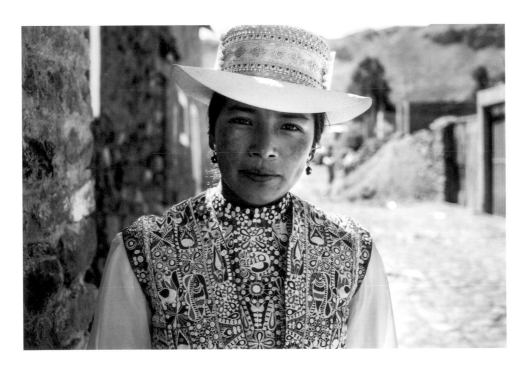

COLCA VALLEY, PERU

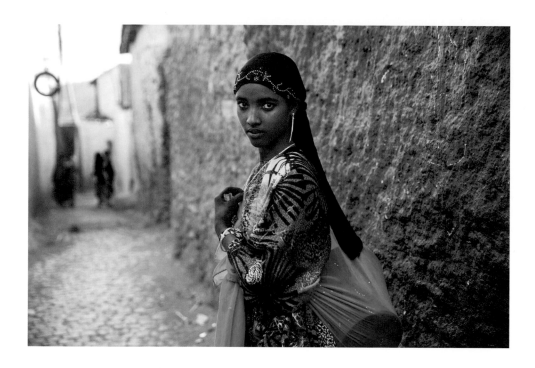

HARAR, ETHIOPIA

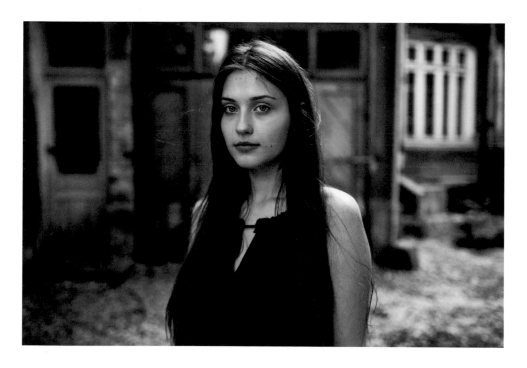

BUCHAREST, ROMANIA

MOSCOW, RUSSIA

I've rarely met a person with more different passions and plans. Beside playing piano, Margarita takes singing lessons, studies journalism, plans to make documentary movies, dreams of exploring remains of ancient cities on the ocean floor, and aspires to design a fashion line.

"I want to create things that will be new and useful for everyone."

PYONGYANG, NORTH KOREA

While traveling in North Korea, I was told that almost everybody learns to play an instrument in school. The best are chosen to become professionals. Music is not just entertainment, but also a way to spread the Workers' Party messages throughout the country.

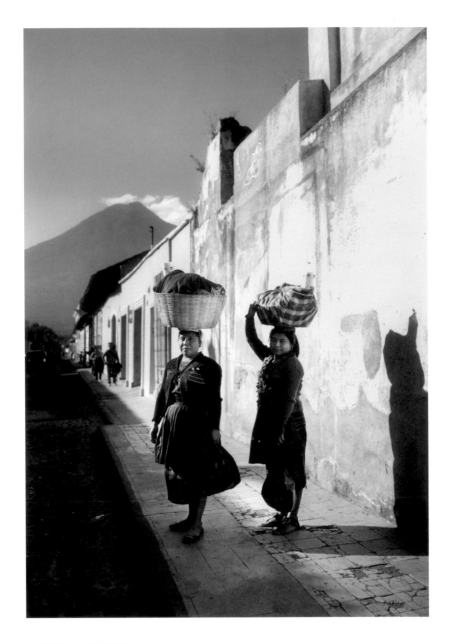

ANTIGUA, GUATEMALA *(Above)*

Mother and daughter on the way home.

JODHPUR, INDIA *(Opposite)*

Grace and strength wonderfully coexist in most Indian women that I met.

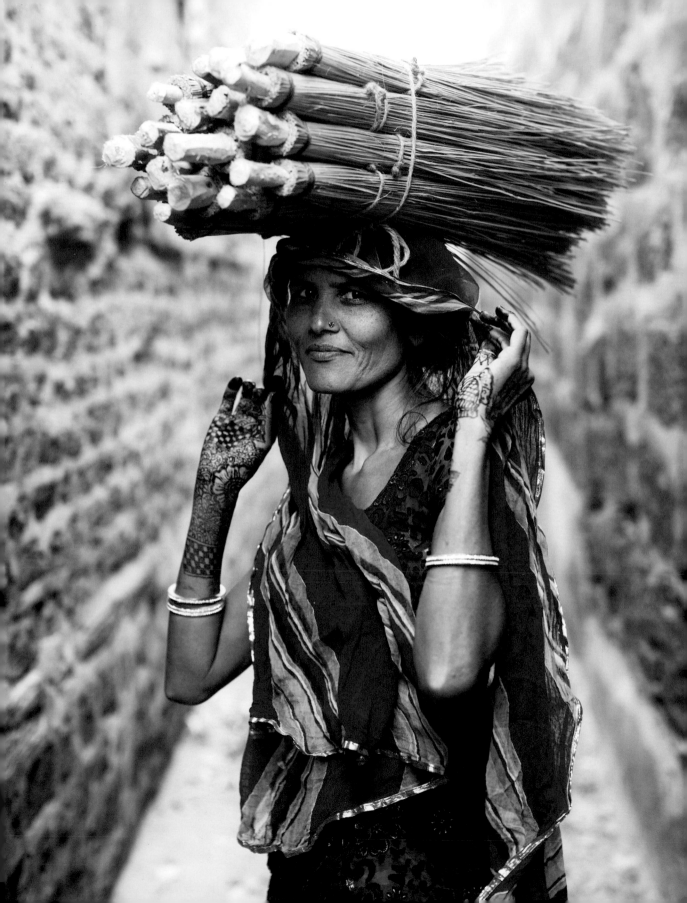

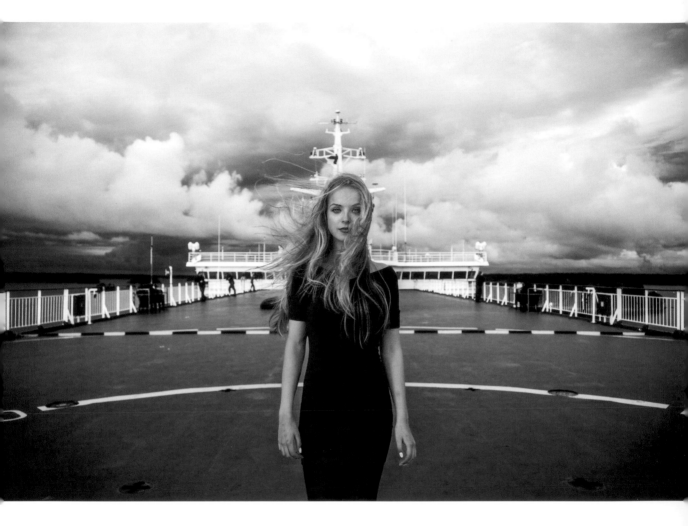

NORTH SEA, FINLAND

Tea, who is Finnish, was taking the busy ferry trip between her country and Sweden.

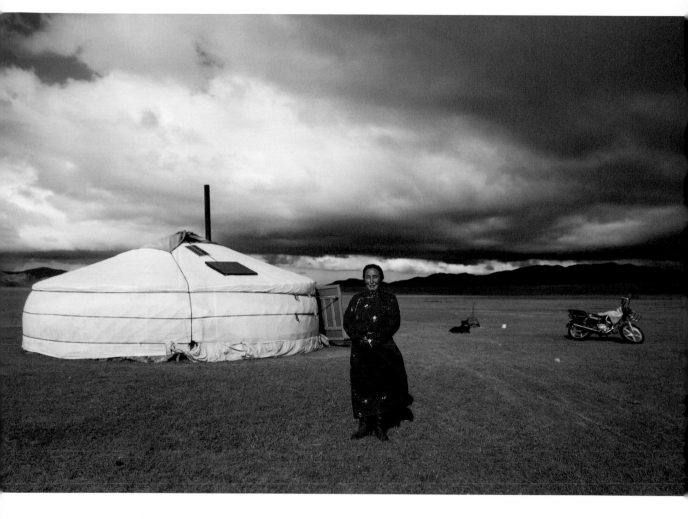

CENTRAL MONGOLIA

For the Mongolian nomads, travel is very different from most other cultures. They move seasonally with their yurts in search of a better place to pasture their herds.

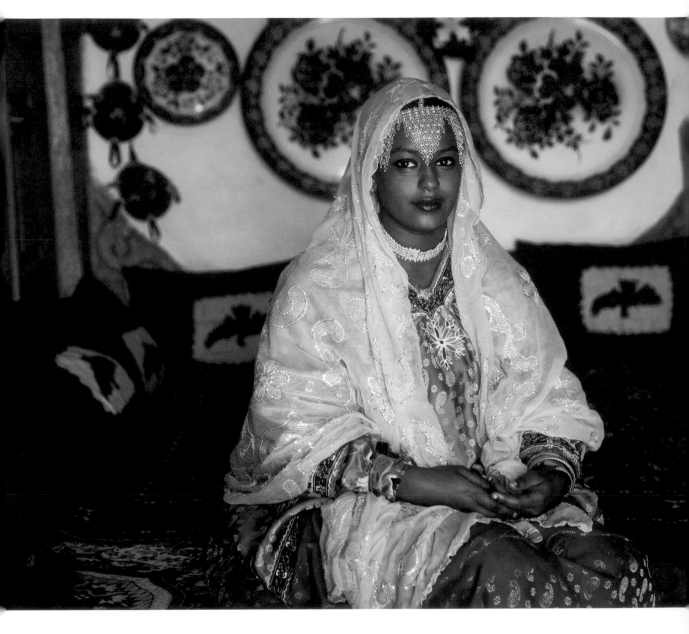

HARAR, ETHIOPIA

This folk dancer wore her performance costume in her grandmother's traditional Harari home.

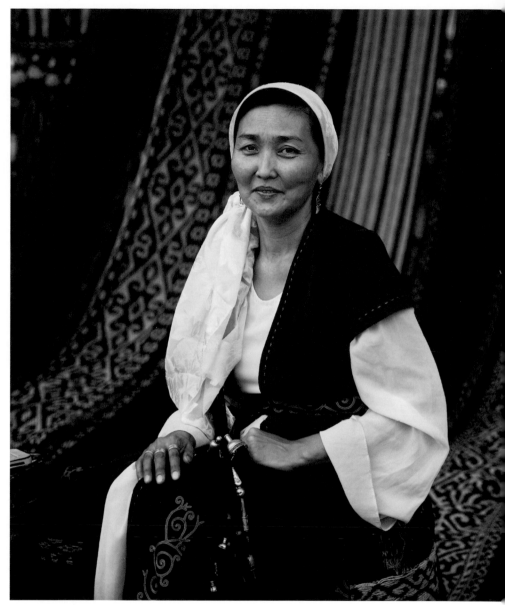

BISHKEK, KYRGYZSTAN

She came to the capital of the country for a
traditional festival where she will sell carpets made
in her village. In Central Asia, carpet making is an
old and powerful tradition.

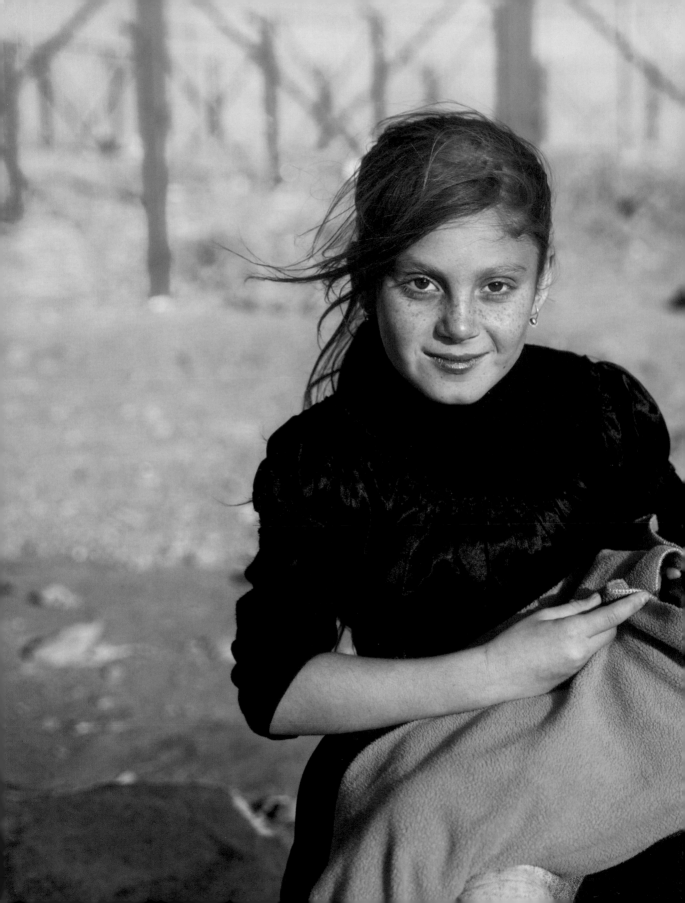

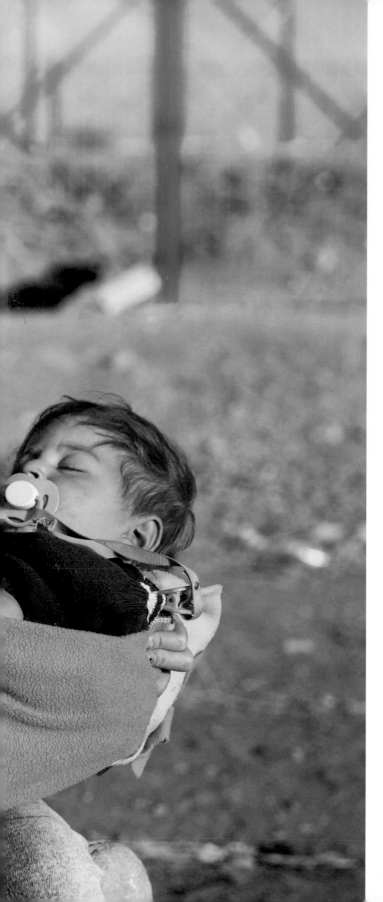

KURDISTAN REGION, IRAQ

I met these beautiful Yazidi children in a refugee camp. Thousands of people from their community have been killed by ISIS just because they were seen as the wrong people to be living there. While visiting countries affected by war, I've witnessed the consequences of intolerance and discrimination. They are horrific!

The victims may be Yazidis, or Muslims, or Christians, or atheists. But the intolerance stems not merely from religious difference. Other times, people are discriminated against for their color, ethnicity, gender, or sexual orientation. At the root of all these conflicts is hate—a hate of difference. Tomorrow, any one of us could also be targeted.

Humankind has made great strides since the Second World War in terms of human rights, but we shouldn't take any gains for granted. We should continue to make this world a more equal place, even if there may be moments when it seems everything is lost.

The smile of this little girl and all the wonderful people that I met in my travels give me hope in humanity. As long as love is on our side, we are stronger and we can create a better world for our children.

Thank you for taking this journey around our planet with me. I hope new adventures will soon follow.

ACKNOWLEDGEMENTS

When I look back, I still don't believe that I've come such a long, challenging, but beautiful path. There's much hate and intolerance in the world, but believe me, there's much, much more love. Many people proved this to me and made this book possible.

Thank you to all the incredible women I photographed. Although I was a stranger, you trusted me with your image, and with your precious stories. In an instant, that moment of connection felt like magic. Thank you to my amazing husband. No words can describe your contribution to who I am today. Thank you to my grandfather. You passed away while I was far from home, working on this project, but I will always remember you as the greatest gentleman I've ever met. Thank you to my parents. You showed me what it means to be a free spirit. Thank you to my in-laws. Because of you I now have four wonderful parents. Thank you to the rest of my family. You make it so hard for me to leave, because I always miss you while I'm traveling! Thank you to my agent, Brian DeFiore. You stepped into my life, when things were very difficult, and you brought light to my path. Thank you to Jenny Wapner, Angelina Cheney, and Jane Chinn. And thank you to Allison Adato for all of your help with the writing. I know it's been a lot of work, but you've been an awesome team. Thank you to Anca Negescu. You believed in my crazy dream when almost nobody else did. Thank you to all people who donated to the project so I was able to continue. Without you, none of this would have been possible. These are just a few of those who supported *The Atlas of Beauty* financially:

Gilles Dandrieux, Raluca Gavra, Pascal Sieuw, Carel Van Apeldoorn, Cristian Tamaş, Christopher Duburcq, Alina Bugeag, Elena&Alex Rada, Francisc Pasc, Lynne Calder, Mircea Goia, John Carbajal, Oana Dragan, Charla Rae Armitage, Alina Savu, Trudy Denise Kemp, Satoko Takahashi, Matteo Berzoini, Kevin Huang, Hewa Schwan, Peter L. Willardson, Simona Kelber, Christoph Sahner, Micha Tschuck, Nefeli Papapetrou Lampraki, Sybille Paeper, Naomi Brown, Ryoko Yatagai, Elisabeth Fernandes, William Leon Naufahu, Margriet Wentink, Hans Mac-Kenzie, Jasdeep Singh Ohri, Amanda Kuhns, Kristin Cattell, Vita Calabrese, Catalin Georgescu, Vlad Muchova, Dragos Gurarosie, Alina Goncharova, Andrea C.Teunissen, Oana Georgiana Lefter, George Liao, Robert Dietze, Paul Gabriel Pasztor, Chan Chung Man, Javed Mohammed, Bruce N. Miller, Shen Nelson, Lavinia Palaghita, Torben Pedersen, Bobbie Chan, Montie Carol, Sally Squires, Jeremy Nguee, Myriam Graf, Ho Viet Hai, Iris Arce Dinaw, Kellilyn Porter, Martin Decker, Silvia Gutiérrez Ferreras, Richard Johnson, Maria Vassileva, Anja Grafenauer, Rainer Maehl, Yang Lee, Craig Young, Hodaya Louis, Morici Miriam, Emma Pettit, Dinah Sackey, Tamara Somasundaran, Kim Huffman, Vicky Licorish, Mayur Vora, Thomas Künzli, Daniel Frutig, Rolf Jeger, Yohanes Wirawan , Zayna Abdulla, Adrien Elmiger, Alexandra Thomas, Jean-Claude Peclet, Henri Garin, Valeria Cocco, Anabel García Pin, Antonio Diaz Sanchez, Yogesh Kumar, Magdelyn Fletcher, Matthew Keppens, Antonina Jaeger, Matthias Grund, Dietrich Buchborn, Markus Grabher, Christopher Mesaros, Erik Wiedenhof, Robert Seasting, Linnea Passaler, Andrea Ronca, Pierangelo Baggio, Ioana Colac, Yuri A Chung, D. S. Raju, Gasper Sopi, Eric Rothwarf, Valeria Sanchez, Bela Vajko, Nahnhy Hyong, Cheng Yu Pong, Emma Allen, Klaus-Peter Hilpert, Christian Monasse, Shannen Johnson, Lluvia Carrisoza, Nanette Nelson, Alin Stegeran, Chow Chi Lok, Olimpia Brandhuber, Lucile Galmiche, Gabriel Cristea, Lorgen Gerard Magpantay, Nanami Fuchida, Jin Seok Park, Irina Ramfu-Flader, Marius Aioanei, Jackie Lynch, Alex Landine, Kim Shi, J. F. Fitzpatrick, Alessandro Pepe, Yuki Daijo, Harry Sang Bui, Tobias Läuppi, Marc Terry Sommer, Cassandra J. Auzins, Paula Talaba, Mariam Naji, Florentina Pana, Sawako Mitsubayashi, Christophe Labarde, Marcus Orbe, Gentiana Coman, Allan Pereira da Silva, Rehana Adam, Nuria García, Pierre Ruhlmann, Marc Smith, Andreea Radulescu, Nelson Shen, Walter Fettich, Haziq Rashid, Christophe

Van den Heuvel, Nathan Ramler, Candice Leibow, Nazanin Pajoom, Michael E. Horgan, Dietrich Hahn, Dorina Mocanu Paun, Terezia Mrazova, Ionut F. Minciuna, M. Bernita Vick, Diana Fulger, Jose Luis Gay Cano, Cedric Favero, Pamela Sanchez Chavez, Roxana Chiriacescu, Lorenz Zahn, Marc De Wilde, George Popescu, Victor Voicu, Renshi Asada, Florin Florea, Andrea Margara, Makoto Yamaki, Graeme Cohen, Mihaela Chita-Tegmark, Martin Singer, Valentin Balan, Alexandra Panaite, Andreea Stan, Laura Jurca, Alina Dumitru, Ciprian Dumitrescu, Larry Syverson.

COLLAGE IMAGE LOCATIONS *(From left to right, top to bottom)*

PAGES 58-59

Ethiopia, China, Singapore, Germany, France, Spain, Ethiopia, Nepal, Uruguay, USA, Switzerland, Mongolia, Greece, Romania, India, Ethiopia, Portugal, Ethiopia, Portugal, Nepal, India, USA, Romania, China, Ethiopia, Chile, China, Germany, France, Portugal, Sweden, England

PAGES 134-135

Portugal, South Africa, China, Germany, Portugal, England, Brazil, Germany, Nepal, Laos, Ethiopia, Tajikistan, Cuba, Panama, Ethiopia, Switzerland, Greece, Romania, North Korea, Ethiopia, Nepal, Sweden, North Korea, Ethiopia, Netherlands, China, Portugal, Ethiopia, North Korea, Iran, USA, Sweden

PAGES 208-209

Uzbekistan, Egypt, Cuba, Portugal, Tajikistan, Netherlands, Italy, Russia, Germany, Peru, Cuba, India, Greece, Portugal, Germany, Guatemala, Russia, Nepal, Russia, Cuba, Argentina, England, Turkey, South Africa, Germany, Colombia, Ethiopia, China, Ethiopia, China, Spain, Mexico

PAGES 244-245

India, Romania, Ethiopia, Portugal, Russia, Italy, South Africa, Tajikistan, South Africa, Germany, Kyrgyzstan, Russia, China, India, Sweden, Panama, Kyrgyzstan, India, Indonesia, Ethiopia, Brazil, Ethiopia, Italy, Ethiopia, Sweden, Romania, Ethiopia, Tajikistan, Irak, Russia, China, France

PAGES 340-341

Ethiopia, Italy, Germany, India, Italy, USA, Brazil, Bulgaria, Sweden, Italy, Netherlands, Russia, India, Cuba, China, Ethiopia, England, Afghanistan, USA, Germany, Palestinian Territories, North Korea, Germany, Italy, Netherlands, Tajikistan, Ethiopia, Netherlands, Tajikistan, Ethiopia, India, China

www.crownpublishing.com
www.tenspeed.com

Ten Speed Press and the Ten Speed Press
colophon are registered trademarks
of Penguin Random House LLC.

Library of Congress Cataloging-in-Publication
Data is on file with the publisher.

Hardcover ISBN: 978-0-399-57995-0
eBook ISBN: 978-0-399-57996-7

Printed in China

Design by Angelina Cheney
Cover photo: Varanasi, India
Title page photo: Kathmandu, Nepal

10 9 8 7 6 5 4 3 2 1

First Edition